D0055348

PENGUIN BOOKS

THE NATIONAL TRUST Ł
OF ENGLISH FURNITURE

Dr Geoffrey Beard is chairman of the Furniture History Society, of which he was a founder-member in 1964. He also edited its first ten annual *Journals*. He has written a number of books on interior decoration in the seventeenth and eighteenth centuries, including standard texts on decorative plasterwork and craftsmen at work in England. His *Craftsmen and Interior Decoration in England, 1660–1820* (1981) was awarded the Sir Banister Fletcher Prize. He now lives in Bath, having left university teaching to concentrate on writing and lecturing.

GEOFFREY BEARD

THE NATIONAL TRUST
BOOK OF
ENGLISH FURNITURE

PENGUIN BOOKS
in association with the
NATIONAL TRUST

Penguin Books Ltd, Harmondsworth, Middlesex, England
Viking Penguin Inc., 40 West 23rd Street, New York, New York 10010, U.S.A.
Penguin Books Australia Ltd, Ringwood, Victoria, Australia
Penguin Books Canada Limited, 2801 John Street, Markham, Ontario, Canada L3R 1B4
Penguin Books (N.Z.) Ltd, 182–190 Wairau Road, Auckland 10, New Zealand

First published by Viking in association with the National Trust 1985
Published in Penguin Books 1986

Designed by Judith Gordon

Set in Clowes Dante
Typeset by CCC, printed and bound in Great Britain by
William Clowes Limited, Beccles and London

TO THE MEMORY
OF
JOHN HAYWARD
1916–1983

CONTENTS

PREFACE

In recent years study of the arrangement and services of the great English country houses has been given new impetus by the researches and writings of, in particular, Clive Aslet, John Cornforth, Dr Jill Franklin and Professor Mark Girouard. In addition considerable thought has been given to the arrangement of furniture within domestic settings by the staff of the Department of Furniture and Woodwork at the Victoria and Albert Museum. In writing this short book about English furniture, it has seemed sensible to divide the furniture into various categories – the furniture made for Crown and court and found in the principal rooms of palace and grand house, that found in more modest country houses, furniture used by the servants 'backstairs', and furniture sat upon by the family in their lavish formal or landscaped gardens and parks. The first four chapters give an account of the nature of the training undergone by furniture makers and of workshop organization, materials and construction; of methods and techniques commonly used; of the relationship between the patron and the trade; and of the decorative styles used.

I have confined myself in the main to the period in which the National Trust's collections are strongest, c. 1500 to the late 1930s. Many of the illustrations show items in National Trust houses.

For much help I am indebted to Dudley Dodd, Martin Drury, Martin Trelawny and Robin Wright at the National Trust; and to Robin Butler, Eileen Carvell, Penelope Eames, Christopher Gilbert, Sir Nicholas Goodison and Christopher Hutchinson. I am indebted to Gervase Jackson-Stops and Robin Wright for encouraging me to write the book, and to Catriona Luckhurst and Esther Sidwell for their calm detachment and expert editorial help.

<div align="right">

Geoffrey Beard
Bath, August 1983

</div>

ACKNOWLEDGEMENTS

For the Plates

By gracious permission of Her Majesty the Queen: 37, 38, 40–44, 72–4

Geoffrey Beard: 61, 62, 64, 109, 122, 123, 125–7

Dedham Historical Society, via the late Benno Forman: 20, 21

Sir Nicholas Goodison: 80

Hotspur Ltd, London: 71

National Maritime Museum, London: 56

National Portrait Gallery, London: 5

The National Trust, London: 1, 3, 4, 5, 9, 10, 12, 17–19, 22–3, 32, 33, 35, 36, 39, 45–50, 53, 54, 57, 58, 60, 63, 66–9, 75, 81–4, 87–93, 107, 115–19

Peter Thornton: 14, 101

Toledo Museum of Art, Ohio: 70

Temple Newsam House, Leeds: 6, 7, 31, 34, 52, 55, 96–8, 111–13, 121 (all except 31 photographed by Christopher Hutchinson)

Crown Copyright Victoria and Albert Museum, London: 2, 11, 15, 16, 59, 65, 76–9, 85, 86, 94, 95, 99, 100, 102–6, 110, 114, 120, 124

Clive Wainwright: 8

Westminster City Libraries Archives Department: 108

For the Figures

The figures are drawn by Raymond Turvey. Figure 1 is based on a figure in Christopher Gilbert's *The Life and Work of Thomas Chippendale* (1978); figures 6–9 on *Furniture History*, VII (1971); figures 2–5 incorporate information supplied by Robin Butler.

PART ONE

THE
TRADE

∿ ONE ∾

THE CRAFTSMEN AND
THE WORKSHOPS

In the late seventeenth century, Joseph Moxon (1627–1700), author of a number of practical manuals, and in particular of *Mechanick Exercises*, suggested that craftsmen should study architectural books, and listed a number he considered suitable. In reality, however, much of the knowledge he thought desirable to help withstand foreign competition found little place in the training of most furniture makers. They were apprenticed to a master, usually in the Joiners' Company; turners had their own company and those who specialized in gilding may have trained under a painter-stainer.

GUILDS, MASTERS AND APPRENTICES

The apprenticeship system, set by statute (5 Elizabeth, ch. 4), allowed masters to take apprentices for instruction for periods of seven to eight years. The virility of the furniture trade may be indicated by the number of apprentices at York put to the joinery and allied trades in the period 1660–1720: there were 136 joiners, 210 carpenters and 6 carvers under training, forming a small but important part of a total 2,659 apprentices in all trades in the city in the same period.[1] At Durham, Bristol, Newcastle and Edinburgh during the seventeenth century, the various trade guilds also occupied important positions in social life.

Having sought out a suitable master, the parents of an intended apprentice paid an apprenticeship premium and were issued with an indenture setting out the conditions of training; the boy or girl then moved into the family circle of the master. It was hoped that, during their seven years of training, they would not only be taught their master's trade, but would also be set an example of good workmanship. They assisted on commissions and as they progressed in ability and knowledge in the several branches of their 'mystery' they were entrusted with more specialized tasks. Many were allowed to measure work, make out accounts and sign receipts against payments made, through them, from patrons to their masters.

When the apprenticeship was finished, sample work was examined carefully by representatives of the Livery Company. Then, at three successive meetings, the apprentice was 'called'; if no one objected to his election, he was sworn in as a member of his guild – before the mayor at the borough court in the case of Durham.[2]

The ordinances of most guilds were very similar. Those at Durham and York gave guidance for a master: he was not to absent himself from guild meetings and was to see that apprenticeship indentures were available to the 'searchers'; he could be put out of his occupation and not be allowed to work within the city if he took or used any goods which did not belong to him; he could take no apprentices until he had been a freeman or brother of the 'mystery' himself for seven years and he was not allowed to take apprentices for a term of less than seven years. There were also fines for default in workmanship and for the use of inferior materials. While it could be claimed that the system provided the framework for a rigid oversight of men and work, a great deal depended on the integrity of the guild officers. The seventh injunction, also found in those regulating London Companies, 'not to have any more Apprentices but two' was openly disobeyed.[3] To take undue notice of it would have limited the capacity of a business to expand and become more efficient. However, training more than two apprentices at a time was not easy.

In 1668, Sir Josiah Child attacked the whole system of apprenticeship because it obstructed trade and restricted the supply of skilled men. The companies, mistakenly in his opinion, tried to limit the number of apprentices in the service of a master craftsman. However an apprenticeship of seven years was the principal method of instructing craftsmen, and this was the accepted way for men to enter the livery companies. A London training was what most apprentices wanted. In later years they regarded this as the best recommendation. Elizabeth Webster and Ralph Brown of Newcastle when setting up in 1768 as partners in an upholstery business advertised in the *Newcastle Chronicle* (26 November 1768) that Ralph had been a journeyman in London with William Reason, the King's Upholsterer; that he had 'wrought at several of his Majesty's Palaces, and Noblemen's Houses, and doubts not, in the various Parts of his Business, to deserve the Name of a Workman'.

A study of the areas from which apprentices were drawn has been done for the Goldsmiths', Grocers' and Fishmongers' Companies; there is no reason to assume those practising the furniture trades differed to any marked degree. 'In the last ten years of the seventeenth century the numbers of apprentices from the London area and neighbouring counties, appear to have been roughly equal to the members coming up to London from more sparsely populated

and rural counties.'[4] However in the next three decades the apprentices from London increased – in the period 1730–1739 73 per cent of the apprentices indentured at the Goldsmiths' and Grocers' Company Halls were from London.

In the first half of the eighteenth century it was still usual, as it had been for the previous century, to enter a London livery company, such as the Joiners' Company, by apprenticeship to a master. However the method was under severe attack, and alternative, easier systems were developing. Increasing numbers took up the freedom of the Company by right of inheritance (patrimony) or bought their way in (redemption). It was also becoming common for freemen of a company to follow a trade which had little relation to the practices of the company they were in, or in which they had served their time. The number entering by servitude gradually decreased and the number of freemen admitted by patrimony increased at a constant rate. Apprenticeship was declining, but since the sixteenth century devotion to the companies had withstood social pressures. Membership conferred social prestige, some business advantages, a share in deciding the political actions of the City of London and, in cases of distress and hardship, provided charitable assistance. Almost all Companies gave pensions to aged members and their widows.

At the end of their training some apprentices stayed in their master's service as journeymen, or were so employed by other masters; a few set up as masters themselves. Robert Campbell, in his book *The London Tradesman* (1747), listed the apprenticeship premiums, the sums needed to become a master and the hours of working.

Upholder	Apprenticeship premium	£20–50
	To set up as a master	£100–1,000
	Hours of working	6 a.m.–8 p.m.
Carver of chairs	Apprenticeship	£10–20
	Setting-up	£50–200
	Hours	6 a.m.–6 p.m.
Cabinet-maker	Apprenticeship	£10–20
	Setting-up	£200–2,000
	Hours	6 a.m.–6 p.m.
Turner	Apprenticeship	£5–20
	Setting-up	£50–500
	Hours	6 a.m.–9 p.m.
Gilders in wood	Apprenticeship	£5–10
	Setting-up	£50–200
	Hours	6 a.m.–8 p.m.

Although it would be wise to regard these figures as approximate, what Campbell has to say about the division of labour is interesting. He regarded the 'upholder' or upholsterer as being in charge, with the cabinet-maker as his right-hand man. The upholder, he noted, must be able to handle his needle and shears with dexterity, but some of this work was usually performed by women, some of whom had also served an apprenticeship. Campbell regarded the 'stuffing and covering a Chair or Settee-Bed ... the nicest Part of this Branch' but stated, loftily, that the skill 'may be acquired without any remarkable Genius'. All the wooden work was then done by the 'Joiner, Cabinet maker and Carver'.

Campbell makes no reference to the established fact that medieval furniture, and much of the furniture made prior to 1660, was constructed or 'joined' by joiners. Both John Evelyn and Samuel Pepys, writing in the 1660s, mention visits to a 'cabinet-maker'. By the mid eighteenth century, the cabinet-maker, according to Campbell, was able to furnish the upholder with:

> Mahogony and Wallnut-tree Posts for his Beds, Settees of the same Materials, Chairs of all Sorts and prices, carved, plain and inlaid, Chests of Drawers, Book Cases, Cabinets, Desks, Scrutores, Buroes, Dining, Dressing and Card Tables, Tea-Boards, and an innumerable Variety of Articles of this Sort ...

In Campbell's opinion the cabinet-maker required 'a nice mechanic Genius, and a tolerable Degree of Strength', with a lighter hand and quicker eye than the joiner. He then stated that anyone who deigned to 'make a figure in this Branch must learn to Draw' – a point which had also been made by earlier writers such as John Evelyn and Sir Christopher Wren. John Evelyn wrote in 1664 (in an appendix to his translation of Fréart's *Parallèle de l'architecture* ...) that he thought 'English mechanicks' impatient at being directed and unwilling to recognize faults; there was a current arrogance, he thought, which implied craftsmen were unwilling to be taught their trade further when they had served an apprenticeship. Again, Batty Langley, writing about cabinet-makers in the introduction to his *The City and Country Builder's and Workman's Treasury of Designs* (1740) noted that:

> tis a very great Difficulty to find, one in Fifty of them that can make a Book-Case &c., indispensably true, after any one of the Five Orders, without being obliged to a Joiner, for to set out the Work, and make his Templets to work by ...

But his remarks suggest a jaundiced, and not necessarily accurate, viewpoint.

Campbell's 'hierarchy' was completed by the 'species of carvers ... who are employed in carving Chairs, Posts and Testers of Beds, or any other Furniture whereon Carving is used'. He noted that there was a class of 'Carvers who do

nothing else but Carve Frames for Looking Glasses', combining their talents with those of the frame-maker and gilder. What Campbell said was repeated in a *Directory*, written for parents and guardians, in 1761 by Joseph Collyer. He noted that 'as a taste for carved work in chairs and other furniture prevails, the ingenious men among these kinds of Carvers are never out of business'.

Justus Moser, a German authority on commercial matters, wrote in 1767 about the trade as most cabinet-makers, and writers such as Robert Campbell, saw it:

The trading craftsman in England first learns his trade, then he studies commerce. The journeyman of a trading cabinet-maker must be as qualified an accountant as any merchant. The master himself no longer touches a tool. Instead he oversees the work of his forty journeymen, evaluates what they have produced, corrects their mistakes, and shows them ways and methods by which they can better their work or improve their technique. He may invent new tools and will observe what is going on in the development of fashion. He keeps in touch with people of taste and visits artists who might be of assistance to him.[5]

Moser's observation on 'the development of fashion' reinforced Campbell's insistence that anyone who could anticipate fashions from Paris, or initiate new ideas, could make a profitable trade. Nevertheless, even a cabinet-maker of Chippendale's eminence was not averse to importing chairs from France to satisfy some of the demand in the 1750s.

TRADE SOCIETIES

As the monopoly of the City Companies weakened throughout Europe in the eighteenth century, London journeymen in particular were not slow to set up an alternative organization. As early as 1731 they had demanded a twelve-hour day, and 'permanently organized trade societies of furniture-makers developed in the second half of the eighteenth and early nineteenth century when many journeymen were still able to become masters'. It used to be thought that the societies developed 'only when the journeyman's prospects of becoming a master were infinitesimal'.[6]

Most eighteenth-century London makers were trained by the guild system, and it was perhaps inevitable that their trade societies observed many guild traditions, although the societies made many improvements. Apart from replacing tools lost in fires (Chippendale's workmen advertised in the *Public Advertiser*, 6 June 1755, their thanks to members of the public for help in this respect) they negotiated improved hours and piece-rates. A strike of London

journeymen furniture makers in 1761 was organized to bring anomalies to their masters' attention. They formed the core of the first permanent trade society, which in 1788 published a price book for piece-work rates. The prices quoted were argued about, and a revised price book was issued in 1793; attempts were made by masters to lower prices in 1797 and there was then a further prolonged strike which ensured that the 1793 prices were accepted.

The example of collective organization set by the London journeymen led to the setting up of similar trade societies in other parts of the country, at Birmingham, Bolton, Leeds, Liverpool, Manchester, Norwich, Nottingham, Preston, Whitehaven, and Wycombe. In Scotland groups formed in Edinburgh and Glasgow, and in Wales there was a Cabinet Makers' Society at Haverfordwest about 1800.

The price guides enabled a master and his journeymen to calculate the labour cost of a wide variety of cabinet wares. There were rival publications, but as a guide to terminology, procedures and costs they form an invaluable source of information. One example of the detailed nature of the 1793 list will suffice (see Plate 99):

A GENTLEMAN'S SOCIAL TABLE

	£	s.	d.
Four feet long, the rail two inches and a half wide, veneer'd all round, solid top, square edge to ditto, four plain taper legs, a pillar and claw stand in the hollow part, the top of ditto turn'd to receive the bottom of a tin or copper cylinder, two feet over and made to turn round, a mahogany top fitted into the cylinder, and cut to receive five tin bottle cases, the claws as in No 1 plate of ditto . . .	1	8	0

EXTRAS

	£	s.	d.
Each inch, more or less, in length	0	0	6
Putting on pieces to form brackets on each side of the legs	0	1	0
Rounding the edge of the top	0	0	9
Astragal on the bottom of the rail	0	3	6
Each extra miter in ditto, when the legs project	0	0	$0\frac{3}{4}$
Framing the top of the stand with a square pannel, flush on both sides	0	2	6
Screwing a bead round the edge of the loose top of the cylinder	0	1	0
Each extra hole to receive a bottle case	0	0	6
When the table is made separate, and as described in the preamble, deduct for the cylinder and stand	0	9	0
Each extra inch in diameter	0	0	2
For the price of extra work in legs or claws, &c – *See Tables of ditto*			

	£	s.	d.
Oiling and polishing the table	0	0	6
Ditto the stand	0	0	4

THE WORKSHOP AND ITS ORGANIZATION

It must not be assumed that our knowledge of English furniture makers and their workshop organization is at an advanced stage.[7] Information has to be sought in many places, is all too fragmentary and needs to be supplemented to a limited degree by reference to continental practices. What we know is for the most part limited to the eighteenth and nineteenth centuries, although in many respects the trade had hardly altered since medieval times: the apprenticeship system was virtually unchanged, variations in tools were slight and only the availability of a supply of a 'new' timber such as mahogany affected techniques or the appearance of what was made. The patterns of activity which governed life were for the most part agrarian, and there were few who could afford luxury furniture. Those that could rarely paid the full price – haggling was a common practice, and the tardy payment of bills a fact of life: 'As I receive my rents once a year so I pay my tradesman once a year' was the maxim of Chippendale's patron, Sir Edward Knatchbull. Patrons rarely understood the technical finesse of fine furniture when compared with that from less reputable firms. Three furniture makers' shops in England have been studied – those of Thomas Chippendale, William and John Linnell and Samuel Norman. All were important firms active in the mid eighteenth century.

In France the *maître-menuisier*, André Jacob Roubo, author of the six-volume account *L'Art du menuisier* (1769–75) described the economic factors in maintaining a workshop: capital, expenditure, the price of materials, cost of labour, taxes, insurance, guild dues and rents all had to be taken into account; then a profit margin and a contingency allowance (perhaps 30 per cent in all) would be added.[8] There is no reason to think the situation was much different in England.

Premises

An 1803 plan of Chippendale's premises in St Martin's Lane, London, drawn up for fire-insurance purposes, survives. It shows a three-storey cabinet-maker's shop, ranged around a yard, with a long extension containing roof-top timber-drying stores, a chair room, veneering room, upholstery shop, veneering, glass and feather rooms; the premises at the front range over Nos. 59–62, with No. 62 being Chippendale's dwelling house and No. 60 acting also as his counting-

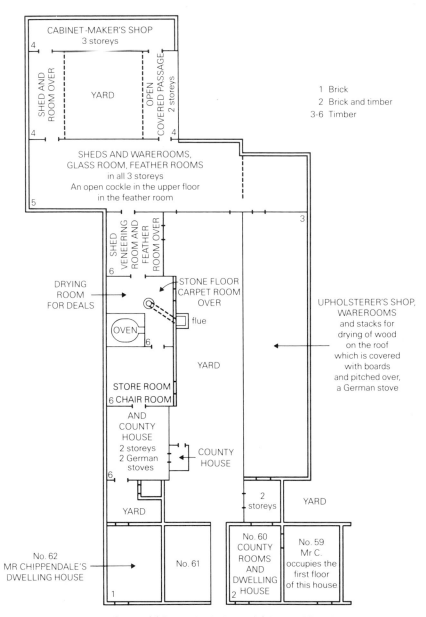

CABINET-MAKER'S SHOP
3 storeys

SHED AND ROOM OVER

YARD

OPEN COVERED PASSAGE
2 storeys

1 Brick
2 Brick and timber
3-6 Timber

SHEDS AND WAREROOMS,
GLASS ROOM, FEATHER ROOMS
in all 3 storeys
An open cockle in the upper floor
in the feather room

SHED
VENEERING ROOM AND FEATHER ROOM OVER

DRYING ROOM FOR DEALS

STONE FLOOR CARPET ROOM OVER

flue

OVEN

YARD

UPHOLSTERER'S SHOP,
WAREROOMS
and stacks for
drying of wood
on the roof
which is covered
with boards
and pitched over,
a German stove

STORE ROOM
CHAIR ROOM
AND COUNTY HOUSE
2 storeys
2 German stoves

COUNTY HOUSE

YARD

2 storeys

YARD

No. 62
MR CHIPPENDALE'S
DWELLING HOUSE

No. 61

No. 60
COUNTY ROOMS AND DWELLING HOUSE

No. 59
Mr C.
occupies the first floor of this house

Fig. 1. Chippendale's premises in St Martin's Lane, 4 May 1803

office. The plan is marked to indicate which parts are made of brick, which of brick and timber, and which are of timber alone.

Cabinet-makers were always afraid of fires, having premises stocked with piles of timber, varnish and glue, and packing and upholstery materials, all highly inflammable. There was a fire at Chippendale's in 1755; the record noted that the tool chests of twenty-two men were lost, an indication of the size of his labour force, which would be supplemented by outside specialist suppliers as needed, Chippendale being responsible to his patrons for 'artistic oversight and quality control' of what the specialists provided. When he rebuilt in 1756 his upholstery department was expanded – its stock, £2,600 in 1756, counted for nearly half the entire insurance valuation.[9]

The growing demand from the middle of the eighteenth century onwards caused firms to expand and diversify, and their premises must have reflected these trends. The partnership of James Whittle and Samuel Norman, with, for a time, a third partner, John Mayhew, advertised in 1758 that they were in new premises and that 'they continue to carry on the Upholstery and Cabinet, as well as the Carving and Gilding Businesses in all their Branches'.[10] However, they too had their premises ravaged by fire, in 1759, and they took the opportunity to take over the Royal Tapestry Manufactory run by Paul Saunders, a successful cabinet-maker and upholsterer. As well as a dwelling-house that included a room for apprentices, the workshops had shops for cabinet work, upholstery, carpets, tapestry, feathers and gilding and silvering rooms. There was in addition a counting-house, a shed for drying timber and a drying yard. Compared with William Linnell's premises at his death in 1763[11] and those of Chippendale, Norman's new rooms provided plenty of space to deal with cabinet-making and upholstery, as well as some which were particular to tapestry, Paul Saunders's speciality.

It was usual for London furniture makers to live in certain areas of the city – near St Paul's Cathedral in the late seventeenth century, and at later dates in St Martin's Lane, Long Acre, and Golden Square. This meant that it was easy for patrons to visit their shops, it allowed some degree of competition and specialization and it encouraged close family relationships, which were often strengthened by marriage – this method of advancement was common both to the great landed families and to the tradesmen they patronized.

Some enterprises prospered beyond normal expectations. In 1786, Sophie von la Roche, travelling in England, visited Seddon's. She wrote in her diary:

We drove first to Mr Seddon's, a cabinet-maker, and before leaving for Windsor I must tell you a little about our unusual visit there. He employs four hundred apprentices on any work connected with the making of household furniture – joiners, carvers,

gilders, mirror-workers, upholsterers, girdlers – who mould the bronze into graceful patterns – and locksmiths. All these are housed in a building with six wings. In the basement mirrors are cast and cut . . . their own saw-house too, where as many blocks of fine foreign wood lie piled, as firs and oaks are seen at our saw-mills . . .[12]

The introduction of more elaborate machines for cutting, grooving and jointing in the late eighteenth century meant that extra space was needed and by the mid nineteenth century the water-driven saw-mills Sophie von la Roche mentioned were using steam to power them. Factory production of furniture did not become well established until the early 1880s.

SUBCONTRACTING

It was usual for eighteenth-century firms undertaking specialized tasks beyond their own competence to place work with others, although the practice raised problems, with loss of control over quality and delays in delivery. Gilding furniture and dyeing cloth, for example, were obviously specialized tasks. The supply of fabrics and wallpapers – for a time in his early years William Hallett (1707–81), a successful London furniture maker, was in partnership with the leading wallpaper purveyor, Thomas Bromwich – was well organized, and many firms also stocked carpet samples. Where a commission required the provision of a heating stove – ten kinds were available in the 1760s from Abraham Buzaglo – or certain kinds of kitchen or laundry equipment, it was often the furniture maker's job to obtain and instal them. He wished to please patrons and had access to suppliers of coal-boxes, mangles, plain 'backstairs' furniture, chopping blocks, garden seats and so on.

Inlaying was another specialized task which demanded high skills. The 'term used in the English furniture trade in the eighteenth century to denote a specialist marquetry worker was not *marqueteur* but "inlayer"'.[13] The cabinet-maker Christopher Fuhrlohg described himself as both inlayer and cabinet-maker. In the 1770s he sold marquetry roundels to furniture and musical-instrument makers, but by the end of the century the new specialization was taking root amongst English craftsmen.

In the early nineteenth century there was a growing demand for brass-inlaid furniture. Thomas Sheraton writing in his invaluable *Cabinet Dictionary* in 1803 suggested brass inlay was within the cabinet-maker's competence, but the revival of Boulle work in brass and tortoiseshell led to the appearance of specialist workers in about 1815. André-Charles Boulle (1642–1732), the most celebrated of the furniture makers and designers working for Louis XIV, had

perfected the technique of Boulle marquetry. The work was prepared by gluing sheets of tortoiseshell and brass and cutting through them with a fine saw, following a pasted-on paper template. By the middle of the nineteenth century two types of specialist were recognized: those who did plain brass inlay and those who worked in the French style.[14]

TIMBER

No furniture maker could advance his business without maintaining and using a wide range of woods, both indigenous and exotic. The diarist and historian, John Evelyn, recognized the importance of 'forest-trees' in his book, short-titled *Sylva*, published by the Royal Society in 1664, at a time when English society was pervaded by intellectual curiosity. When King Charles II returned from exile in Holland in 1660 the new spirit of the Restoration encouraged a departure in furniture design from simple pieces made in oak. Evelyn, in the course of some twenty-three chapters on various woods, noted oak, beech and walnut as important to the furniture maker, and noted also that cedar, withstanding worm and the corrosiveness of the air, was a wood 'worthy of eternity'.

Evelyn's book appeared at a time when the English forests were depleted and English oak was needed, above all, for making balks for ships, both for commerce and defence. Stylistic changes in furniture at this time – to more sophisticated forms – meant that furniture makers needed finer woods, with more predictable grain, knot free and capable of receiving fine carved detail. Evelyn felt that beech was vulgar and 'subject to the worm, weak and unsightly', and indicated that there were no problems with the use of walnut, except for its availability. He wrote:

. . . were this Timber in greater plenty amongst us we should have far better utensils of all sorts for our Houses, as Chairs, Stools, Bedsteads, Tables, Wainscot, Cabinets &c.

He applauded its use by the French, particularly for those 'inlayings' which used the 'firm and close timbers about the Roots'. English sources of walnut were limited, and had been depleted by a severe frost in 1709, which had killed many trees. Moreover English walnut lacked the grain and colour of walnut from France and Italy, also characteristic of the walnut from the plantations of Virginia and Pennsylvania. At the end of the seventeenth century 'wallnut tree planck' came into England from France, Holland, Spain, Portugal, Italy, Pennsylvania, Virginia, Maryland and Barbados.[15] The need to

economize in its use led to a greater use of veneers and to the search for an alternative wood.

West Indies mahogany was the effective solution. Mahogany had begun to be imported regularly into England about 1715, although it had come in from the late seventeenth century as a veneer for marquetry. Mahogany was also abundant in Jamaica and the British-owned islands in the Caribbean. 'Jamaica wood' (so described in the Customs House ledgers) was allowed in to Britain duty free for the twenty-one years from 1722, as part of the lifting of import duties on a wide range of goods by Sir Robert Walpole's administration. Mahogany from the Spanish islands of Santa Domingo and Cuba and from the Province of Honduras was liable from 1724 to a duty of £8 a ton, but the wily sea captains passed a lot of it through Kingston to come to London and Bristol as duty-free 'Jamaica wood'.[16]

These sources, because of differences in climate and soil, each produced different varieties of *Swietenia mahagoni*. Jamaican mahogany was similar to that from Santa Domingo, heavy, strong and close-textured. The latter was called 'Spanish mahogany' and, when old, was nearly black. It had a close grain, making it suitable for carving. Cuban mahogany was lighter in weight, with a straight grain, and was favoured by chair-makers, who liked its reddish-brown colour and its suitability for carving. Honduras mahogany from Central America was not imported in any quantity until the second half of the century. It was a stable wood from which boards of great width could be obtained, for making table and bureau tops.

Most cabinet-makers held large stocks of mahogany and other woods. In 1760, when Samuel Norman took over the stock of Paul Saunders, there was 11,986 feet of one-inch-thick mahogany to hand, valued at one shilling a foot. In addition there was a considerable quantity of deal, for use in making the carcases of furniture, some lime for carving trophies and swags, '306 foot of Virginea Walnut Tree', some two-inch cherry tree and one-inch pear tree, and nearly four quarters, by weight, of black ebony. Beech for chairs and other purposes was available in thicknesses ranging from one inch to four inches; there was 2,300 feet of veneers and 272 lb of glue.[17]

Timber merchants could view the mahogany on the quays at Bristol and London, and it was sold there, 'without reserve', in lots of about 3,000 feet, from frequent shiploads of 100,000 feet or more. In 1785 a Bristol load was advertised at '24 to 36 Inches and upwards wide'.[18] Some of the wood for veneers was obtained by European furniture makers through the international exchange at Amsterdam. Robert Campbell wrote in *The London Tradesman* (1747)

. . . the Timber Merchant properly is the Importer of Timber from abroad in his own Bottoms; He is furnished with Deal from Norway, either in Logs or Plank, with Oak and Wainscoat from Sweden; and some from Counties in England; with Mahogony from Jamaica, with Wallnut-Tree from Spain. These he sells to the Carpenter, Joiner and Cabinet-Maker at Considerable Profit.

An advertiser in the *London Evening Post* (26 June 1753) stated however that he had 'A Large Parcel of Mahogany for Fourpence a Foot, River Measure, which is as cheap as Wainscoat'.

In 1796 it was stated by William Marshall in his *Planting and Rural Ornament* that the

'cabinetmakers' chief woods are MAHOGANY and BEECH; next to these follow DUTCH OAK (Wainscot), DEAL, ELM; and lastly, WALNUTTREE, CHERRYTREE, PLUMTREE, BOX, HOLLY, YEW, and a variety of woods for inlaying of cabinets. In some country places, a considerable quantity of ENGLISH OAK is worked up into tables, chairs, drawers, and bedsteads; but, in London, BEECH is almost the only English wood made use of, *at present*, by the cabinet and chair makers.

Sheraton's *Cabinet Dictionary* (1803) gives details of the woods and veneers in common use in the late eighteenth century. Satinwood from the West Indies or Guiana had been introduced about 1760, and differed appreciably from the East Indian variety introduced some twenty years later. Sheraton wrote that amongst cabinet-makers it was 'a highly valuable wood, the best of which is of a fine straw colour cast, and has therefore a cool, light and pleasing effect in furniture . . .' While both varieties were 'of a fine straw colour' the latter clouded more under polish, but the fine grain and rich figuring in both made them most popular until replaced, generally, about 1810 by rosewood. This fine dark wood from Brazil or India was hard and heavy with an even grain. It had been known from the sixteenth century (particularly in Portugal) in inlays and veneers, but it was not until the Regency period onwards that it was used in England in the solid, often inlaid with brass.

A number of exotic woods came into use in the late eighteenth and early nineteenth centuries. Coromandel or 'streaked ebony' was stated by Sheraton in 1803 to be 'lately introduced into England . . . and used for banding'; kingwood, similar to rosewood and also from Brazil, was employed in cross-banded borders, as was tulip wood, another Brazilian wood of yellowish-brown colour with reddish stripes. Sycamore, stained greenish-grey and called 'harewood', was used for bandings and veneers, as was the rich bird's-eye-figured light brown amboyna from the West Indies. White insets of geometric or naturalistic form were done in fine-grained holly. On a more utilitarian

note Sheraton indicated the use of 'a common kind of Cedar, in colour much like dark mahogany . . . for the bottoms and backs of the common drawer work . . .' This function was, however, reserved increasingly from 1800 for American pine or deal, which took stain and screws well and was easily worked.

During the period of the Napoleonic wars heavy import duties were put on foreign timber, and in 1821 colonial timber was also made subject to import duties. As in the 1720s, when merchants were protesting they needed many raw materials from abroad to survive, protests were made to the Select Committee on Import Duties (1840). This affected the use of mahogany and as Sir Robert Walpole had done in 1722, Sir Robert Peel, over a hundred years later (1841 and 1846) reduced the tariffs on foreign timber and freed colonial timber from duty altogether. Blackie's *Cabinet-Maker's Assistant* (1853) noted the increases in tonnage of mahogany imported after 1845, and by the middle of the century at least 25,000 tons were entering England annually. It had long held supremacy as the dark wood most recommended for bedroom and dining-room furniture, but its use had declined gradually in both England and America in the early nineteenth century. By the end of the century there was a demand for the honest oak of Sir Ambrose Heal and others; another factor in the decline of mahogany was that makers became skilled at staining, graining and marbling to simulate the finer woods.

TOOLS AND MACHINERY

We have, in England, no visual record which compares to the plates of furniture-making in Denis Diderot's *Encyclopédie* . . . (Paris, 1751–65, plates 1762–72) or André Jacob Roubo's *L'Art du menuisier* (Paris, 1769–75), issued as part of the *Descriptions des arts et métiers* (1761–88). We must treat with caution the illustration of tools used by English joiners given in Joseph Moxon's *Mechanick Exercises* (1703).

The English manufacturing centre for tools in the eighteenth century was Birmingham, with some concentration at Sheffield in succeeding years. In addition to an extensive home trade, Birmingham manufacturers exported tools to America, and also supplied metal mounts for use by furniture makers. Many of the tools which have survived from the furniture workshop of the Dominy family of East Hampton, New York, were of English manufacture.[19] They comprised braces and bits, chisels of various kinds, clamps for bending slats and holding parts during glueing, compasses, files, three kinds of gauge, gimlets, knives, lathes, mallets, mitre-boxes, planes, saws, spokeshaves, squares,

screwdrivers and vices. They are typical of what any well-equipped workshop possessed.[20]

The schedule of 'stock-in-trade' which was drawn up when Samuel Norman took over Paul Saunders's workshop in 1760 provides a list of the equipment in use. There were two turner's lathes, the one driven by a foot treadle and the other by a large hand wheel, together with the chucks and turning tools. Vices, sharpening stones, a varnishing iron, glue-pots and various cramps, a mitre-box for cutting angles and templates for Chinese frets were some of the items listed, along with the thirty-two journeymen's benches. As Saunders was an upholsterer he possessed flat-irons, a copper cistern for paste, work-tops and trestle legs, lead weights, a beating-frame and poles for feathers, a large wrought-iron drying stove, scales and weights, drying racks, a cording stool and a waxing board. Each journeyman would have his own personal chest of tools which explains why the schedule only lists the large items in general use and contains no mention of tools such as planes, chisels, gouges, awls, measuring rules and saws. The early trade societies (p. 19) undertook 'to repair the loss of tools by fire – the chief end of our meetings'.

The tool chest of the American furniture maker Duncan Phyfe (1768–1854) survives[21] and contains what all furniture makers needed – saws (mounted in the lid), a fret-saw, clamps, chisels, gouges, planes, awls and measuring devices. Most of the chisels had ivory handles, fitted with blades of the usual eighteenth-century shape, tapering from the cutting edge to the shaft, rather than the parallel blade produced by the mid-nineteenth-century Sheffield makers. Finally, according to The Book of Trades or Library of the Useful Arts, printed for Tabert & Co., in London, 1804, the cabinet-maker's chief tools were:

Saws, axes, planes, chisels, files, gimlets, turn-screws, hammers, and other tools which are used in common by the carpenter and the cabinet-maker: but those adapted to the latter are much finer than the tools required by the house-carpenter . . .

Mechanical methods of construction began to affect production only by the start of Queen Victoria's reign in 1837. Skilled hand-work was still usual, although many machines to ease hard jobs had been patented by Sir Samuel Bentham and others in the late eighteenth century. These included machines for cutting various joints, for rebating, planing, sawing, grooving and cutting veneers. By the middle of the nineteenth century steam was being used effectively in saw-mills, one of which (at Battersea) specialized in cutting veneers, on a machine patented in 1805. Carving machines were patented – Thomas Brown Jordan's (1845), may have been invented in order to cope with the mass of repetitive carving required for the rebuilding of the Houses of

Parliament; it was followed, in New England, by Auger's carving machine (1848).[22]

The leading nineteenth-century firms had power-driven machines in their workshops by the 1850s – the firm of Holland and Sons installed steam-power in 1853 for driving lathes, vertical and circular sawing, making joints and cutting frets. By about 1865 Pratts of Bradford had power-driven veneering machines and saw-mill;[23] by 1880 the Lancaster and London firm of Gillows had one of the finest mechanized shops in the country[24] and machinery was also used in the production of Windsor chairs in the High Wycombe area.[25] Needless to say there was a decline in the standards of hand-work.

∾ TWO ∾

METHODS AND TECHNIQUES

CONSTRUCTION

In a short study such as this only the most basic aspects of furniture construction can be given.[1] Reference to figs. 2–5 will identify some of the terms most frequently used.

Until about 1650 it was thought that wood needed to be embellished to make it acceptable visually. In consequence, a common wood such as deal would be used for the carcase and the furniture maker glued veneers to it. In his endeavours to enhance the wood, he added mouldings to frame the veneers, or used inlaid borders with the grain running at right angles to the edge; this was known as 'cross-banding'.

In the eighteenth century the cheap carcase wood was often disguised, particularly on the back of commodes and chests. The French-born *ébéniste* (an

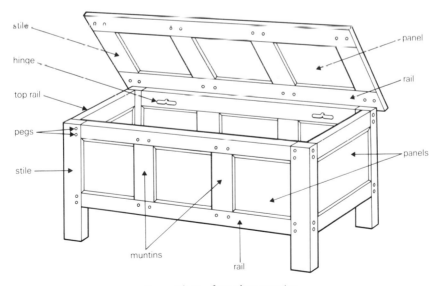

Fig. 2. Chest – framed construction

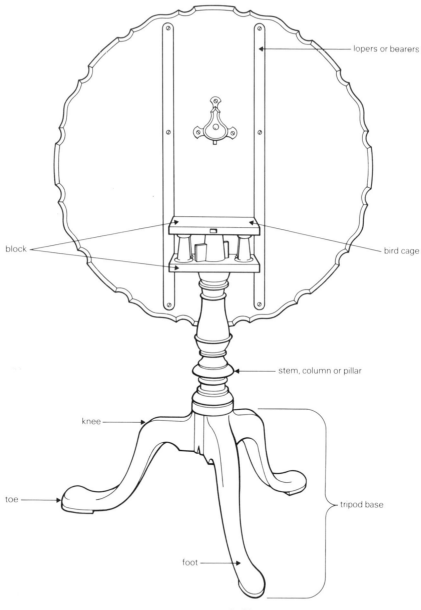

Fig. 3. Tripod table

ébéniste specialized in veneered furniture), Pierre Langlois, who worked in England in the 1760s, was one of many who blackened the deal – where it was not veneered – to make it look like ebony. Sometimes he produced a grooved back frame into which he put chamfered panels – other makers merely glued and screwed horizontal boards to the side panels. However, many walnut bureau bookcases have oak interior sides and back, and some mahogany bookcases also have oak backs in a panelled construction. Some staining of deal with red size, sanded and waxed, was also done to blend with the mahogany sides. Whenever furniture was made by a joiner the bottoms to drawers were nailed, invariably, to the lower edge of the drawer sides. The cabinet-maker improved on this by setting the drawer-bottom into a rabbet cut in the drawer sides and back. However these flush-bottomed drawers rubbed against the dust-boards – partitions between the drawers – and wore unevenly; a refinement was to extend the drawer sides below the drawer bottom, and to glue a runner to them and to the drawer bottom so that it raised the whole above the dust board.

The art of construction is seen to good advantage in commodes (chests of drawers with shaped or serpentine fronts). So that the drawer and door fronts

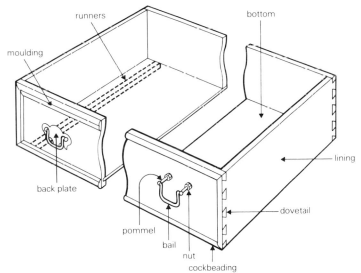

Fig. 4

would stay in true shape the front was composed of laminated sections cut with a band-saw. The linings of the drawers are often a pointer to the quality of a piece of furniture. Those which have deal in them often have blue paper

to hide this. The best were lined with hard, thin, wainscot oak, which resisted wear caused by friction with the carcase; ash and elm were much used in the eighteenth century. The best pieces also incorporated mitred beads at the sides and back of drawers to hide the joins, and a further sign of quality (particularly on walnut and mahogany furniture) was to have cockbeads (moulding) set round a drawer front made of cross-banded wood. Late in the eighteenth century Thomas Sheraton noted that 'there is a common kind of Cedar, in colour much like dark mahogany . . . It does well for the bottoms and backs of the common drawer work.' This, with a poor-quality mahogany, came from Honduras; it was popular as it was often wide enough to be fixed without jointing. These woods were sometimes used to make carcases and for the dust-boards, but yellow deal was more often used for this.

English furniture incorporates many variations in quality, the deciding factor being fitness for purpose. A survey of 'common' or vernacular furniture revealed a considerable use of oak, elm, ash and painted pine.[2] A pine carcase would frequently be veneered in burr elm (which looked somewhat like walnut). The mortise and tenon joint was popular from the sixteenth century onwards, and was made stronger by the addition of a peg. (For much of the eighteenth century the joints of chairs were pegged rather than glued because of the poor quality of the glues available at the time.) The introduction of another effective joint, the dovetail, in the late seventeenth century, made possible the use of thinner pieces of wood with the minimum of glue. It was used extensively in the construction of drawers, and, becoming finer and less obtrusive as the years progressed, is an aid, along with other considerations, to approximate dating.

Early bookcases have fillets attached to the carcase for the shelves to rest on, but by the mid eighteenth century the shelves ran in grooves cut in the sides. Nineteenth-century shelves rested on pegs pushed into pre-drilled holes. If a piece of furniture such as a table was supported on legs, these were held together in rails, which were formed into a frame using mortise and tenon joints. The table top was fixed to this frame by pegs in early examples and, from the early eighteenth century (when better glues were available), by blocks which were glued to the underside of the table top and to the rail. From the 1740s, screws were put into countersunk holes in the rail and screwed in to the underside of the table top.

The construction of chairs demonstrates that the art of good furniture-making depends on the combination of delicate components to produce functional strength. The seat rail, into which a drop-in upholstered seat is often inserted, forms a square, braced at each corner, which is tenoned to the front

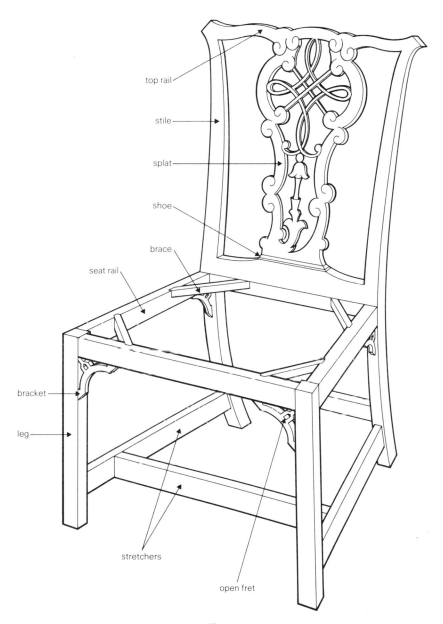

top rail

stile

splat

shoe

brace

seat rail

bracket

leg

stretchers

open fret

Fig. 5

legs and the back uprights or stiles. The stiles form part of the frame of the
back, and the frame is finished by a top rail, and by a central carved or veneered
splat to support the sitter's back. This is inserted in a recess on the underneath
of the top rail and at its base into a shoe attached to the back seat rail. The legs
may be strengthened by brackets between them and the seat rail, and by side
and cross stretchers tenoned into the legs. If the front legs are of cabriole form
they will have been cut, expensively, from a single piece of wood. This leg had
'ears' or 'shoulders' at its knee, and these were made separately. The arms of
armchairs were tenoned or screwed into the stiles, and screwed to the seat rails.
The screws were countersunk and concealed by small blocks of wood.

The front corners of trap-seat chairs often suffer from being forced outwards
by new upholstered covers being put over the old ones. This increases the size
of the seat, while the rebate in the rails into which the seat is pushed – by
hand, or by sitting on it – remains the original size. This puts strain on the seat
rails and careful examination of them will often reveal the loose corners.
Where the upholstery was attached by nailing to the seat rails (a 'stuff over'
seat) its frequent replacement has left the earlier nail marks visible.

UPHOLSTERY

Upholstered seat furniture is, within the history of furniture, of comparatively
recent origin, only becoming acceptable in function and appearance in the
mid sixteenth century. It satisfied the demand for comfort, relieving the
hardness of an unyielding wooden seat. In simple terms, padding materials
were placed beneath a cover, which was then nailed to a wooden frame, or
were supported by webbing stretched across and nailed to the frame. In the
late Elizabethan period, Sir John Harington wrote that 'the fashion of cushioned
chayres is taken up in every merchant's house' – materials were embroidered
and bordered with rich fringes, and beds were elaborately draped with velvet
hangings in addition to having mattresses, pillows, cushions, blankets and
sheets. Henry VIII's possessions in 1547 included many velvet embroidered
beds, created by members of the Upholsterers' Company, which had been
founded in the early fifteenth century.

While the historical evidence in the form of inventories details the use of
many embroidered items, few early examples survive. The 1601 Hardwick
Hall Inventory[3] is useful in detailing which wooden forms and stools were
furnished with needlework cushions. Many variants are described in terms
such as: 'Three stooles of cloth of golde and crimson velvet with red and yellow

silk frenge.' Some of the Hardwick chairs described in the inventory were presumably of the X-form, extant at Knole (Plate 23), and were covered with Turkey work, made by knotting wool on canvas to form a pile.

In the seventeenth century the status of the upholsterer gradually improved, and the Upholsterers' Company of the City of London was granted a fresh charter in 1626 (lost in the Great Fire of London) which confirmed its fifteenth-century foundation. They had plenty of work and it has been noted[4] that in the 1680s, frequent changes were made to the furnishing of grand interiors such as those at Ham House, home of the Duke and Duchess of Lauderdale. A detailed study of the seventeenth-century upholsterer and his materials shows that patrons were able to choose from a range of coverings brought from many distant parts of the world.[5] One of the most expensive was silk; beds or chairs upholstered in silk were provided with 'cases' or covers of cheaper material to protect them from dust and sunlight.

The beginning of the eighteenth century was marked by 'a sudden rise in the popularity of needleworked upholstery. This coincided with the introduction of the winged easy chair which offered an ideal surface for covering with finely executed biblical or mythological scenes' (Plates 48 and 50).[6] The most durable material for this was wool needlework on canvas. It was fixed to the frame by nails, often gilded, or, in the case of chairs or settees with movable seats, to the seat itself (p. 36). Many of the needlework designs can be traced to John Ogilby's *Virgil* (1658), which remained popular for at least a hundred years; some simply followed the pattern of Italian damasks. Subjects from Aesop's *Fables*, stylized vases of flowers and pastoral scenes were worked in tent stitch (commonly known as *petit point*) in which the unit is a series of parallel diagonal stitches.

The quality of needlework on chairs declined after 1730, and declined further after the 1750s. It is difficult to establish whether needlework is original to the furniture it adorns; without documentary evidence the only pointers are shape and fading of dyes in the appropriate places. The decline in the importance of upholstery may be noted in the first edition of the important mid-eighteenth-century pattern book, Thomas Chippendale's *The Gentleman and Cabinet-Maker's Director* (1754). The woodwork with its carved splats and fretwork is more prominent, and new styles in seat furniture were introduced from France.

The subtle changes in furnishing led to the need for different types of upholstery fabrics. Large-patterned damasks and velvets became unsuitable, the use of needlework was abandoned in favour of leather, and tapestry, both in France and England, was, in the latter part of the eighteenth century,

restricted to a few sets of Gobelins manufacture made in the 1760s to designs by Robert Adam.[7]

The eighteenth-century procedures for upholstering a chair are given in detail in Diderot's *Encyclopédie*; they were, briefly, as follows. Strips of webbing were interlaced and stretched across the seat frame to form a support for the stuffing. This was of curled horsehair and was stitched to the webbing to prevent movement. An extra roll of hair was fixed to the front rail where the wear was likely to be heaviest. The hair was covered with a layer of linen and then the top covering was laid over and brass-nailed to the seat rails. The upholstery of the back of the chair was fixed to the frame and covered at the rear, where it was hidden from view, by a cheaper plain fabric such as serge. If brass nails were used they were often set in a decorative pattern; nails of common appearance were hidden by various forms of decorative braid (gimp) made of silk, woollen or other cord.

We have already noted (p. 36) the importance given to beds during the medieval and later periods. They provided an opportunity for the upholsterer's most skilled work and for the use of the most lavish fabrics. The state beds depicted in the late-seventeenth-century engravings of Daniel Marot had their wooden frameworks covered with skilfully cut velvet or other silk and the curtains and valances are edged with fringes. The headboard and inside of the tester was decorated with elaborate scroll-work and the effect was heightened by the use of braids (Plates 5 and 33). To provide additional warmth and to protect the fabrics from sunlight and dust case curtains were arranged to enclose the bed – these may be seen to advantage in the replacement curtains on the bed at Dyrham Park, Gloucestershire (Plate 32).

State beds remained popular during the early years of the eighteenth century, and developed into the form known as the 'angel' bed in which the tester is suspended from the ceiling rather than supported by foot posts. One of the most impressive examples (c. 1720) is at Erdigg Park (Plate 35). Improved standards of building in the 1750s made draughts less of a problem in the country house, making it possible to reduce the thickness of bed hangings, and hence, to arrange them more elegantly, raising them by pulleys rather than running them on encircling rods. George Hepplewhite listed the many materials in use in the 1780s, although he indicated that bed 'furniture' could be executed 'of almost every stuff which the loom produces'. Types of cotton ('Manchester stuffs') and printed silks, velvets and cut velvets, were useful for servants' and state apartments respectively. George Smith in his *Designs for Household Furniture* (1808) indicated that velvet, calico, silk, and Genoa velvet were suitable for beds; chintz was also popular. Considerations of hygiene made washable materials desirable.[8]

One of the upholsterer's tasks was the making of bedding. A typical eighteenth-century state bed had a straw pallet laid on the bed frame, then a thick mattress of curled hair and two more filled with carded wool. An upper mattress of satin was filled with wool. The bolsters and pillows were filled with down. On servants' beds there were fewer mattresses, and they were filled with inferior grades of feathers. In 1833 Loudon in his *Encyclopedia* indicated that hair and wool were still used for bedding, although sea grass, flocks and chaff were suitable for 'common' mattresses. The interior-spring mattress was only just making its appearance at the time he was writing.

The upholsterer also attended to the provision of window curtains. They were rare in the medieval period and were used singly at a window; even Hardwick Hall, one of the greatest of the late Elizabethan houses, did not have every window curtained when the 1601 inventory of its contents was compiled. Only one of its curtains was of damask, and no attempt was made to match curtains to the other furnishings in a room.

After the 1660s two curtains were introduced at windows, more for adornment than for practical reasons; the indefatigable Celia Fiennes, on her travels in the 1690s, noted that curtains at Windsor Castle matched the beds and chairs. They were drawn on rods, and by the early eighteenth century the rail was concealed by a pelmet box in matching material. In the middle of the century curtains were either festooned or draped. For the first, rings were sewn on the curtain in vertical lines and cords passed through them to an upper pulley. Pulling the cords raised the curtains but exposed the sides of the window frame. For reefed curtains the rings were sewn in a diagonal line from bottom to top; when the cord was pulled through the pulley the curtains were raised across the window and draped elegantly down the sides. An extract from William Vile and John Cobb's bill of July 1758 for the extensive work they were doing for the 6th Earl of Coventry gives details of the requirements:[9]

1758 July 8	£	s.	d.
For 2 Pullie Sashs and bracketts	0	6	0
For 33½ Yards of Green Lute String* at 7/6	12	11	3
For 33½ Yards of Sarney† to Line Ditto at 1/4	2	4	8
For 6½ Yards of Fringe at 9/–	2	16	3
For 26 Yards of Lace at 3d	0	6	6
For braides, Leads, Silk, thread, tape &c	0	7	0
For 40 Yards of Line, 2 Tossells and 4 brass hooks	1	7	0
For Makeing the 2 Green Lutestring Festoone Curtains, Lin'd and Fring'd Compleat	1	4	0

* Lustring or 'lutestring' was a silk fabric which had been dressed to give the surface a glossy sheen.
† Sarcenet or 'sarney' was a thin silk used for linings.

When Thomas Sheraton compiled his *Cabinet Dictionary* in 1803 festooned curtains were still popular but becoming old-fashioned. Curtains were now hung in pairs and drawn to each side by draw strings over pulleys. Printed cottons became commoner, and muslin or gauze secondary curtains hid the room from curious eyes. Window blinds of glazed printed cotton were introduced about 1830 and remained fashionable for the remainder of the nineteenth century.

Many upholsterers advertised that they also acted as undertakers, and apart from providing the usual services they hung the church in black, supplied appropriate clothes for the mourners and trappings for the carriage horses. They embellished the coffin with black cloth or velvet adorned with patterns of brass nails. Cabinet-makers and upholsterers who held Crown appointments acted through the Office of Works to attend to these matters at the death of a king or queen – in 1751, at the death of Frederick, Prince of Wales, they were carried out by Benjamin Goodison, who provided the coffin, and the upholsterer William Reason, who embellished it.

In summary it should be stated that apart from undertaking, the upholsterer was still no mere chair-coverer. He was an accomplished interior decorator responsible for the complete furnishing of the house. He was at a higher social level than a cabinet-maker and, according to Robert Campbell's *The London Tradesman* (1747), had become 'a Connoisseur in every article that belongs to a House'. He employed:

Journeymen in his own proper calling, cabinet-makers, glass-grinders, looking-glass framers, carvers for chairs, Testers and Posts for Beds, the Woolen Draper, the mercer, the Linen Draper and several species of smiths and a vast army of tradesmen and other mechanic branches.

JAPANNING

In 1688 John Stalker wrote the manual which provides most of our information about the techniques used on japanned furniture. Entitled *A Treatise of Japaning and Varnishing . . .*, it also dealt with the 'Art of Guilding, Separating and Refining Metals' as well as the 'Curious way of Painting on Glass', and gave rules for 'Counterfeiting Tortoise-Shell and Marble' and 'Staining or Dying Wood, Ivory &c'.

Trade with the East became increasingly prosperous after the Restoration of Charles II. The merchants of the flourishing East India Company were

importing cabinets, chests and screens adorned with Chinese ornament, and it soon became necessary to satisfy the demand by making similar objects in England. Stalker gave many pages to recipes and directions for japanning and varnishing. He divided the materials of the craft into three classes; gums, metals and colours. Seven types of gum were used to form different varnishes. The gum chosen was dissolved in strong spirit of wine so that it would spread easily and lie evenly on the work. The metals were principally brass dust, commonly called 'gold-dust' – the best quality was manufactured in Germany. Silver dust which was made in England was also less satisfactory than the imported variety, which 'enjoys a lively bright lustre' whereas that 'we made here is dull, dead and heavy . . .' Powdered tin, 'green-gold' and 'dirty gold' were used for painting 'garments, flowers, houses and the like' and several natural, artificial and adulterated coppers were also used. These metal specks were worked over mouldings, inside and outside drawers and panels, and laid on the black ground of the furniture being decorated.

In the actual process of japanning considerable attention was given to achieving a very smooth surface, using several coats of whiting and size to seal the grain in rougher woods such as deal. The preferred surface was of close-grained pearwood veneered to a deal carcase. The ground was 'black varnished' by applying three coats of varnish mixed with lampblack. This was followed by six further coats, also mixed with lampblack but thinned with Venice turpentine. Each coat was allowed to dry thoroughly and smoothed before application of the next. The nine coats of varnish were simply a preliminary stage. Twelve further coats, of similar composition, were applied, with the same drying and smoothing process between each application. After the last coat of varnish the furniture was allowed to stand untouched for five or six days while the varnish hardened. It was polished and finished with lampblack and oil. If the instructions were followed correctly Stalker asserted the result would be 'as good, as glossy, as beautiful a Black as ever was wrought by an English hand, and to all appearance it was no way inferior to the Indian'. The colour of the ground could be varied by mixing the body colour with white lead and size. Meticulous smoothing and polishing were necessary to approximate to the highly reflective surface characteristic of oriental lacquer.

After this stage the ornament was painted on to the surface in metal dusts; Stalker describes how raised work, made of a paste of whiting, pigment and gum, was 'cut, scraped and carved' to the design being used. It was not a job for the 'heavy rustick hand', and variations in technique and patterns to encourage ladies to practise the craft as a pastime became available by about 1760. Chippendale stated in his pattern book (1754) that some of his designs

werc suitable to japanned decoration, and the rage for chinoiserie design at the time encouraged many other cabinet-makers to supply 'japan-work'.

GILDING

The art of gilding, or covering an object with a thin layer of gold leaf, was known to the Egyptians, and examples have been found in the tombs of the Pharaohs. Since medieval times two principal methods of gilding have been in use – oil gilding and water gilding. The former is the cheaper of the two and is also more durable. Because of the oil medium it is more resistant to damp, but it cannot be burnished to the high lustre which can be attained with water gilding.

The techniques had been set out by Cennini as early as 1437 and, with some variations, were followed by subsequent writers. In 1673 William Salmon in *Polygraphice . . .* implied that to lay gold on anything simply involved applying finely ground lead tempered with linseed oil to the surface to be gilded, laying gold leaf on the sticky solution, letting it dry and then polishing it. Stalker in his japanning treatise (1688) elaborated at great length, however, and few can have had the patience to follow the complicated instructions Mrs Artlove gave in 1730 in her *The Art of Japanning, Varnishing, Pollishing and Gilding*.

In essence the gilder's first concern was to provide a suitable base, or 'ground', for the gold leaf, which was harder and smoother than the wood being adorned. The base was usually made of gesso, a paste of gypsum or other plaster ground in water, with glue or gelatine as a binding medium. This paste was applied in thin coats, and, as with varnish, allowed to dry and harden between applications. The final surface was rubbed until it had the smooth hard finish of ivory. This ground served for both oil and water gilding, but Stalker claimed that the best surface for oil gilding was made of paint-pot scrapings, white lead or red ochre.

When the ground was ready for oil gilding a substance, or 'mordant', which 'bites' to the gold leaf, such as linseed oil mixed with white lead, ochre or raw sienna, was put on to the smooth gesso with a brush. When this was still tacky the gold leaf was laid on and any creases or small fragments dusted off. The gold was finally polished with cotton-wool or thin leather, but could not be burnished.

Water gilding was always put on a gesso ground, with a mordant of red Armenian clay bound with water and white of egg or, more usually, as time progressed, parchment size. Stalker recommended the adding of candle grease

1. Gilded gesso – the cresting of a pier glass – by John Belchier, 1726 (Erddig, Clwyd)

and some size to his mordant recipe, and the exact composition depended to some extent on the colour of the ground on which the gilder liked to work. Blue, red and yellow were common – the two latter disguised any gaps and blemishes in the gilded surface. In water gilding, as the name implied, the mordanted surface had to be moistened with cold water, and two coats of gold ('double gilding' often appears in accounts) were applied to achieve a fine effect. The final surface was polished with a pad ('matt gilding') and if a burnish was desired, with a burnisher formed from a highly polished stone such as agate.

It may be useful at this point to give Thomas Sheraton's succinct note from his *Cabinet Dictionary* (1803):

In laying on the gold leaf, no water must be left under the gold, but it must be blown out, as much as the nature of the case will admit of; or otherwise, when the cotton wool is applied to burnish it with, the gold will rub off. After thus burnishing, proceed to a second lay or coat of gold as at the first, which will cover all the defects of the first lay occasioned by burnishing, and having waited until this second coat be dry, burnish as before; and if there be any defects of gold, such places must be repaired. Some recommend to have the work done three times over, but twice will do as well, if carefully done.

Many seventeenth- and eighteenth-century patrons made lavish use of the gilder's skill, and in most principal rooms the frieze and cornice would be charged in accounts as 'gilt with fine gold in Oyll'. The gold was beaten into thin sheets between layers of vellum or 'gold beater's skin'. Some indication of the amount necessary for any large task is given in Antonio Verrio's bills in 1691 for work at the Heaven Room, Burghley House, Northamptonshire. His gilder, René Cousin, charged £37 0s. 10d. for 4,446 sheets of leaf gold, of which 1,030 were used on the cornice alone.[10]

The cost of the gold leaf might exceed the cost of the furniture it adorned. In Richard Price's bill for a bed for the king's bedchamber at Whitehall in 1683, the French bedstead with tester (£10) with carving work on it amounted to £17 15s., while 'gilding the aforesaid Carved worke' cost £20.[11] Samuel Norman's chairs for the Crimson Drawing Room in Moor Park were listed in the 1766 inventory: '10 very rich Elbow Chairs Gilt complete in the best Burnish'd Gold and Varnish'd 5 times over, stuff'd with best curl'd hair in fine Linen on Castors'.[12]

MARQUETRY, INLAYING AND VENEERING

The paucity of contemporary information forces us to rely on Thomas Sheraton's accounts of these techniques in his *Cabinet Dictionary* (1803). He defined veneering as 'the art of laying down and gluing very thin cut wood, of a fine quality and valuable, upon common wood'. Its object, in his opinion, was 'cheapness, and sometimes appearance' but he added that 'the ground, glue and extra time are equivalent to the expence of solid wood, except it be to save very rich solid boards'. He observed that 'inlaying' – the term used in the eighteenth century for working in marquetry – had been 'much in use between twenty and thirty years back' but was now 'laid aside, as a very expensive mode of ornamenting furniture, as well as being subject to a speedy decay'. Working in marquetry was a specialized craft which required the assembly and inlaying of cut veneers of various woods into a contrasting ground.

Cabinet-makers used veneers and bandings for decorative effect. The banding could be of two kinds – *straight*, where the wood was cut along the length of the grain, and *cross*, cut across the grain. This was the more expensive method, the bands being made of short lengths of veneer, which required jointing. The band was often edged with a 'stringing line', a fine *string* of sycamore, box or light-coloured wood. Inlaying with brass was very durable; Sheraton noted in his *Drawing Book*, describing plate XXX, a library table,

the strength, solidity, and effect of brass mouldings are very suitable to such a design when expense is no object. For instance, the pilasters might be a little sunk, or pannelled out, and brass beads mitered round in a margin, and solid flutes of the same metal let in . . .

The French *maître-menuisier*, André Jacob Roubo, finished his invaluable account *L'Art du menuisier* in 1775. He devoted a chapter to veneering and illustrated workmen cutting marquetry and veneers. For cutting veneers the skill lay in getting as many thin sheets from a log as possible, although quality was proportionate to the thickness of the veneer. The log was placed upright in a vice and two men used a two-handled saw held in a rectangular frame to cut vertically down into the log to produce the thin sheets of veneer. Allowance had to be made for the thickness of the saw, but 'through a lifetime's practice they were able to produce from one *pouce*' (some 27 mm) 'no less than ten or

2. Chest of drawers of oak and pine, *c.* 1780; it is veneered with satinwood, cross-banded with rosewood and inlaid with green-stained wood (Osterley Park, Middlesex)

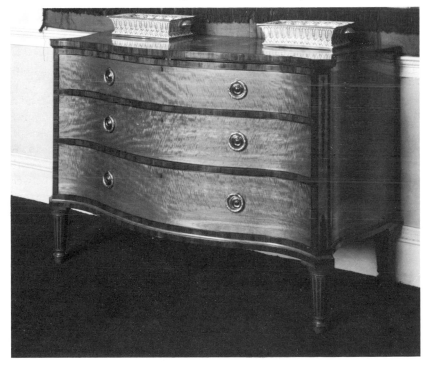

eleven sheets of veneer'.[13] The development of the term *ébéniste* came from the craftsman's association with ebony veneers.

Marquetry is a decorative veneer made up from shaped pieces of wood (and sometimes other materials such as bone and ivory), which form a mosaic or picture inlaid flush with the surface being adorned.[14] It was in vogue in France, Holland, and England in the seventeenth and eighteenth centuries, and some outstanding pieces of English marquetry furniture were created in a revival in the mid-1760s. An illustration in Roubo's *L'Art du menuisier* shows the marquetry workman seated on a stool on which a vice was mounted. The thin panel of veneer was clamped in front of him and, supporting it with one hand, he used a fine fret-saw to cut out the pattern. The saw had a rectangular frame deep enough to allow him to saw from top to bottom of the panel if required.

The veneers were often stained with iron oxide, or buried in hot sand to effect shading to the required depth of colour, before being glued into position. John Evelyn in *Sylva* (1664) wrote:

> When they would imitate the naturall turning of leaves in their curious compartiments and bordures of flower works, they effect it by dipping the pieces so far into hot sand as they would have the shadow.

In order that the veneers forming the panel should hold firmly a stout piece of wood, slightly convex on the underside, and larger than the panel being fixed – a *caul* – was heated and then clamped in position. The heat from the caul passed through the veneers and softened the glue; the caul was not removed until the piece was cold and stable. John Evelyn, again, in *Sylva* mentions various coloured woods in use:

> Berbery for yellow, Holly for white. Our Inlayers use Fustic, Locust or Acacia, Brazile, Pruce and Rosewood for yellow and reds with severall others brought from both Indies.

Sycamore, box, maple and applewood were also used, set into grounds of straight-cut walnut, figured and burr walnut, lignum vitae, kingwood, coromandel and laburnum. In the important English marquetry furniture of the 1760s the ground is usually of mahogany, satinwood or harewood veneer, with decoration in box or holly.

VARNISHES AND POLISHES

The use of varnishes arose from the desire to give a hard, shining, transparent coat to the surface of the wood, making it more durable and more ornamental.

The principal varnishes were either oil or spirit based, but oil-based varnishes have a longer pedigree, and were in use in England in the sixteenth century. They were formed by dissolving a resin such as copal in linseed, walnut or poppy oil. The copal was basically of Spanish origin and the linseed oil was obtained from flax. After the Restoration in 1660 oil varnish was still preferred. Evelyn's *Sylva* (1664) called it 'Joyner's Vernish' but, in addition to oil extracted from nuts, he also referred to juniper oil, from which was made 'an excellent good vernish for pictures, for woodwork, and to preserve polished iron from rust'. Varnish made from spirits of wine and gum lac became popular in the late seventeenth century as interest in japanning grew and in trying to imitate the varnishes of Japan and China, which, as Evelyn noted, had 'hitherto been reserved so choicely among the virtuosi'. As the alcohol of the 'spirits of wine' evaporated the varnish was faster in drying than one containing linseed. A polish was obtained by the use of a fine siliceous powder known as *tripoli*, suspended in olive oil or water, and from careful rubbing down of each varnish coat; the final coat of varnish was polished to give it a shine.

In addition to oil polishing Evelyn recommended melting beeswax,

mixing it with your lamp black and size, and when tis cold, make it up into a ball and rub it over your former black, lastly, with a polishing brush (made of short stiff Boar's bristles) labour it till the lustre be to your liking.

The beeswax was frequently mixed with turpentine, a thin resin in a volatile oil obtained from various coniferous trees. Beeswax was known from the middle of the sixteenth century; it did not darken oak, as oil polishing did, and less costly pieces were often finished without the use of tripoli powder by the use of wax.

The indefatigable Thomas Sheraton, painstakingly setting out all processes in his *Cabinet Dictionary* (1803), had a great deal to say about polishes. The methods he described were: (i) soft wax – 'a mixture of turps and beeswax' to which was added 'a little red oil to help the colour of the wood' – polished with a cloth, and (ii) unsoftened wax rubbed into the wood by means of a cork for inside work, the 'clemmings' left by the wax being cleaned away by rubbing on powdered brick dust with a cloth. He went on to indicate that the general rule for polishing plain cabinet work was as follows:

Linseed oil (either plain or stained with alkanet*) with brick dust is spread over the surface and rubbed together, which produces a polishing putty under the rubbing cloth. This kind of putty will infallibly secure a fine polish by continued rubbing.

* A red dye obtained from the root of the plant of the same name.

For chairs he recommended that they should be

generally polished with a hardish composition of wax rubbed upon a polishing brush with which the grain of the wood is impregnated.

The mixture was specified as being wax, turpentine and a little copal varnish, with the addition of red lead and Oxford ochre to give colour. It was worked into a ball and formed one of the principal ways of polishing up to about 1820.

An examination of various Chippendale bills published in 1978[15] shows that he charged for varnishing when an item contained, for example, 'Emblematic Heads in Ivory', or were burnished silver 'Gerandoles' which would otherwise tarnish. He also refers to stained chairs and to 'very large best Red stain'd Chairs' supplied to Sir Lawrence Dundas, and similar ones to Sir Rowland Winn.

These polishing and varnishing methods were challenged about 1820 by the introduction of 'French polish'. The dark red resinous shellac was melted, strained and dissolved in spirit; it was then applied in several brush coats and hardened to a high shine. Loudon in his *Encyclopedia* (1833) said it was 'by far the best for bringing out the beauties of the wood, and giving it a brightness and richness of colour which nothing else hitherto invented can produce'. He recommended its application to all fine pieces in libraries and dressing-rooms, and for all drawing-room furniture. For the tops of dining tables however Loudon recommended linseed oil, as French polish reacted to heat. The pattern-book compiler Thomas King, in his *Modern Style of Cabinet Work Exemplified* (1835), said that wood should be left plain 'to show the beauty of the French polish'.

However following a change in taste later in the century many makers reverted to waxing oak, the honesty of the finish suiting a particular aesthetic mood – as it did again with the Cotswold School early in this century.

❧ THREE ❧

THE COMMISSION

ROYAL PATRONS

Furniture needed for the royal palaces was commissioned from makers through the Office of the Great Wardrobe, headed by the Lord Chamberlain. The Great Wardrobe had been set up originally 'for the maintenance, repair, and storing of the royal tapestries, but [was] also largely engaged in weaving new ones'.[1] In time it supervised the provision of all furniture for royal use, as well as seeing to temporary fittings for plays or music. It needed to employ skilled craftsmen, who, in addition, could be counted on to extend long credit – royal patrons were as tardy in making payment as most of their courtiers. In 1691 John Gumley supplied a looking-glass to William III; he was not paid for it until eleven years later.

The Great Wardrobe was established in 1679 at Hatton Garden where 'His Majesty's Chief Arras Worker', Francis Poyntz, had his house. He was one of the last technical directors of the Mortlake tapestry works, which had been founded by James I in 1619. Poyntz died in 1685, and payment of debts to his orphans was requested by the Treasury in order that his house in Hatton Garden should not be seized by the landlord. At Christmas 1685 the Wardrobe moved to Great Queen Street in Soho and from that address controlled all the lavish expenditure of King William and Queen Mary, Queen Anne, and the Hanoverian Georges for little short of a hundred years. Among the commissions passed through the Wardrobe were John Vanderbank's Soho tapestries of chinoiserie subjects, the rich furniture for Hampton Court by Thomas Roberts, John Pelletier and others, gesso pieces by James Moore and mahogany cabinets, bookcases and tables created by Benjamin Goodison, William Vile, and William France.

When ordering furniture, a written command would be sent to the Master of His Majesty's Great Wardrobe – this example is dated 6 June 1689 and is addressed to the Earl of Montagu as Master.[2]

These are to Signifye unto Yor Lordsp his Majties pleasure that you provide and deliver, or cause to be provided and delivered unto the Grooms of his Majties Bed Chamber; Two beds and bedsteads with Curtains, hangings for two Roomes, Eight

Chaires, two paire of Stands, Two Tables, four Candlesticks with Snuffers, two Looking Glasses, two Chamberpots, two basons, Two paire of Endirons, two paire of tongues and two fire Shuffels, for ye use of ye Groomes of his Maj^ties Bed Chamber in his Maj^ties Service, And for so doing, this shall be Yor Ldps Warrant. Given under my hand . . .

The Master of the Great Wardrobe would then issue an order to the relevant craftsmen, one of the craftsmen who had been given the king's warrant to serve him – the equivalent of the present 'By Royal Appointment' warrants granted to specialist suppliers. The furniture is described in great detail in the Lord Chamberlain's accounts, but only a small proportion of it survives. We are a little more fortunate with furniture made for private patrons.

PRIVATE PATRONS

Most patrons found furniture makers through the recommendations of friends who were satisfied with work done for them. However, visits to workshops were common in the eighteenth century; pattern books and architects' recommendations were also important. After the first contact had been made, the craftsmen would visit the house to examine the intended setting and to take measurements. On these occasions the craftsman might present sketches to his client. Thomas Malton's *Treatise on Perspective* (1775) comments:

There is nothing influences a Gentleman more in the favour of his workman, when he is pleased to want something whimsical and out of the way, than to take his Pencil and sketch out the Idea the Gentleman had conceived, and was big with, yet could not bring forth without assistance. He who can do that and at the same time display a little modern taste in Ornament, being Known, is certain of success.

In 1768 John Spencer visited Thomas Chippendale's London workshop on the recommendation of his architect, John Carr of York:

Mr Car went with me to Mr Tyler the Statuary, paid him his Bill, from thence he went with me Cobbs, Chippendales & several others of the most eminent Cabinet Makers to consider of proper Furniture for my drawing Room.[3]

The architect was evidently keen to see that the furniture ordered suited the interiors he had designed.

In 1773 the architect, Sir William Chambers, reproached his patron, Lord Melbourne, for failing to consult him over the furnishings for Melbourne House in Piccadilly, which were to be provided by Chippendale. Chambers regarded himself as 'really a very pretty Connoisseur in furniture' and

disapproved, among other things, of the method of fitting up Lady Melbourne's dressing-room and the number of chairs for the great room. For his part, Chippendale was irritated by Chambers's assertion that some of the 'small Drawings . . . may be improved a little' and was unwilling to prepare the necessary large-scale workbench drawings without confirmation from Melbourne.

Lord Melbourne moved into his partly furnished London house early in 1774, and by October he was trying to bring Chambers to heel. He wrote to him that he did not want any gilding whatever, even in the furniture. He was opposed to 'a load of gilding' and thought the elegance of a room lay with the lightness of 'well disposed well executed ornaments', while Chambers thought that 'glasses without gilding are large black spots which kill the effect of everything about them'. Lord Melbourne finally countermanded Chambers's instructions to Chippendale and Chippendale had the plain seat furniture painted 'white without any ornament'.[4]

Such disagreements do not seem to have occurred between Robert Adam and his cabinet-makers, although the many surviving drawings show that the architect was keenly interested in the conception as a whole. The 1st Duke of Northumberland wrote to Adam in November 1764:

> I must desire you will order those Carved Mouldings which have been so ill executed by Mr Adair to be returned him & amended in such a manner as you shall approve of for I would not, upon any account suffer any work to be fixed up at Sion that is not completely finished to your satisfaction.[5]

The craftsmen obviously had to please their patrons in order to survive – Sir Rowland Winn, displeased, told Chippendale in September 1767 that he would 'take care to Acquaint those Gentlemen that I have recommended you to & desire that they will oblige me in employing some other person . . .' The craftsman could ill afford to reply in like kind when payment for his work was delayed.

PATTERN FURNITURE

At a workshop a patron could often see pattern or specimen furniture of the kind he intended to order. Sometimes patrons would get a provincial craftsman to copy a London cabinet-maker's pattern piece more cheaply, if the London price was too high; provincial makers were frequently asked to copy London chairs to make up a set. Sometimes the 'pattern chair' survives – there is a

splendid example at Holkham Hall, Norfolk, attributed to William Hallett. It is referred to in the 'Weekly Department Accounts' for March 1738 as 'Mr Hallett for a pattern chair for Holkham, £3 5s. od.'.

PATTERN BOOKS

Between 1660 and 1820, almost a hundred craftsmen's textbooks or instruction manuals were issued.[6] Most of them – such as Batty Langley's *The City and Country Builder's and Workman's Treasury of Designs*, first published in 1740, with at least four subsequent editions – assumed a considerable knowledge of geometry. While most furniture makers learned some geometry in the course of their apprenticeship, their skill owed as much to copying by example as to any mastery of facts and figures. Furniture pattern books, on the other hand, were often dedicated to a noble patron, required no technical knowledge on the part of the reader, and illustrated furniture which was currently available and in the forefront of fashion. Before the mid eighteenth century, however, there were very few to choose from. Many architectural pattern books were published, but the only significant works in the field of furniture were the publications of Daniel Marot, issued in Dutch about 1700, and John Vardy's *Some Designs of Mr Inigo Jones and Mr William Kent* (1744). Marot's work had a considerable influence in England, and Inigo Jones and William Kent both made a significant contribution to the Palladian movement in architecture and decoration.

By the second half of the eighteenth century the situation had changed, for there were now many sets of engravings and pattern books depicting furniture styles to guide patrons in their choice. The most successful eighteenth-century pattern book was Thomas Chippendale's *The Gentleman and Cabinet-Maker's Director* (1754), which had run to a third edition by 1762, and established Chippendale's name as synonymous with the style of the time. He was fortunate that his most important rivals, Hallett, Vile, Cobb and the Linnells, did not issue competing volumes. Chippendale's business success was probably due to his inclusion of the Rococo style in the first edition of the *Director*, and to his adoption of Neo-classicism by the third edition, eight years later (1762). His book was very valuable to other makers; 65 per cent of the subscribers to the first edition were furniture makers.[7]

Chippendale's publication was followed by two others, much inferior. The first, *Household Furniture in Genteel Taste . . .*, was said to be by 'A Society of Upholsterers', but was in fact compiled by a print-seller, Robert Sayer. Copies

of the first edition of 1760 are rare, but the book had run to a third edition by 1763. Chippendale contributed plates to it, and so did William Ince and John Mayhew. Ince and Mayhew also published *The Universal System of Household Furniture*, with 'above 300 designs'. It was dedicated to the Duke of Marlborough, an indication of their intention to rival Chippendale's *Director*, which was dedicated to the Duke of Northumberland (and the third edition, impressively, to His Royal Highness Prince William). At first *The Universal System* was issued in fortnightly parts, but the effort of maintaining the regular schedule soon defeated the compilers, and in 1762 the enterprising Sayer gathered what they had done into a single folio volume. Sayer also compiled *The Chair-Makers Guide* (1766); it is possible that some of the plates in this book, too, were contributed by Chippendale.

From the 1730s on, a patron could examine a wide selection of sets of engravings, as well as pattern books. The most noteworthy were those by Matthias Lock[8] and Thomas Johnson. Lock was responsible for twelve sets between 1740 and 1769 (some may be by another member of his family with the same Christian name), with titles such as *Six Sconces by M. Lock . . .* (1744), or *A Book of Tables, Candlestands, Pedestals, Tablets, Table Knees etc. by Matt Lock*. (This was first issued in 1746, and appeared as a second edition in 1768.) Lock's designs were in a flamboyant Rococo style, and he and his obscure collaborator, Henry Copland, were for many years credited with authorship of Chippendale's drawings. However, Chippendale was a consummate draughtsman and this theory, first propounded in 1929, is no longer held.[9]

Thomas Johnson was a talented designer who had gained his practical knowledge in his trade as a carver and gilder. He published twelve designs for girandoles in 1755, but his most ambitious publication was *One Hundred and Fifty New Designs, by Thos. Johnson carver . . .*, which appeared in parts from 1756, was bound together in 1758 and had a second edition in 1761.[10] His designs, many of them extremely spirited, would have required extraordinary talent, such as his own, to carve them, as well as a patron who did not mind a lavish display of gilded wood. A few pieces only have been attributed to him, notably a fine set of four candlesticks, *c.* 1758, which correspond closely to plate 13 in Johnson's *One Hundred and Fifty New Designs*.

As the eighteenth century progressed, the involvement of the architect and the ability of the craftsman to provide drawings increased. Chippendale provided small finished coloured sketches for his clients so that they could visualize what was planned, and John Linnell's many drawings[11] show a rare talent. The late eighteenth century saw the publication of books by George Hepplewhite and Thomas Sheraton and antiquarian interests in the early

nineteenth century were well served by Thomas Hope's *Household Furniture and Decoration* (1807).

We are still sadly deficient in our knowledge of the less important early Victorian pattern books: a bibliographical study of the whole subject is overdue. J. C. Loudon takes first place with his *Encyclopedia of Cottage, Farm and Villa Architecture* (1833), but one of the most prolific producers of pattern books in the 1830s was Thomas King, who claimed he was 'an upholsterer of 45 years' experience'. The Victorian preoccupation with rounded forms and buttoned comfort is much in evidence in King's *Original Designs for Chairs and Sofas* ... (1840); he published some seventeen volumes in all, and provides us with much of our knowledge of nineteenth-century style.

BRANCHES OF THE BUSINESS

When a patron had decided what he wanted, assisted by a visit to a workshop, consultation with the craftsman or examination of pattern books, an estimate was given and, on acceptance of the estimate, the work was put in hand. The appropriate timbers and veneers were selected and orders given to the cabinet shop, the chair or glass rooms and the upholstery shop. It was also necessary to establish what metal 'furniture' – knobs, locks, mounts – the pieces needed; and all the stages through to the final packing and delivery had to be co-ordinated.

Sheraton, in his *Cabinet Dictionary* (1803), noted that three factors contributed to success in cabinet-making. 'The quality of cabinet work', he wrote, arises 'chiefly from the abilities of the workman, the directions given him or the state of the wood which is used to work on'. Able journeymen were necessary for the success of any trade, and good masters would hold a satisfactory stock of timber and see that their men used it to the best effect. There was considerable care to see that work was 'made very close' – a Chippendale phrase – and was the best the shop was capable of.

Sheraton realized that few patrons would be able to appreciate all the stages in making which led to the final price. He wrote:

> it is difficult to ascertain, in many instances, the true value of furniture by those who are strangers to the business. On this account gentlemen often think themselves imposed upon in the high price they must give for a good article.

Some of the cost lay in maintaining separate specialized departments such as chair rooms. Again Sheraton is explicit:

Chair-making is a branch generally confined to itself; as those who professedly work at it, seldom engage to make cabinet furniture. The two branches seem evidently to require different talents in workmen, in order to become proficients.

He noted that two chairs of the same pattern could have remarkable differences if one had been done by 'a skilful workman' and the other by one who did not appreciate 'the beauty of an outline'. It is regrettable that there is a seeming absence of marks or initials on most eighteenth-century furniture (some carcase pieces by Gillows apart); it is thus difficult to chart minor technical differences in a maker's output.

The allied skills of carving and gilding were carried on near to the cabinet and chair shops, but each had its own craftsmen, who were often members of the Joiners' Company in London. Most cabinet-makers had extensive contacts with upholsterers and with providers of fabrics, fringes and other small requisites. Some of them imported French mirror-glass for use in their own glass room; others put the work out to specialists. It was, however, cheaper to obtain the mirror plates in a rough state and to be able to cut, silver, bevel and polish them on the premises. In the glass room was stored a range of 'best crown glass' to use in the doors of bookcases, in hall lanterns and in picture frames.

Any cabinet-maker who also had an upholstery business stocked an extensive range of metal hardware – if he made high quality furniture, he would have a range of brass and ormolu handles, locks, escutcheon plates, mounts and castors. If the maker could not do the casting and chasing himself, at his own workshops, he had to order from the pattern books of the suppliers – most were in Birmingham – or make wooden patterns of what he wanted and send them to the casters.[12]

Finally there was the important question of packing and delivery of the items chosen. There is little reason to think that seventeenth-century procedures for packing items were much different from those in use later, although methods of transport were undeniably improved as time went on. Most furniture of quality was swathed in paper cases to protect the surface, and 'matts' – a frequent item in all furniture-makers' bills – were made from straw or plaited rushes and packed around the items as they were put into wooden cases. An extract from William Vile and John Cobb's bill of 1 July 1758 to the 6th Earl of Coventry makes the matter explicit.[13] Eight chairs were being provided, covered in damask provided by the Earl, and with blue-and-white checked covers to protect the upholstery from sunlight. Further protection was provided for the journey:

	£	s.	d.
For 8 Paper Cases to ditto, Strengthen'd with Cloth tape, thread &c.	0	12	0
For 2 Cases, Battens, Screws, Nails &c to pack 6 of the 8 Chairs	1	8	0
Paid Cartage with 2 loads to the Inn	0	5	0

A larger bill from Chippendale to Edwin Lascelles, in November 1773[14] is similar:

	£	s.	d.
2548 feet Strong Packing Case for all the Goods, the Joints well secured	42	9	4
Deal for Battens, Screws, nails, paper, packthread, Packing & Loading the whole	9	5	0
11 large Matts	—	13	9
2 Blankets	—	15	—
Paid Cartage to the Inn, sundry cases	—	16	6

The patron decided whether the cases should be sent by land or sea transport. The straining of crates on deck and the possible injury to goods by sea water were deterrents to transport by sea. However, the coastal vessels plying between Leith, Newcastle, Hull, Kings Lynn and London were in frequent use. Various inns served as collection points for regular wagons. Valuable pieces were insured by the cabinet-maker, which allowed him to claim if damage occurred in transit. To the furniture historian, packing charges are often a useful indication of destination when goods were ordered for a town and a country house at the same time. When the furniture arrived at its destination, outworkers, usually, but not invariably, a reliable member of the furniture maker's staff, unpacked the items, inspected them for damage, and set them up. This could often be a complicated job if bed-hangings, curtains and wallpapering were involved.

Provincial firms were ever eager to take over from their London competitors and one factor which often angered patrons was that London makers charged for coach hire, as well as for the time their men spent in travelling. Sir Edward Knatchbull told Chippendale in 1778 that this was unreasonable. It would not have been charged by local men, and he expected an abatement of his bill, in lieu of which he intended to have it inspected by another London maker to judge whether it was a fair and just bill. The practice, however, seems to have been a usual one, and Sir Edward presumably lost his case.

George Hepplewhite's statement in the preface to his *The Cabinet-Maker and Upholsterer's Guide* (1788) sums up the makers' aims:

To unite elegance and utility, and blend the useful with the agreeable, has ever been considered a difficult, but an honourable task . . .

It was an aim that could not be fulfilled cheaply.

~ FOUR ~

DECORATIVE STYLES

This chapter is devoted to a discussion of the development of decorative styles and their effect on the appearance of English furniture.

In the England of the Middle Ages, the Gothic style, characterized by the pointed arch, predominated. The French architects had set the pace with their supreme achievements in the Gothic style, and its presence in England had been strengthened by the Norman Conquest. Nevertheless, England, by the year 1400, was beginning to establish its independence from contemporary European influences in thought and design. One result of England's emancipation from French ways was the establishment in England of the Perpendicular Gothic, a style which has no parallel on the Continent.

THE RENAISSANCE

When Henry VIII had a temporary banqueting hall erected on the Field of the Cloth of Gold in 1520, he was aiming to dazzle François I and the French court with a strange extravagant building, which would very soon be demolished, expressing the distilled essence of rivalry and superiority of taste. What actually happened was that a bridge was set up for the introduction into England of foreign decorative influences in all their attractive variety. Both the King and Cardinal Wolsey welcomed the heralds of the Renaissance, in the shape of sculptors and stuccoists from Italy, to work at Westminster Abbey, Hampton Court and Henry's great palace at Nonsuch.

In Italy the Renaissance style was based on the rebirth and re-interpretation of ancient Roman ideals. The motifs of the Italian Renaissance were then copied in other European countries, but the resulting styles varied widely. The Renaissance was spread mainly by sets of prints illustrating the new designs.[1] The invention of printing in the middle of the fifteenth century had meant that new ideas and information could be disseminated much more quickly and cheaply than hitherto.

Especially important were the prints of the prolific designer Hans Vredeman de Vries (1527–1604), who had travelled throughout Germany and the Low

Countries and lived in Antwerp and Hamburg. His studies of Renaissance ornament, architecture and gardens had a considerable influence throughout northern Europe, as did those of his son, Paul. Cornelis Bos and, particularly, Cornelis Floris also published designs showing the new type of interlacing strapwork which the Italians had introduced into France when working at Fontainebleau in the 1530s. Sebastiano Serlio, who worked at Fontainebleau in the 1540s, issued his seminal architectural treatise in parts from 1537 on. It contained a vast repertoire of motifs for builders and furniture makers. The first book in English to describe the classical architectural style was John Shute's *The First and Chiefe Grounds of Architecture* (1563).

The widespread application of these and other engravings ensured the success of the new style. By the time that King's College Chapel at Cambridge was ready to be equipped, in the early sixteenth century, the transition had been made, and its organ screen was carved in full-blooded Renaissance style. From the 1530s onwards, the big houses of the Tudor nobility followed the Renaissance ideal of symmetry in their architecture, and the furniture which they contained was decorated with strapwork and with a riot of robust and mannered carving and inlay.

The growth of trade in the late sixteenth century, the age of the Elizabethan merchant venturers, encouraged further interest in the decoration of other countries and provided the means to indulge in copies. It also financed the occasional extravagance, such as the silver furniture at Knole shown in Plate 4. It was a period which recognized quality and, acutely, its absence.

The early seventeenth century saw the introduction in England of strictly classical architecture. It was brought to England by Inigo Jones, who had visited Italy and returned with a first-hand knowledge of the classical Roman monuments and with a profound admiration for the work of Palladio. On his return he designed the Queen's House at Greenwich, England's first truly classical building, and the Banqueting House in Whitehall. The trauma of the Civil War in the 1640s, however, and the death of Inigo Jones in 1652 sealed off, to some extent, the architectural and decorative influences of the sixteenth and early seventeenth centuries from those which followed the Restoration of Charles II to the English throne in 1660.

BAROQUE

The Counter-Reformation, brought into being by the reforming zeal of the Council of Trent (1563), may have been an important factor in the growth of

3. Detail of the Baroque-style back-board of the state bed made in 1697 by Francis Lapierre
(Hardwick Hall, Derbyshire)

4. Silver furniture in the King's Room, 1676–80
(Knole Park, Kent)

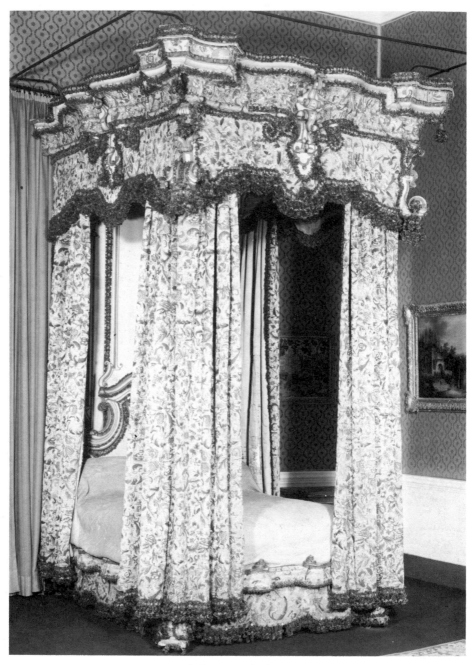

5. State bed, *c.* 1700 (Clandon Park, Surrey)

the Baroque style; some art historians argue that it is already present in early classical forms. It may be characterized as a style which employs irregular forms, and movement in mass, space and line on a grand scale. It involved a fusion of the arts of architecture, illusionistic painting, stucco and sculpture; real space was extended by the use of *trompe-l'oeil* painting. In interiors the ceremonial canopy of state was all-important and the placing of furniture was formal, with chairs 'in straight lines along inside walls while against the pier

6. Sofa, *c.* 1700, upholstered in Genoese cut velvet; provided by Philip Guibert
(Temple Newsam House, Leeds)

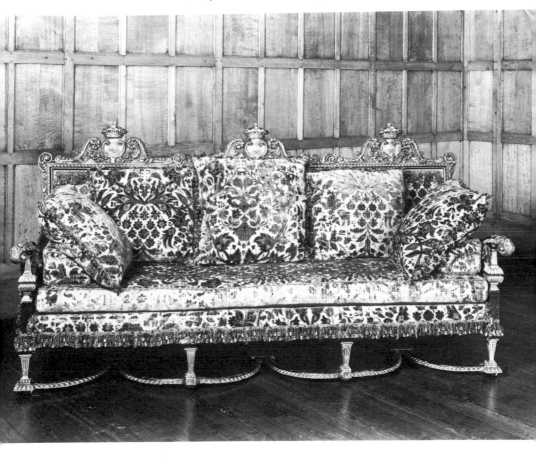

between the windows stood an almost inevitable set of matching furniture: a
pier-glass with a table under it, flanked by a pair of candlesticks . . .'[2] There
was a concern for surface embellishment, an extensive use of japanned panels
and gilded surfaces, and a taste for luxury and splendour satisfied by rich
upholstery, bed hangings draped magnificently and day beds almost as
sumptuous.

PALLADIANISM

During the reign of Queen Anne (1702–14) the reaction against Baroque
exuberance showed itself in the use of modest proportions, restrained ornament
and fine veneers in furniture which was intended for modest town houses.

7. Design for a settee by William Kent, published in John Vardy's
Some Designs of Mr Inigo Jones and Mr William Kent, 1744

Furniture destined for the great houses of the ruling Whig noblemen, such as Sir Robert Walpole's at Houghton Hall, Norfolk, though still grandiose, combined the forms of Venetian Baroque with pedestals, brackets, shells, broken consoles and pediments derived from the designs of the Italian architect Andrea Palladio (1508–80). Palladian ideals had been reinterpreted by Inigo Jones in the early seventeenth century, and revived by Lord Burlington in the early eighteenth century. By their efforts, and those of the craftsmen they controlled, the decline of Baroque was hastened, and English Palladianism was established as a style which gave dignity and grandeur, excelling that of the 'ancients' on which it was based.

ROCOCO

Precise and polished as the great stone Palladian houses were, with their well-ordered arrays of state rooms, change in fashion was so swift that even while

8. Rococo title-page of Pierre Babel's *A New Book of Ornaments*, 1752

they were displacing Baroque palaces they were themselves under threat. The gay, asymmetrical Rococo style originated in Italy and was in active use in the France of Louis XIV in the last years of the seventeenth century. When it was introduced to England, the heady style influenced architects and decorators who had hitherto shown unswerving allegiance to Palladian ideals. The circumstances of its introduction to England, about 1730, were artificial in that the high Baroque forms from which continental Rococo developed had never been readily absorbed by English patrons and craftsmen. (As the craftsmen made what the patrons ordered, and as the patrons were well-travelled and knowledgeable, this can only be explained by their preference for 'foppish and effeminate Ornaments, instead of Grandeur and Simplicity'.) But by 1750 every person with a pretension to 'taste' was avid for decoration in the exotic Gothic and Chinese styles, derivatives of Rococo, as well as in the asymmetrical Rococo style itself. Taste in furniture and objects of virtu was but one 'manifestation of the creative impulse which underlies all the artistic work of an age'.

9. Mahogany chairs in the Gothic style, *c.* 1760 (Croft Castle, Herefordshire)

The Rococo, Gothic and Chinese styles of the 1740s had in common 'a violation of the principle of symmetry . . . a superfluity of ornament . . . and a looking backward or outward toward a different culture'.[3] The sinuous S- and C-shaped curves of Rococo, combined with an exquisite sense of balance and tension, were promulgated by means of engravings, which provided the stimulus to copy and adapt and were very welcome to the craftsmen of the time as workshop patterns.

The Gothic style was available to tempt those with antiquarian tastes. While most people now connect this enthusiasm for tumbled follies and weed-cracked battlements with Horace Walpole and his mid-eighteenth-century house at Strawberry Hill, it can in fact be traced back to Wren, Vanbrugh and Hawksmoor and, in the strictest sense, may be held never to have quite died away at all since its medieval origins. It survived to await an eager revival in the Victorian period.

The Chinese style became very popular during the Rococo period. Chinoiserie is the name given to European imitations or evocations of Chinese art, usually

10. Chinese 'Chippendale' dressing-table, c. 1770 (Clandon Park, Surrey)

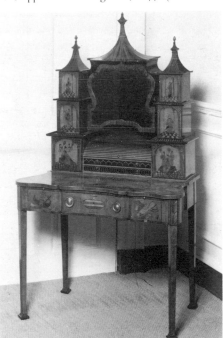

Chinese-style decoration on European-style objects. The desire for 'Chinese' items was still strong in the latter half of the eighteenth century and some of the happiest products of Thomas Chippendale senior's Neo-classical years were his green Chinese lacquer commodes (at Nostell Priory, Yorkshire). The pagoda in the grounds of Kew Palace, designed by Sir William Chambers, was another example, of great eloquence and verve. The Prince of Wales ensured the style's continuing popularity when he set up the Chinese room at Carlton House in the 1790s[4] and transformed an elegant seaside villa by Henry Holland into the Brighton Pavilion (from 1802).

NEO-CLASSICISM

After this period of exuberant decoration, the fashion, ever eager for novelty and invention, changed again around the 1750s and 1760s. The new style was derived from classical antiquity. The first volume of Stuart and Revett's *Antiquities of Athens*, published in 1762, revived interest in Greek architecture; and the Scottish-born architect Robert Adam returned to England in 1758 after four years' study in Italy and created the Adam style, incorporating classical ornament. He introduced 'a beautiful variety of light mouldings gracefully formed and delicately enriched'. Symmetry and order had come back, the disciplines of classical style restored. The 'littleness and ugliness of the Chinese, and the barbarity of the Goths', as the contemporary writers had it, were banished 'that we may see no more useless and expensive trifles . . .' Adam chose particularly competent craftsmen to carry out his designs and supervised every detail of their work to ensure that it was of excellent quality. This collaboration produced results that have rarely been equalled. When Robert Adam died in 1792, however, the taste for classical architecture again suffered a decline. The eye had to condition itself to a revival of Gothic and to styles derived from Egypt and France.

11. Neo-classicism:
pedestal and urn
made by John Linnell in 1767
to Robert Adam's design
(Osterley Park, Middlesex)

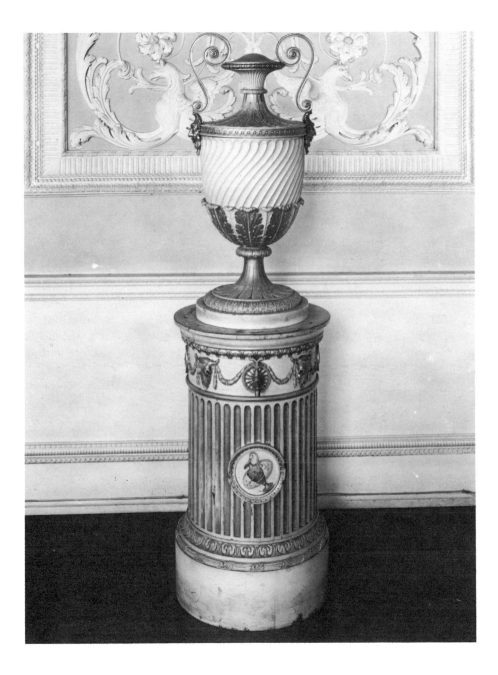

THE VICTORIAN PERIOD

The exercise of patronage was wedded in the Victorian period to commerce, and many different styles affected the nineteenth-century visual imagination.

It is perhaps too simplistic to suggest that the evolution of styles and furniture in the Victorian period may be traced entirely from the large number of pattern books and 'Descriptions' which survive. However, the books are valuable as contemporary records charting the shifts of middle-class taste.

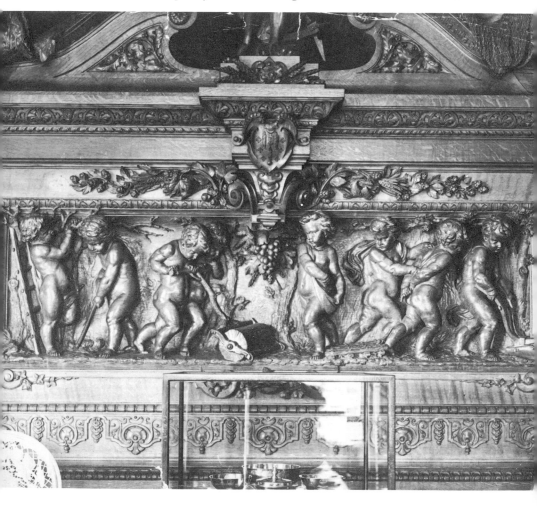

The author who set out most precisely the styles of furniture available – with line drawings – was John Claudius Loudon (1783–1843). His *Encyclopedia of Cottage, Farm and Villa Architecture* was published in parts, beginning in 1832, five years before the youthful Princess Victoria became queen. The first edition was published in 1833, and the book went through many subsequent editions; after Loudon's death his wife Jane issued a supplement in 1846 with over a thousand pages and two thousand engravings.[5] The *Encyclopedia* was immediately useful to builders and furniture makers, dealing as it did not only with the principles of criticism in architecture, but also with furniture for cottages, farms and villas. Loudon wrote about the fashions for furniture current in the 1830s, when furniture was still made by hand:

> The principal styles of design in furniture may be reduced to four, viz., the Grecian or Modern style, which is by far the most prevalent; the Gothic or Perpendicular style, which imitates the lines and angles of the Tudor Gothic Architecture; the Elizabethan style, which combines the Gothic with the Roman or Italian manner; and the style of the age of Louis XIV, or the florid Italian, which is characterized by curved lines and excess of curvilinear ornaments. The first or modern style is by far the most general, and the second has been more or less the fashion in Gothic houses from the commencement of the present century; since which period the third and fourth are occasionally to be met with, and the demand for them is rather on the increase than otherwise.

Loudon himself preferred the Grecian style, although furniture makers did not always use it with fluency. He praised Gothic, but regarded 'Louis Quatorze' as 'unsuitable to the present advancing state of the public taste'. As for the Elizabethan style it had no need of Loudon's advocacy because the Queen's own decorators, H. W. and A. Arrowsmith, stated that of the four fashionable styles 'none are in themselves more picturesque or so well suited to the manners and customs of the English people than the Elizabethan'.[6]

There were at least twenty-five major international exhibitions between the seminal Great Exhibition of 1851 in London and that at Turin in 1902, a year after the lonely old Queen was laid to rest. The furniture shown at such exhibitions was important, and often influential, but it was unrepresentative. Exhibition pieces, highly carved, polished, and made with considerable attention to detail, were not what a country-house squire of moderate means would buy, but they may well have influenced the shapes and functions of the furniture his children acquired.

12. Carved oak, Warwick school of carving, 1858 (Charlecote Park, Warwickshire)

The Grecian Style

This was Loudon's 'Modern Style'; he considered it to be the style most appropriate for the dining-room, and it was the style which predominated in the furniture provided for London clubs and livery halls in the 1830s. It was also favoured by the important Regency makers and designers such as the scholarly Thomas Hope and the commercially minded Charles Smith. As early as March 1828 Sir Walter Scott commented in the *Quarterly Review* 'that an ordinary chair, in the most ordinary parlour, has now something of an antique cast – something of Grecian massiveness, at once, and elegance in its forms . . .' The dining-chairs which Loudon illustrates are presumably of the form which Sir Walter had in mind when he observed that they 'give a comfortable idea of stability to the weighty aristocrat or ponderous burgess' – chairs with a broad cresting rail or shoulder board, straight turned front legs, and rear ones splayed at a backward angle. It was a variation on what the Regency designers had done and, executed in mahogany with quilted seats, remained popular until about 1850. Much of the 'Grecian' furniture made in the 1840s, as shown in the pattern books of prolific compilers such as Thomas King,[7] had a tendency towards comfortable rounded forms and lavish upholstery, with carving retained only for scrolls or gilded foliage.

The Gothic Style

According to Loudon, the 'Gothic or Perpendicular style' is that 'which imitates the lines and angles of the Tudor Gothic Architecture'. The designer of Loudon's own time to make most effective and general use of the style was A. W. N. Pugin,[8] author of *Gothic Furniture in the Style of the Fifteenth Century* (1835). But Pugin's furniture – as for Scarisbrick Hall, Lancashire (*c.* 1837) – was expensive to make. The columnar legs, quatrefoil piercings, pinnacles and crockets meant much work for the carver, J. G. Crace. Crace, who was of a distinguished family of decorators,[9] read a paper in 1857 in which he restated his belief that the Gothic style was supreme:

> In my opinion there is no quality of lightness, elegance, richness or beauty possessed by any other style . . . [or] in which the principles of sound construction can be so well carried out . . .[10]

These 'principles of sound construction' were applied effectively later in the Queen's reign by designers such as William Burges, Bruce Talbert, Morris & Co., Charles Bevan and Norman Shaw.

The Elizabethan Style

In the nineteenth century the Elizabethan style, with some elements deriving from the Picturesque of the previous century (made popular by the writings of Richard Payne Knight and others), was becoming more popular. The pattern-book writers – Henry Shaw's important *Specimens of Ancient Furniture* had appeared in 1834 – suggested that such furniture should be made of oak or walnut – mahogany was not, 'at any time, at all suitable for Elizabethan furniture'.[11] Arrowsmiths', the Queen's decorators, approved of the style; the Lucys of Charlecote in Warwickshire, an important family, had oak spiral-turned chairs in their dining-room in 1837, the year of the Queen's accession. Some oak pieces were made up from fragments of original carvings taken from monasteries, in France and elsewhere, which had been secularized during the long Napoleonic Wars. By the time of the Great Exhibition in 1851 the style was considered to be holding its own with that of the Palladian revival, and it continued to do so for almost a further fifty years.

The Louis XIV Style

Loudon's 'style of the age of Louis XIV [reigned 1661–1715], or the florid Italian' had been introduced to England soon after the disruptions of the French Revolution and the Napoleonic Wars at the end of the eighteenth and start of the nineteenth centuries. In France, the restored monarchy was anxious to revive the *ancien régime* and to rid themselves of anything that had become fashionable in the Revolutionary and Napoleonic periods. In England, George IV, who had a lifelong admiration for French furniture,[12] eagerly added to his already extensive collection – and what the King did, his subjects did too. The decorations and furniture at Belvoir Castle, Leicestershire, for the Duke and Duchess of Rutland, who visited Paris in 1814, set the fashion which their friends and his club followed. In 1828 the Duke of Wellington, high in popular esteem, also furnished his London residence, Apsley House, at Hyde Park Corner, in the French style.

By the time of Queen Victoria's accession in 1837, furniture in the style of Louis XIV and furniture in the style of Louis XV was all labelled indiscriminately 'Old French'. However, ornament could now be roughed out on the lathe and finished by hand; as this meant that it could be produced more cheaply, it was once more used in profusion. Although the blemishes of the workmanship, hidden under thick gilding, were condemned by some, much drawing-room and boudoir furniture was made in the French style at this period.

R. N. Wornum, in an essay on the 1851 Exhibition entitled 'The Exhibition as a Lesson in Taste', pointed out the importance of Renaissance ornament, but indicated that 'the Louis Quatorze varieties prevail in quantity'. Many French craftsmen, fleeing from the political troubles of France in the late 1840s and the Paris Commune of 1871, found ready employment with English furniture makers; the 7th Duke of Marlborough, who succeeded in 1857, used their skills at Blenheim Palace.[13]

Many patrons preferred furniture with marquetry decoration, and so Louis Seize style became popular, not only with the Queen, but with many of her subjects. At the end of the century the Arts and Crafts movement brought about another change in taste.

LATE-NINETEENTH-CENTURY STYLES

We now move on from the four styles described by Loudon to those which were current later in the century. Furniture in the Grecian style continued to be made until the mid-1850s. The use of Gothic flourished throughout the century; Bruce Talbert's influential *Gothic Forms Applied to Furniture* was published in 1867. The Elizabethan style and the *mélange* of French styles also retained their importance, but both had a stronger showing at mid-century and during the following decade than they had later in the century. They had to face severe competition from exotic rivals and from indigenous movements.

The Palladian Revival

Andrea Palladio's architecture had become known in England through the work of Inigo Jones and interest in it was revived in the eighteenth century by the 3rd Earl of Burlington and by William Kent. Arguments as to the supremacy of Rome over Greece, or vice versa, were fiercely waged in the eighteenth century and, in the nineteenth, interest in 'Roman' architecture and decoration served as a corrective to the 'Grecian' style. Original pieces of furniture were altered and many eighteenth-century pattern books were reissued or compiled afresh by publishers such as John Weale.

The nineteenth-century 'Palladian' revival was blended into the Louis Quatorze style.[14] In its brief flowering it had as significant an impact as the classical designs of Hepplewhite, Sheraton and Robert Adam on accomplished makers in the 1860s.

The Japanese Taste

When the International Exhibition opened in London in 1862, there was much to arouse interest, particularly the exhibits from Japan, which were immediately admired. Three leading English designers, William Burges, Christopher Dresser and E. W. Godwin, publicized the style and made adaptations of it – an 'Anglo-Japanese' style of furniture – and so created a market for it. The furniture in its original form was not suitable for western houses, but the high standards of craftsmanship were keenly appreciated. Godwin never visited Japan, but he copied the rectilinear forms of the Japanese furniture with the help of prints, and he used Japanese leather paper for the panels of his furniture.[15]

Art Furniture

Art furniture is not a specific style; it is the term applied in the 1860s to furniture produced by firms which employed designers of the calibre of E. W. Godwin, B. J. Talbert, Charles Eastlake and William Burges. These designers advocated simple forms, and painted surface decoration was much used. Much art furniture was designed by architects.[16]

The Arts and Crafts Movement

The activities and the reforming zeal of William Morris have been much written about.[17] His teaching, and that of John Ruskin, inspired the Arts and Crafts Movement which flourished in the 1880s. The aims of the reformers were to improve standards of design and to encourage handcraftsmanship – to 'turn artists into craftsmen ... and craftsmen into artists'. They had a considerable influence on design, but they were bound to fail in their aim of bringing good design and craftsmanship to a wider public, for handcraftsmanship is expensive.

Art Nouveau

The last twenty years of the nineteenth century saw the rise of the Arts and Crafts Movement and of Art Nouveau. In 1882 Arthur Heygate Mackmurdo, an architect much influenced by the work of John Ruskin and William Morris, founded the Century Guild, based on the ideals of the medieval guilds, which stood for cooperation amongst craftsmen rather than exploitation and

competition.[18] The title page of his book *Wren's City Churches* (1883), is the earliest example of what we now know as 'Art Nouveau'. Art Nouveau was a style of surface decoration, of swaying, flowing lines derived from natural

13. Mackmurdo's title-page for his *Wren's City Churches*, 1883

forms. The School of Nancy, in France, produced much of the best Art Nouveau furniture; the Paris Exhibition of 1900 was dominated by it. Wood does not lend itself easily to the style, being less malleable than silver or glass, but the furniture of Emile Gallé, Eugène Vallin, Louis Majorelle, Alexandre Charpentier and Henri van de Velde, who all used clay maquettes, achieved a freedom which evaded English makers. The heyday of the style lasted little more than ten years, straddling the boundary between the nineteenth and twentieth centuries, but it abounded in verve and inventiveness.

PART TWO

THE
FURNITURE

FOR CROWN AND COURT

THE MEDIEVAL HOUSEHOLD

England had abundant supplies of certain kinds of timber, and there was plenty of work for carpenters and joiners. Patrons were interested in textiles and plate, as well as in furniture, for they enriched and brightened the sombre wainscoted rooms which the joiners had fashioned, indicating to all the possession of more than ordinary wealth. It has been stated 'that the great medieval household had to be organized to effect the daily movement of furnishings . . . rooms were like the stage of a theatre in which certain basic props were permanent, and in which, by the deft arrangement of portable property, the area was transformed into an arena to suit the action which was about to take place'.[1] The house was open in plan, with the hall acting as a room of display and decision. At Cotehele, Cornwall, something of the former grandeur of the medieval vaulted hall can still be imagined, despite the fact that the present refectory table is on fixed legs and dates from the late sixteenth century. Medieval tables were set upon trestles and taken down at the end of the meal. Capulet, in *Romeo and Juliet* (1.2.27) refers to this type of table when he cries 'turn the tables up'; when the top was lifted off, the pieces could be stacked against a wall to make more space. The diners sat on forms or stools, below tapestries or painted settings of courtly splendour. While they ate, using spoons and knives – forks had not yet been invented – they could marvel at the splendour of the great 'cupboards' (in French, the *buffet*) displaying sets of gold and silver plate and drinking vessels. The ceremonial salt was set on the high table on the dais, and the important guests took their places, according to rank, 'above the salt', to the right hand of the host. At a lavish banquet, such as those given by Henry VII, where the guests were offered lamprey in galantine or 'castle of jelley in temple-wise made' and other elaborate confections, the hardness of the simple forms and joined stools might almost have been forgotten.

The supply of furniture was still scanty well into the sixteenth century and, as there were too few joiners to cope with the demand, most attempts at improvement were tardy and ill-considered. Only the king himself had furnishings which were suited to his station.

On 16 July 1506, King Henry VII bestowed the indentures of his new foundation of a chantry chapel in Westminster Abbey upon Abbot Islip and the assembled Benedictine Convent of St Peter. The illuminated pictures[2] which adorn the written record of the event show the seated King, robed and crowned and holding the sceptre. His exalted rank is determined not only by the kneeling monks, but by a suspended 'celour', or canopy, over his throne. It was an assertive sign of rank of great antiquity. It formed the distinctive part of the 'hung' state beds which adorned many great houses, marking the monarch as superior. Certain items of furniture – canopies and chairs of state – were set aside and their use restricted to those of exalted rank.

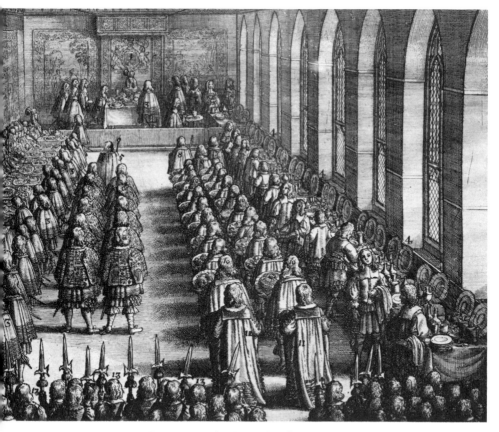

14. A banquet given for the Knights of the Garter in the time of Charles II.
A canopy distinguishes the King's chair; the side tables on the right are described in the key
as court cupboards (p. 82)

The early sixteenth century was a time of change and gradual improvement to both houses and furnishings. There was much to do because the traditional styles were more relevant to status than to comfort. Apart from great four-post beds of considerable luxury, with costly hangings – objects to be revered, enhanced and passed on to one's children – comfort had long been ignored. Prudence necessitated the possession of a 'joined' chest for the storage of plate and muniments (or, in churches, vestments and altar cloths). Convenience required the possession of a food cupboard or 'aumbry'. Much else that we would consider essential found no place in the medieval house.

Considerable speculation has arisen over the question 'when was a cupboard

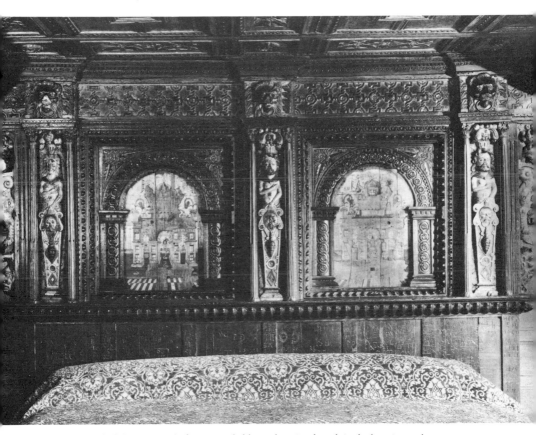

15. The head of the Great Bed of Ware, probably made at Southwark in the late sixteenth century
(Victoria and Albert Museum, London)

16. Hanging livery cupboard, seventeenth century (Victoria and Albert Museum, London)

not a cupboard?'[3] The special 'table' for the display of plate was certainly called a 'cupboard' – the word *bord* still means a table in the Scandinavian languages. By the 1550s some cupboards were being fitted with doors, and were thus cupboards in the modern sense, 'a piece of storage furniture consisting of an enclosed space with a door in front'. The two main types, shown opposite, are the court cupboard, deriving its name from the French word for short i.e. low, and the 'livery' or 'dole' cupboard usually placed in bedchambers. They stored food, drink, candles and the contents of emptied pockets with ease, but by the early seventeenth century seem to have had doors and be structurally somewhat different from the court cupboard with its open shelves. It was but a brief step to enclosing the open shelves with a canted cupboard at the top, and a full-width cupboard between the base uprights.

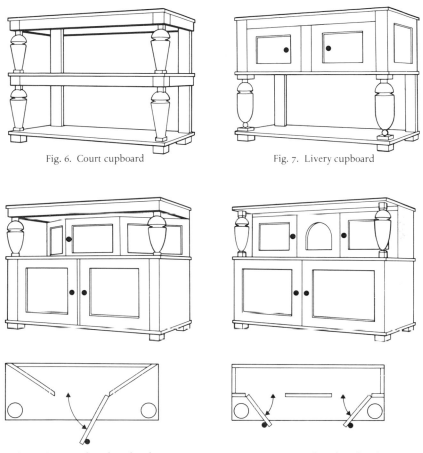

Fig. 6. Court cupboard Fig. 7. Livery cupboard

Fig. 8. Court cupboard, enclosed Fig. 9. Livery cupboard, enclosed

ELIZABETHAN PRODIGY HOUSES

When Queen Elizabeth I succeeded to the throne in 1558 there was already a considerable interest in developing foreign trade and industry. This encouraged travel, determined taste and provided some of the material wealth with which old houses were renovated for their status-conscious owners. Great mansions were built both by the newly rich and by the established nobility.

The 'prodigy houses', as these Elizabethan mansions were called, had a 'great chamber', where the family, their guests and the senior household officers ate apart from the servants. Other innovations were the 'long gallery' – for walking and playing games, and often used as a portrait gallery as well – and the parlour, which served as an informal eating room.

Those at court, and the rising middle classes below them, now felt a desire for greater comfort, and saw no reason why they should not indulge it. They wanted more furniture, since there were now a greater number of rooms in use, and they wanted more elaborate, better-constructed, framed and panelled furniture.

The increase in trade meant that the supply of timber was expanding and woods other than oak were more freely available. Pattern books and engravings showing northern interpretations of the new Italian Renaissance designs were circulating at this time in Germany and the Netherlands, England's Protestant allies. Inevitably, English furniture design was soon affected by a wide range of new stylistic influences. In particular, three distinctive ornamental features appeared – strapwork, inlay and bulbous ornament on table legs and bed-posts.

Strapwork was an intricate scrolling, arabesque ornament carved in low relief. Rosso Fiorentino had taken the motif from Italy to France in 1535 to incorporate in François I's gallery at Fontainebleau. Before long, the Fleming, Cornelis Floris, was filling the pages of his pattern books with it, and the Elizabethans soon abandoned themselves to a riot of robust and vulgar ornament. Strapwork was well suited to display, and it could also be adapted to represent flowing acanthus foliage, inlaid in one of the woods suited to such use – holly, ebony, sycamore, box and poplar. Renaissance decorative forms, inlaid on elaborate panels, friezes, and headboards, were complemented by turned or carved posts with massive urn- or bowl-shaped swellings and flanked by a diversity of carved ornament. This is particularly evident in the furniture made c. 1540 for Sir Thomas Wentworth (now at Temple Newsam House, Leeds) which has similarities in its carving to the Salkeld Screen in Carlisle Cathedral. It has been suggested that the carvers may well have copied wood-block illustrations in books such as Heinrich Vogther's *Kunstbuchlin*.

Painted furniture went out of fashion in Elizabeth's reign. There was a growing desire for luxury. The chronicler William Harrison, writing in the late 1570s, noted many improvements:

The furniture of our houses . . . is growne in maner even to passing delicacie: and herein I doo not speake of the nobilitie and gentrie onelie . . . Certes, in noble mens houses it is not rare to see abundance of Arras, rich hangings of tapestrie, silver vessell, and so much other plate, as may furnish sundrie cupboards . . . even the inferiour

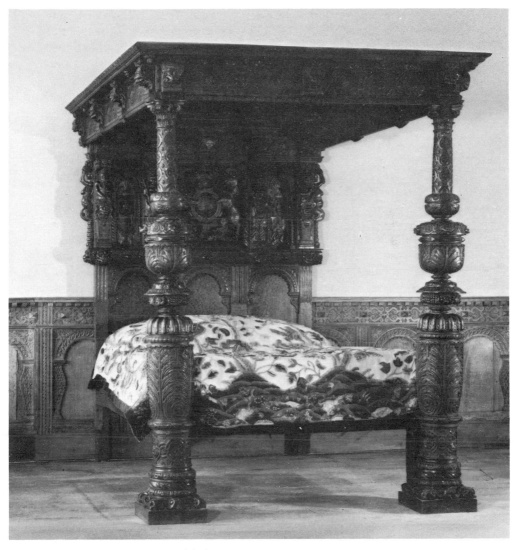

17. Oak bed, *c.* 1612 (Montacute House, Somerset)

artificers have for the most part learned also to garnish their cupboards with plate, their joined beds with tapistrie and silke hangings, and their tables with carpets & fine naperie.[4]

Rooms were used for more than one purpose – especially for eating and sleeping – and the oak joined, or 'joint', stools were packed, when not in use, with the legs turned inwards, resting on the table stretchers. Randle Holme writing in *The Academy of Armory*, a manuscript dated 1649, explained that 'joynt stooles' were so described because they were 'all made and finished by the joyner', distinguishing them from turned stools, 'made by the turner or wheelwright . . . wrought with knops and rings'. Useful as they were, they were hard to sit on; Sir John Harington, writing about 1596, found wooden 'waynscot stools so hard that since great breeches were layd aside, men can skant endewr to sitt upon' them. Lords and ladies, he insisted, needed 'easye quilted and lyned formes and stools'. When Queen Elizabeth I was Harington's guest at Kelston in Somerset in 1592 the rules for his household were supervised carefully, and his innovative experiments with water-closets were hastened forward.

Accounts of the Queen's Progresses throw much light on the vast preparations needed to move a large household and all its furnishing appurtenances in the late sixteenth century.[5] Hundreds of carts bearing baggage, including furnishings for the houses at which she intended to stay, travelled some ten to twelve miles a day. Her descents on private houses, though an honour, were often feared, since the cost of food and extravagant furnishings had to be provided by the courtiers she visited – the Earl of Leicester outdid most by entertaining her at Kenilworth Castle in 1575 for three weeks. Jacob Rathgeb described the lavish royal accommodation in 1592 at Theobalds Palace, where William Cecil, Lord Burghley had several 'tables of inlaid work and marble of various colours' and at Hampton Court 'all the apartments were exceedingly beautiful and royally ornamented'. In 1598 another foreign traveller, Paul Hentzner, noted the looking-glasses, cabinets and beds at Windsor, and the royal beds, silver cabinets, and jewel-chests, rivalled by valuable arrays of plate and textiles, at Whitehall.[6]

Hardwick Hall, in Derbyshire, the home of Elizabeth Talbot, Countess of Shrewsbury ('Bess of Hardwick') survives intact, if somewhat altered, as the considerable achievement of a remarkable and redoubtable owner, who at the death of her fourth husband in 1590, became mistress of a great fortune.[7] The many-windowed house, designed by Robert Smythson, was ready for occupation by the autumn of 1597. The surviving inventory of 1601[8] lists the contents at the completion of the elaborate decoration and furnishing. Together the house and furniture comprise the principal surviving Elizabethan setting, although some of the furniture is hardly representative of late Elizabethan taste, as there was substantial restoration work in the 1780s and later.

The house, on ground floor and two upper floors, has some sixty-four rooms, ranging from the spacious gallery (which occupies half of the second storey), to small closets and landings. On the ground floor was the entrance hall, and a stone staircase which led to a first-floor withdrawing room, the Low Great Chamber and the Chapel. The state bedroom, the High Great Chamber (or Presence Chamber) and the long gallery were on the second floor. Most of the rooms still contain remarkable hangings – which would help to exclude the draughts from the large windows – and sets of needlework pictures of subjects such as the 'Sacrifice of Isaac' and the 'Judgement of Solomon'.

Unfortunately, 'only a handful of significant items are identifiable with entries in the Inventory'. The 'Aeglantyne' table, an Elizabethan marquetry centre table, was listed in the High Great Chamber in 1601, and has been in that room since the mid eighteenth century. It was made in 1568 on the marriage of Bess's son, Henry Cavendish, with her step-daughter Grace Talbot. Her coat-of-arms, impaled by Henry's, appears amid strapwork ornament upon the walnut top, which is richly veneered with a profusion of coloured woods depicting musical instruments – viols, lutes, rebecs, flutes and sackbuts – an open music book, flowers, playing cards and a romantic legend. With its

18. Games table, c. 1580 (Hardwick Hall, Derbyshire)

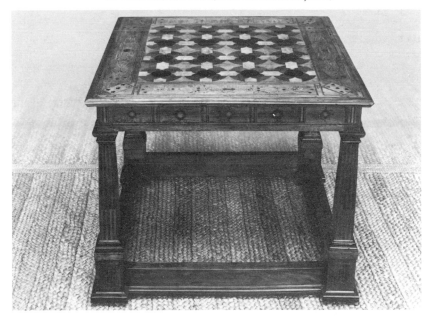

elaborate top and inlaid stretchers connecting the four legs at the base it is similar in construction to the smaller marquetry centre or games table which has square reeded and tapered legs. Several of these tables are mentioned in the Inventory, but only one survives at Hardwick. The elaborate 'Sea-Dog' or 'Chimera' table, originally in the withdrawing chamber, follows a design by Androuet Du Cerceau; it has four carved and winged sea-dogs supporting a bulbous frame with paired balusters and a rectangular top. Two elaborate panels of Elizabethan 'hunt' embroidery survive, but set on a mid-nineteenth-century chair. Only two of the humble joined stools have survived, and their late-sixteenth-century frames are covered with seventeenth-century Turkey work. An oak chest, with arcaded panels and elaborate decoration in walnut and marquetry, has two drawers in the base. It bears a resemblance to the so-

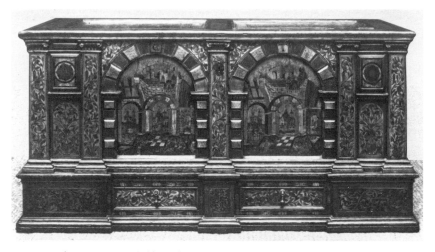

19. Chest, c. 1570, probably made in Germany or by Germans working at Southwark
(Hardwick Hall, Derbyshire)

called 'Nonsuch' chests, which were inlaid in holly wood with designs representing formal architectural scenes. (These were probably made by immigrant German craftsmen settled in Southwark in the sixteenth century; they were given this name in the nineteenth century because it was thought that the designs represented Henry VIII's palace at Nonsuch.)

At Hardwick the redoubtable Countess had a bed hung with scarlet woollen cloth, with five additional curtains of purple 'bays'. The red material was trimmed with gold and silver lace and gold fringe; convenience in respect of

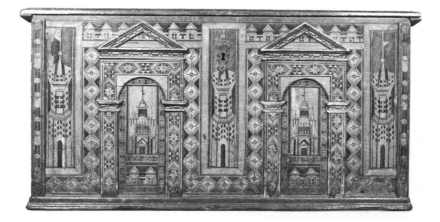

20 and 21. Nonsuch chest, probably made at Southwark between 1609 and 1637
(Dedham Historical Society, Massachusetts), and detail

warmth was sacrificed to display. Some of the other beds in the house had silk hangings. The bed in the 'Pearle Bed-Chamber' was magnificently carved and gilded, and had double valances, with hangings of black velvet embroidered with gold and silver thread interspersed with pearls. The valances, which hung from the tester, were further embroidered with black, gold and silver fringes. The bed in the 'best Bed-Chamber' was more elaborate; its tester was 'hung' on cords, with six curtains, a central panel of cloth of gold, and a counterpane of 'Cloth of tyssue', a silken material laid with silver thread.

The Lower Great Chamber served as the dining hall and contained a long table, two square tables and a two-tiered cupboard covered with two table covers or 'carpets'; it also contained upholstered chairs, upholstered forms and joint-stools. Large numbers could also dine in the ground-floor Great Hall, which contained six forms and three long tables; a smaller, less draughty dining chamber was used for everyday meals. The large rooms were lighted by candle chandeliers and the smaller ones by candles set in brass sconces.

The information which can be gleaned from sixteenth-century inventories gives a good indication of what contemporary furnishings were like. The inventory for Arundel Castle, Sussex, compiled about 1580, shows that the gallery contained six inlaid walnut chairs, six joined stools (with tops pierced by a hand-hole for lifting), and three more chairs covered in black leather. An inlaid, square, framed table and a walnut cupboard completed the richer furnishings. The eight trestle tables in the Great Hall were made of fir, and the only seating was two chairs, two joined forms and sixteen 'stools of waynescotte' – the ever-present jointed stools. There were also two cupboards. Wall hangings and 'Turkey Carpets' for placing over the high table, enriched the furnishings. The sparsely furnished bedrooms contained only oak cupboards and bedsteads, enlivened by a single Venice rug and '1 olde quilte of silke tawnie'.[9]

The use of marble on furniture, while well understood in Renaissance Italy, was still rare in England. When Jacob Rathbeg, private secretary to Frederick, Duke of Württemberg, visited Theobalds Palace in 1592, he noted 'several tables of inlaid work and marble of various colours' there, and, in a garden summerhouse, 'a table of black touchstone or marble'. A slightly later inventory than the Arundel one – listing the possessions of John, Lord Lumley, in 1590[10] – illustrates a marble-topped table on six bulbous legs. The tables are shown in the company of marble cisterns, fountains and lavabos, decorated with the Lumley arms and owing much, as does the Hardwick sea-dog table, to the designs of Du Cerceau.

Richly upholstered chairs were now more fashionable, and a development from those of Tudor days, which had tall straight backs and solid arm supports.

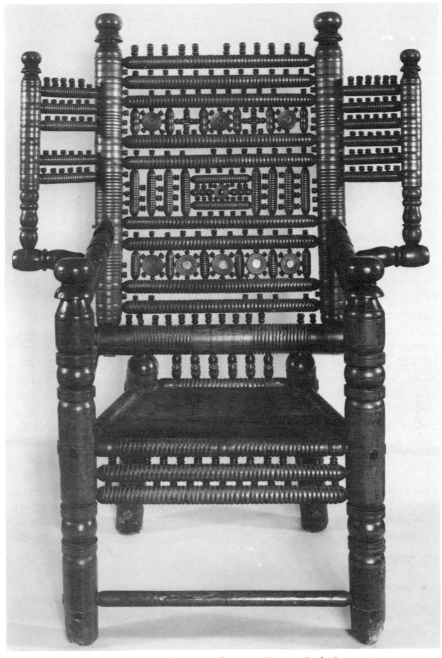

22. Turned armchair, late sixteenth century (Dunster Castle, Somerset)

The Lumley inventory shows that in the three residences listed there were '76 chares of cloth of gold, velvet and sylke'. At one of the three residences, Lumley Castle, Durham, the Great Chamber also contained two draw-leaf tables, a type which could be extended by leaves beneath the main top, and which seems to have come into use in the early 1550s. (There is mention of a *drawing-table* in the Duke of Somerset's inventory of 1552.) The Lumley inventory also supports Sir John Harington's statement that upholstered stools were in abundant supply by the end of the century. He possessed an enormous number – fifty-seven of inlaid walnut, and 118 of wainscot; many had loose cushions; they would be used either for sitting on or as footstools. Few early upholstered stools survive anywhere and the important collection at Knole contains some of the best.

Chairs were comparatively scarce throughout the sixteenth century – the fifty-two rooms of The Vyne, Hampshire, in 1541 contained only nineteen. Lighter Italian-type models, including the X-shape chair, were introduced. During the latter half of the sixteenth century a number of X-chairs and stools, travelling coffers and boxes, mostly upholstered in velvet or cloth-of-gold were supplied to the Crown by its coffer-makers, the Greene family. They also made a type of light chair called a *caquetoire* (from *caqueter*, to chatter); in France this could describe any small low chair, but in England it meant specifically one with a narrow back and outward-bowed arms. The back was often carved with Renaissance ornament and a profile head. Due to the close ties between the French and Scottish Crowns at this time the *caquetoire* chair is also found in Scotland.[11]

During the late years of Elizabeth's reign, chairs were becoming more plentiful, some being of elaborate turned construction and others having a direct ceremonial importance beyond their appearance. It was a mark of respect to offer a chair to a guest, and a contemporary literary reference underlines the point. In *Arden of Feversham* (1592), Arden's wife is told to 'place Mosbie, being a stranger, in a chair, and let your husband sit upon a stool'. The allocation of seats at the English court was based on the French system. The sovereign sat on a chair and the right to sit on a stool (*tabouret*) in his presence was reserved to princes, dukes and Court dignitaries and their wives. In 1604 'tabourets of brocade with a high cushion' were provided for the Constable of Castile and his party when James I entertained them at the Palace of Whitehall; 'their Majesties sat at the head of the table on chairs of brocade with cushions, and at the Queen's side sat the Constable, a little apart, on a tabouret of brocade with a high cushion of the same'.

THE JACOBEAN OAK TRADITION

At the beginning of the seventeenth century, patrons were eager to adopt foreign ideas; they welcomed the Vitruvian ideals of harmony and symmetry in décor, and required that rooms should be suitably furnished for their purpose, whether 'office, entertainment or pleasure'. (Vitruvius was a Roman architect of the first century BC whose treatise *De architectura* survived and greatly influenced Renaissance architecture and design.)

Thomas Sackville, the 1st Earl of Dorset, was Lord Treasurer to Queen Elizabeth and to King James. He came into possession of Knole, in Kent, between 1603 and 1605, and immediately began to alter it and add elaborate new buildings. However, he continued to live either at Horsley, Surrey, or Buckhurst, Sussex, and his official duties as Lord High Treasurer often kept him in London at Sackville House. He died in 1608 and his manuscripts perished in the Great Fire of London in 1666. The 2nd Earl of Dorset died within a few months of succession; the 3rd Earl, despite his marriage to the celebrated and shrewd Lady Anne Clifford, was noted above all for wild extravagance. And, to crown all, there was a disastrous fire at Knole in 1623. In such circumstances, it is little short of miraculous that any of the furniture or the documents which record its history have survived.

No firm conclusions can be drawn about the origins or makers of the early items at Knole, but some of the principal items were probably made for James I and Anne of Denmark. It is worth noting, but dangerous to exaggerate, the family connections of a leading cloth merchant, Sir Lionel Cranfield – whose papers are in the Knole archives – with Lord Dorset's family. Sir Lionel's daughter married the 4th Earl's son and heir. Sir Lionel himself (later created 1st Earl of Middlesex) became Lord Treasurer in 1621, a post which had been held by the 1st Earl of Dorset until his death in 1608. Sir Lionel bought silks, velvets and taffetas from Italy, and linens and fustians from various parts of Germany. He speculated in woods for making dye with Sir Arthur Ingram, the builder of Temple Newsam House at Leeds, and he invested in a silk farm. He was obviously in a good position to supply exotic fabrics, and something of what he had in stock may have been acquired by the Knole 'embroiderers', and those working for Hatfield and for the Royal Wardrobe in London. Whatever its source, the upholstered furniture at Knole provides adequate testimony to the rank of the owners.[12] There are five X-frame 'chairs of state' intended to be set under a canopy for important persons – the Mytens portrait of James I at

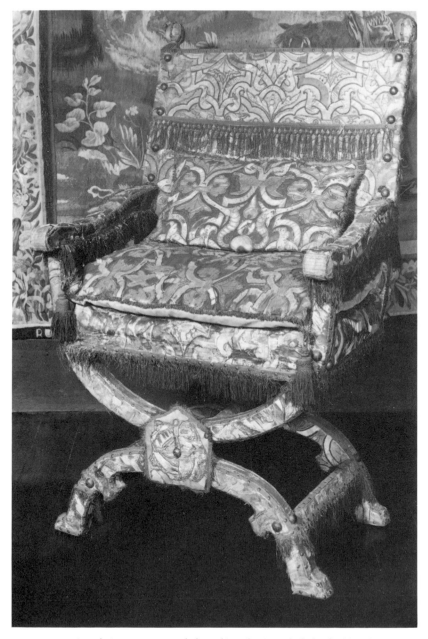

23. Armchair, *c*. 1610–20, upholstered in red satin with cloth of gold appliqué
(Knole Park, Kent)

Knole shows him in such a chair – made between about 1610 and 1625. One, c. 1610, is covered in red silk and silver tissue, and another, of slightly later date, has a white and red painted frame with arabesque decoration. This obviously complemented the original scarlet and silver cover. Yet another, of the 1620s, is upholstered in crimson and silver damask and is stamped with the Hampton Court inventory mark and the date of the inventory, 1661. The chair probably came to Knole because leading court officials, such as Charles Sackville, 6th Earl of Dorset (?1642–1706), had the right to take 'perquisites' – furniture for private use – at the death of the sovereign.[13]

A little later in date than the elaborate X-frame chairs of state, were the chairs of about 1630–40, with square joined frames, padded seats and low padded backs but no arms. They were given the name 'farthingale chairs' in the nineteenth century because they were made without arms to accommodate the farthingale or hooped petticoats worn in the reign of James I. The woodwork, of simple turned components, was undistinguished, although some examples have attractive fluted, baluster, bobbin-type or twisted components incorporated. Most of these chairs were covered with Turkey work – wool pile on a canvas backing, in imitation of Turkish carpets.

Often chairs were covered with leather, attached with brass-headed nails.[14] Many of these leather-covered chairs survive, and they are often depicted in portraits of the period – Arthur, Lord Capel and his wife, for example, are shown seated on two red leather, nail studded chairs in Cornelius Johnson's portrait of them with their attractive young children, dated c. 1639 in The National Portrait Gallery, London.

The ravaging of property and the imposition of severe restraint on luxury and ornament during the Civil War and Commonwealth period in the 1640s and 50s was disastrous for the creation, or survival of, upholstered furniture. Turned wood and leather might survive military depredation – upholstered furniture did not to any extent. When Dame Mary Verney revisited her Buckinghamshire home, Claydon, in 1661, after soldiers had been quartered there, she wrote that the house was

most lamentably furnished, all the linnen quite worne out . . . the spitts, and other odd thinges so extreamly eaten with Rust thatt they canot be evor of any use againe . . . the cloath of the Musk-coloured stools soyled, and the dining-room chairs in Ragges.[15]

DUTCH INFLUENCES

The political turmoil of the mid seventeenth century meant that some furniture after the Restoration was still being made in the style of earlier times – the chest of drawers at Montacute, with its similarities to the court cupboard (p. 83) of the previous century, is an example.

On the other hand, the journeyings of the Royalists who had fled abroad and returned to England after the Restoration heralded a new mood in the decorative arts in England.[16] They had observed, questioned and even commissioned craftsmen to produce furniture. They saw to it that when Charles II returned to England in 1660 Italian and Dutch ideas in particular were well received. Pepys wrote, at the end of May 1660, 'This day the month ends . . . and all the world in a merry mood because of the King's coming.' He had come a few days earlier, fresh from a final banquet at The Hague given by the States of Holland. In May 1661 the King married the Catholic Catherine of Braganza by proxy; she remained in Lisbon and did not come to England for the formal ceremony until a year later, but the marriage aroused an interest in what Portugal and its territories, such as Goa, could produce. The furniture makers soon had to create furniture to accommodate the Queen's predilection for drinking tea – tea tables, tea kettles, cups, to use with what the poet Edmund Waller in 1680 called the 'best of herbs'. It was a fashion which cabinet-makers did their best to encourage and to serve. The introduction of a new fashion or the revival of an old one was always good for trade.

The overwhelming influence on the King and his courtiers however came from Holland. Its successful East India Company had long imported lacquer cabinets, and English makers soon set these on elaborate gilt-wood stands.

One of the King's principal ministers was his long-time Scottish friend, John Maitland, 2nd Earl and later 1st Duke of Lauderdale (one of the members of the Cabal). He had been with the King in Holland, and had fought alongside him at the fateful Battle of Worcester, after which he had been imprisoned for nine years. In the year of the Restoration, 1660, he was appointed Secretary of State for Scotland, a vice-regal position he held almost to his death, twenty-two years later, in 1682. By his marriage to Elizabeth Murray, daughter of the 1st Earl of Dysart, he came into possession of Ham House, in Surrey, which had been built in 1610; his father-in-law had taken over the lease in 1637, and had made some alterations to the interior. During the 1670s he and his red-haired wife enlarged the house, adding new suites of rooms and furnishing them with a lavishness which transcended even what was fitting to their exalted

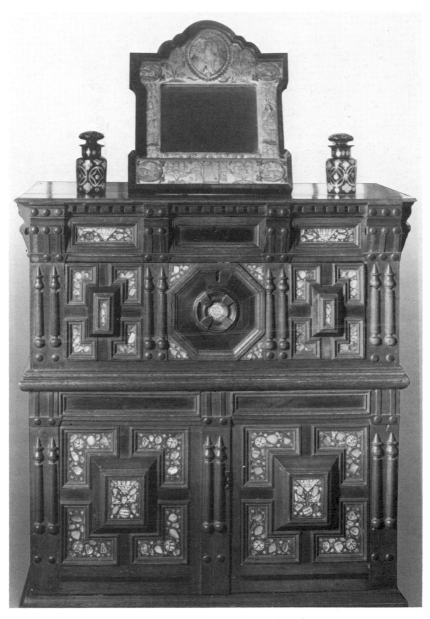

24. Chest of drawers, oak inlaid with bone and mother-of-pearl, dated 1662
(Montacute House, Somerset)

25. Bookcase, c. 1675, by Thomas Sympson
(Dyrham Park, Gloucestershire)

rank. It drew much criticism on to Lauderdale, who the Earl of Aboyne had rhymingly dubbed as 'the Hector of State, the rascal we hate'.

The contents of Ham House were listed in three inventories[17] in the 1670s, and much of the important furniture listed therein survives. The Duke, who derived great wealth from his Scottish estates and positions, was used to spending lavishly and having what he wanted. He employed many foreign craftsmen at Ham and at his Scottish houses. Dutch joiners and carvers provided wainscoting, window frames and furniture, and some items were bought in Holland.[18] There were cabinets from Antwerp, silver-mounted side tables, Japanese lacquer cabinets, cabinets veneered with ivory, cedar sideboards, armchairs with spiral-turned legs and cane seats and backs, kingwood writing boxes, ebony-framed mirrors and a strongbox with brass mounts. In the Duke's closet there were two 'sleeping chayres' covered, one with crimson velvet, the other with black and gold damask; there was also a Dutch form of 'scriptor', or writing-desk with a fall front, made in walnut and mounted with silver. It has been established that the spiral-turned legs of the stand were originally silvered to match the couch and chairs in the room.

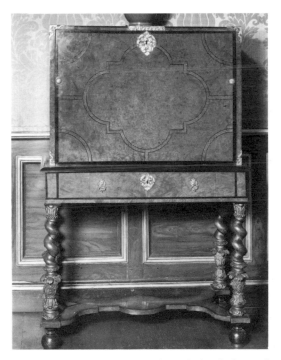

26. 'Scriptor' or writing-cabinet, c. 1675, walnut inlaid with ebony, silver mounts
(Ham House, Surrey)

THE BEST BED

The decoration and furnishings at Ham, dating from the late 1630s and from the 1670s, justified John Evelyn's observation that the house was 'furnished like a great Prince's'. One of the most important rooms at Ham in the Lauderdales' day was the Queen's Bedchamber. The inventories show that it had a magnificent 'winter' state bed with protective case curtains set on a dais against the wall facing the two doors. This bed was replaced in summer with one embellished with brass and ostrich feather plumes of two colours, said to have been made in Portugal. Both beds were replaced in 1679, and again in 1683, and the chairs were given new covers *en suite* with the new beds on both occasions.

From the Middle Ages onwards considerable attention was bestowed by patrons and furniture makers upon beds; 'the best bed' often features in wills or in inventories of house contents. Early in Queen Elizabeth's reign, beds with carved headboards in oak and walnut appear to have belonged only to the wealthy, but rising standards in domestic comfort brought them gradually within the means of the yeoman class. This type of bed, which is also common in the first half of the seventeenth century, had a panelled tester supported on bulbous posts, and the bedclothes were laid on wooden slats. The headboard was often inlaid with holly, box, poplar and sycamore, and carved to give an architectural effect; or it might be decorated with rich heraldic blazoning appropriate to its owner's status. These early beds were draped in a variety of ways, in rich fabrics such as figured velvet, embroidered linen or, in humbler examples, fustian or 'steyned' cloth.

In the seventeenth century these 'wainscot' beds, descendants of the medieval bedstead, began to give way to beds with a lighter framework, though still with elaborate hangings. The frame was usually of beech, and the tester, cornices and back were covered with the same material as the curtains. The four posts were tall and slender, and were often covered in taffeta.

About twenty-five grand state beds made between 1670 and 1700 survive in England, including some made by Huguenots who had fled from religious persecution on the Continent. William III's bed at Hampton Court is one of these; it is 17 feet (5.2 m) high and is topped with vase-shaped finials with ostrich plumes. It is closely rivalled in splendour by the bed made for the 1st Earl of Melville about 1697, now in the Victoria and Albert Museum.[19] This is some 14½ feet (4.5 m) high and is decked in crimson silk and Genoa velvet, lined with white Chinese silk damask and trimmed with crimson silk braid.

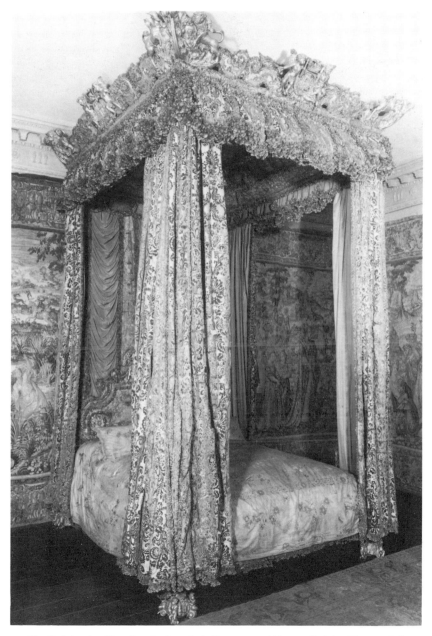

27. The bed in the Venetian Ambassador's Room, c. 1688; supplied by Thomas Roberts, upholstered by Jean Poitevin (?) in green and gold figured velvet (Knole Park, Kent)

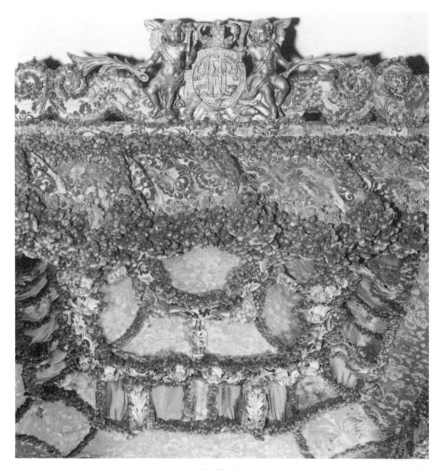

28. Detail of bed in Plate 27

There are other excellent late-seventeenth-century beds at Knole,[20] Bening-brough, Warwick, Belvoir, Lyme and Dyrham. The bed in the Venetian Ambassador's Room at Knole seems to have been provided by the English maker, Thomas Roberts, who worked in the royal palaces for some thirty years at the end of the seventeenth and beginning of the eighteenth centuries. A royal warrant, dated 28 August 1688, required Viscount Preston, Master of the Wardrobe to James II, to obtain from Roberts 'a bed of green and gold figured velvet with scarlet and white silk fringe', six stools and two armchairs for use at Whitehall Palace.[21] The bed is decorated with James II's insignia, but within

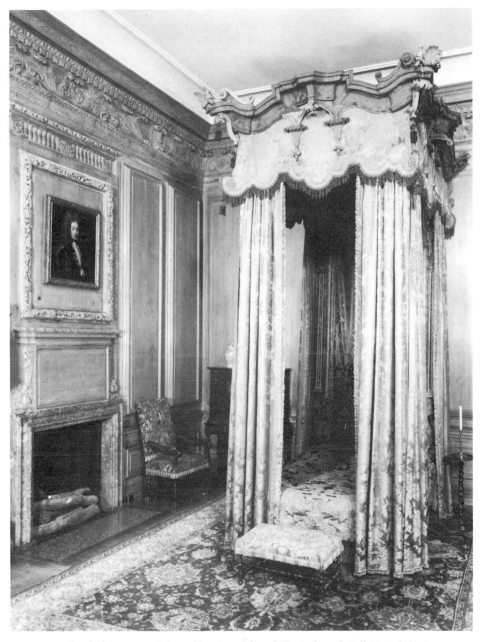

29. State bed, *c.* 1700, upholstered in crimson damask (Beningbrough Hall, N. Yorkshire)

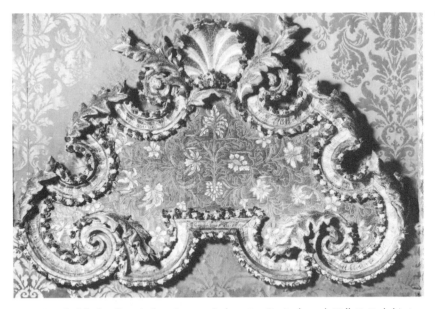

30. Detail of the headboard of another state bed, *c.* 1695 (Beningbrough Hall, N. Yorkshire)

a few months of its completion the King and Lord Preston had fled abroad; the bed finally came into Lord Dorset's possession, and so to Knole, as part of his 'perquisites' as Lord Chamberlain.

During the seventeenth century, the King's requirements for furnishings were supervised by the Master of the Wardrobe. In the surviving accounts (in the Public Record Office), a great deal of information about kinds of furniture and materials can be found. During the reign of Charles II the King's upholsterer was the French-born John Casbert. He provided curtains, canopies of state, beds, chairs, stools and screens in the 1660s, and was also entrusted with decoration of three royal yachts. In 1661, shortly after the Restoration, Casbert and a joiner, John Whitby, made chairs of state and stools in crimson damask with gold and silver fringes for use at Hampton Court. One of the chairs of state, now at Knole, as we have noted has the Hampton Court inventory mark stamped on it.

After 1672 Casbert was succeeded by Jean Poitevin, with the assistance from 1678 of 'His Maties Joyner to his Great Wardrobe, Richard Price of St Martin's Lane'. Price, who died in 1683, seems to have had a lucrative business, and to have specialized in supplying caned chairs with arm-rests. References to Dutch

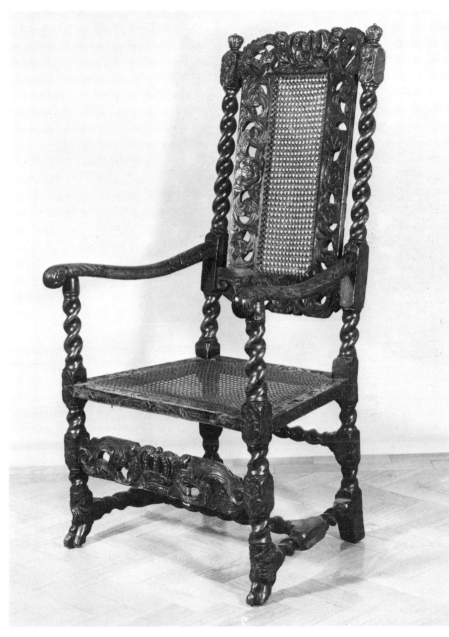

31. Armchair, *c.* 1680, of pegged construction; attributed to Richard Price
(Temple Newsam House, Leeds)

turning in his bills, and to other items as 'French', that is in the French taste,
show that he kept abreast of continental developments in furniture making.

In 1685, Louis XIV revoked the Edict of Nantes, by which, in 1598, Henri
IV had granted religious toleration to Protestants. Many Huguenot (French
Protestant) craftsmen, particularly silversmiths, tapestry and fabric weavers,
furniture makers and upholsterers fled to other countries, particularly England,
bringing with them continental ideas and influences. One of these, of seminal
importance to decoration and furnishing, was Daniel Marot the elder (1661–
1752). He had sought refuge in Holland the year before the Edict was revoked,
and entered the service of William of Orange, who became King of England
in 1689. His designs, of a highly decorative Baroque character, were soon
engraved and issued in parts; they had an even greater influence in England
after the publication of the collected edition of his works at The Hague in
1702. Styling himself 'architecte de Guillaume III, roy de la Grande Bretagne'
Marot made at least four visits to England in the 1690s, and worked for
William at Hampton Court and elsewhere at the head of the Anglo-French and
Anglo-Dutch furniture makers and embellishers.

Marot's engraving of a state bedchamber, plate 34 in his *Nouveaux Livre
d'Appartements* (1702) showed a type of 'lit à la duchesse' or state bed, which
was already popular in Holland and soon became fashionable in England.
Making the elaborately draped tester and flamboyant head- and footboards
were severe tests even for specialist craftsmen. Something of the abilities
needed can be seen in the enchanting fragments (Plate 3) surviving at Hardwick
Hall from the bed supplied by Francis Lapierre in 1697 to the 1st Duke of
Devonshire for use at Chatsworth. The flying, or 'angel', tester allowed front
posts to be dispensed with, and skilfully cut fabric set over carved wood shapes
on the headboard imitated Baroque flourishes hitherto unknown in England.
The decoration follows closely plate 29 in Marot's book and cost the Duke the
sum of £497, of which the crimson hangings alone cost £470. The bed was
paid for in instalments of £6 a week.[22]

The dour William Blathwayt ordered a state bed in about 1702 for his
Gloucestershire seat, Dyrham Park. By his industry Blathwayt had become a
Secretary of State to the King and, after his marriage to the Dyrham heiress in
1686, spent several years transforming and furnishing the house. He controlled
much of the work from Holland, for he was employed as a diplomat at
Amsterdam and The Hague. He was an ardent supporter of Dutch ideas and
was fluent in the language.

The Dyrham state bed is covered with yellow and crimson velvet and has an
interior of sprigged satin. Marot had indicated in his book that costly hangings

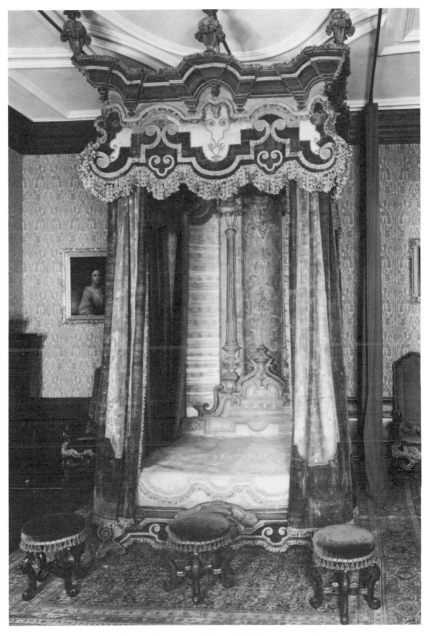

32. State bed, c. 1704 (Dyrham Park, Gloucestershire)

should be protected from sunlight and dust by a case curtain (*tour de lit*). The 1710 inventory of the Dyrham contents describes the original case curtains as in a light woollen fabric called 'red cheney', and the present ones approximate to that. Plate 33 shows the elaborate 'architectural' nature of the decoration.

33. Detail of the tester of the bed in Plate 32

CHINESE INFLUENCE ON ENGLISH FURNITURE

In the early seventeenth century, the cargoes of the East India Company often included lacquer artefacts, particularly screens (which could be packed flat) and small boxes and cabinets.[23] The East India trade had a considerable effect on English social life, for people drank imported tea, wore silk dresses and waistcoats, and enriched their homes with 'Indian'[24] wallpaper and printed linens, both of Chinese origin. Imported lacquer cabinets, chests and screens were fashionable, and furniture was specially made to incorporate lacquer panels of Chinese or English manufacture.

While the majority of the surviving cabinets are lacquered black, others have coloured grounds of blue, olive-green, red, chestnut and (rarely) ivory. In some the raised decoration is defective – a point noted in 1688 by John Stalker in his treatise on japanning (see p. 40), written to instruct English practitioners in the art. The fine cabinet of about 1690 (illustrated overleaf) shows English japanning at its best. The rectangular cabinet is mounted on a richly carved and gilt pine stand; the cresting above the cabinet is ornamented with a central basket of flowers above a *lambrequin* motif, pairs of birds amid scrolling foliage and corner finials. The cabinet itself is japanned inside and out with partly raised chinoiserie scenes in gilt on a black ground, with silvered, red and brown details. Its double doors enclose ten drawers, which are stained red inside. The stretchers probably once supported a pair of small circular platforms for vases.

The taste for things from the East was also evident in textiles. The Chinese coverlets and hangings for the state bed at Erddig may have been a gift to the owner from his near neighbour, Elihu Yale, who had worked for twenty years for the East India Company (and later founded the college which was to become Yale University). They were provided by 'Mr Hunt', presumably the upholsterer Philip Hunt who had his premises in St Paul's Churchyard, as did John Belchier, a London cabinet-maker who supplied a considerable amount of gesso furniture for Erddig.[25]

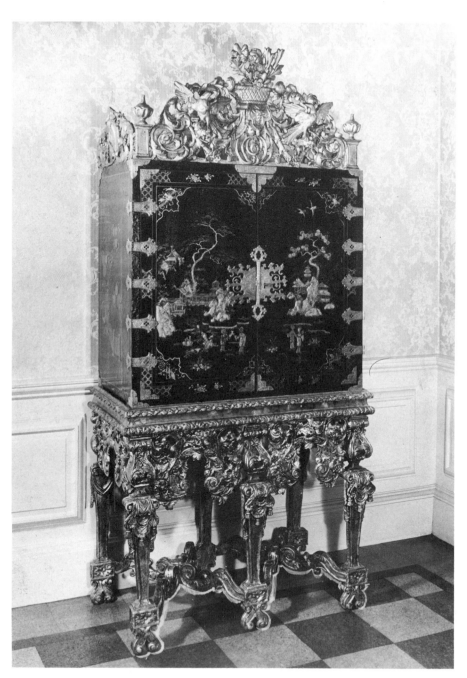

34. Cabinet japanned inside and out with partly raised chinoiserie scenes, *c.* 1690
(Temple Newsam House, Leeds)

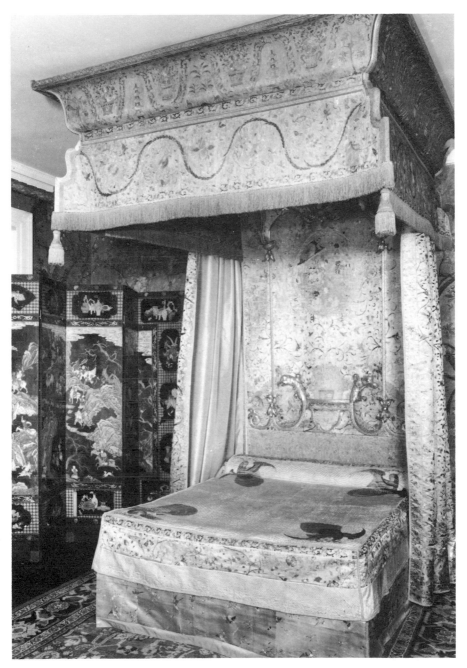

35. State bed assumed to be by John Belchier, with upholstery by Philip Hunt, 1720
(Erddig, Clwyd)

ROYAL PREFERMENT

The activities of Gerreit (or Gerrit) Jensen, specialist cabinet-maker to the royal household, extended from the reign of Charles II to the end of that of Queen Anne (c. 1680–1715). Of Dutch origin, Jensen was one of the craftsmen working for the King at Hampton Court, and for the 1st Duke of Devonshire, for the fitting and decoration of Chatsworth. At Chatsworth he provided glass for the windows of the south and east fronts, the silvered mirror-glass for the dining-room and some doors, wainscot-framing, and carving in some of the state rooms.[26] Celia Fiennes, who visited Chatsworth in 1696, noted in the State Dining-Room a 'Large Door, all of looking-glass'; Jensen's bill for it records that he provided '8 glasses, 4 of them 40 inches and 4, 29 inches' with mouldings and ornaments, for the considerable sum of £105.

Jensen's name is, however, more usually associated with furniture decorated with marquetry or japan, and sometimes metal inlay; he was an accomplished craftsman, and had almost a monopoly in the Boulle technique. A small but significant group of furniture at Windsor, Hampton Court, Kensington Palace, Boughton, Drayton and Deene is credited to him. The seaweed marquetry card-table at Clandon Park is typical of his work in the 1690s. It is decorated in

36. Card-table with seaweed marquetry in the style of Gerreit Jensen,
c. 1690 (Clandon Park, Surrey)

elaborate arabesque marquetry, and the front four legs pivot in pairs to support the top when it is being used.

In Queen Anne's reign the furniture supplied by Jensen became less elaborate and was competing with japanned or gilded furniture. At his death in 1715, his position as royal cabinet-maker was taken over by Peter and Elizabeth Gumley and their son John, and in due course they were joined by James Moore, who was adept at incising and gilding gesso-covered furniture.

The Gumleys' active years spanned the late 1680s to the late 1720s; they dealt in japan cabinets, tables, stands, chests of drawers and writing-tables as any cabinet-maker might, but specialized in looking-glasses. (The monopoly in glass had ended with the death of the 2nd Duke of Buckingham in 1687.) Gumley had his London shop in the Strand at the corner of Norfolk Street and enjoyed the confidence of many supporters, notably Richard Steele, who wrote favourably of his wares in *The Spectator* and *The Lover*. Conversely Alexander Pope makes a waspish comment on John Gumley's daughter, Anna Maria – to whom Lord Hervey denied 'any one good and agreeable quality but beauty' – in his poem of 1717, *The Looking Glass*:

> Could the sire, renowned in glass, produce
> One faithful mirror for his daughter's use!

At Jensen's death the names of Gumley and Moore, often separately, start to appear in the Lord Chamberlain's records. John Gumley had inherited his father's business about 1694, and became a freeman of the Glass Sellers' Company in 1704. A mirror at Chatsworth has the inscription 'John Gumley, 1703' scratched on it – one of a pair for which he was paid £200 in that year.

37. Gilt slip from a mirror, *c.* 1715, supplied by John Gumley
(Hampton Court Palace, Middlesex);
reproduced by gracious permission of Her Majesty the Queen

More significantly, a mirror at Hampton Court has 'Gumley' carved on a gilt slip intersecting the glass panels of one pilaster.

Moore became renowned for 'carved and gilt work' – incised or raised work in gilt gesso. His name is incised on a candle-stand in the royal collections and a table at Clandon Park is attributed to him. His candle-stands have similarities to those of John Pelletier (also in the royal collection – Pelletier supplied furniture and mirrors to William III) and to the work of Aberell and Eichler in Augsburg.

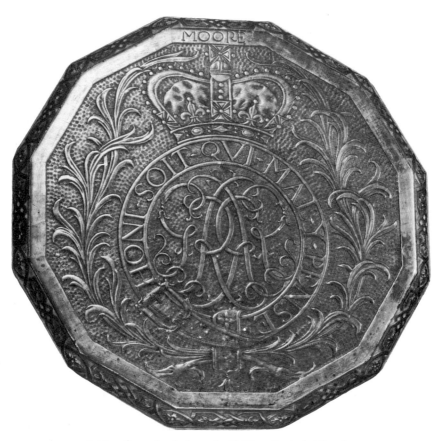

38. Top of carved and gilt stand with 'Moore' incised at the edge
(Hampton Court Palace, Middlesex);
reproduced by gracious permission of Her Majesty the Queen

When giving evidence against Henry Joynes, the Comptroller of the Works at Blenheim Palace – Sarah, Duchess of Marlborough who called Moore her 'oracle', had gone to law against many of the Blenheim craftsmen in 1724–5 – Moore stated his age to be fifty-four. We can assume, therefore, that he was born about 1670, and that he started working with the Gumleys about 1690. He was active in royal commissions with John Gumley from 1714 or 1715.

In 1720 he was working for the 3rd Earl of Burlington, then decorating Burlington House in Piccadilly, and his apprentice Benjamin Goodison received

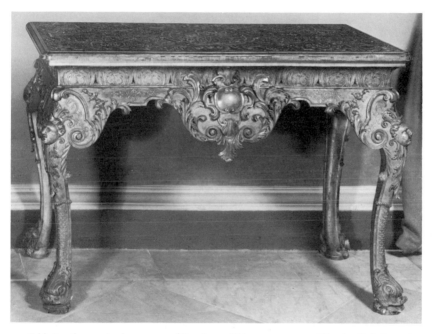

39. Table in gilt gesso in the manner of Gumley and Moore, c. 1715–20 (Clandon Park, Surrey)

money on his behalf. Goodison succeeded Moore in royal preferment soon after his master's death in October 1726 after being wounded on the head when out walking.

Goodison had called Moore 'my master' in 1720, and as he did not die until 1767, we may assume he was born a little after 1700 and had set up on his own by 1727. He became one of the most accomplished makers of the mid eighteenth century, blending, with consummate skill, a lavish use of heavily

carved and gilded mahogany with rich fabrics and upholstery. The royal accounts, although long and involved, are the best clue to the range of work Goodison was able to provide.[27] Here is part of an account he rendered in 1737, when he was much involved with work for Frederick Prince of Wales, in conjunction with the Prince's architect, William Kent (1685–1748):

Item: to *Benjamin Goodison*, Cabinet-maker; for two Chimney Glasses in Wallnuttree Frames, two Pair of wrought brass Arm and One hanging Glass in a Walnuttree Frame, Eight Dressing glasses in Walnuttree Frame, two smaller ditto, Fifteen Side Glass Lanterns in Walnuttree Frames with fifteen brass Candlesticks and Shades to twelve of them. One Fire Screen in a Walnuttree Frame cover'd with India paper, two Screens with four leaves Each in ditto Frames and Cover'd Ditto. Two mohogany Tea Kettle stands, A New Glass to a Walnuttree side Lantern, one very large Mohogony Chest of Drawers, One ditto and One other ditto, one round Mohogony Table on a pillar and Claw Foot, Two Mohogony Oval Dining Tables, Ten Mohogony Shelves for Book Cases, A Mohogany Stand on a pillar, and Claw Foot . . .

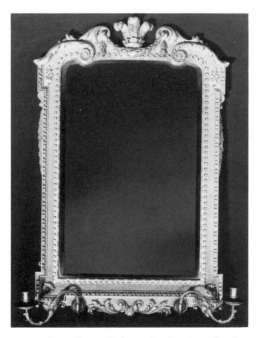

40. Looking-glass made for Frederick, Prince of Wales,
by Benjamin Goodison, 1732–3 (Hampton Court Palace, Middlesex);
reproduced by gracious permission of Her Majesty the Queen

In 1739 he was asked to provide a 'square Mohogony flap Table six feet long and three feet and an half wide to lay the Prince of Wales's Robes on at the Parliament House' as well as 'a looking Glass in a black frame for the Dublin Yacht'. He was required (in 1740) to carry out new gilding of

a large Peer Glass Frame and repairing the Carved Work of ditto, new Gilding the Frame of another Glass, repairing the carved work, silvering and fitting the Glass and gilding the Pilasters to Ditto the whole heighth of the Room

– work he was presumably well versed in from the days of his apprenticeship to Moore. Royal commissions also included a 'Mohogony Stan'd & Perches for a Parrot' (1741) and a 'Mohogony Library Table with Drawers on one side and Cupboards on ye other ye top covered with black Leather & Casters to ye bottom – £16 10s.' (1750).

Private commissions came at a steady pace, but had to take second place to Goodison's very considerable royal commissions. An early private commission was at Longford Castle, Wiltshire for the 1st and 2nd Viscounts Folkestone.

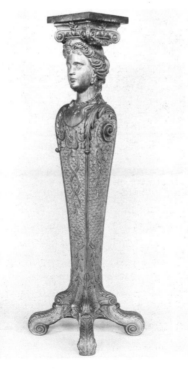

41. Gilt term by Benjamin Goodison, 1732–3 (Hampton Court Palace, Middlesex); reproduced by gracious permission of Her Majesty the Queen

His name first appears in the Longford accounts in 1737, but these record names and payments only, without giving details. In 1740 Goodison received £413 and the six subsequent payments, 1741–50 totalled £1,024 19s. 6d. These large amounts – by contrast to the £95 odd paid by the Folkestone

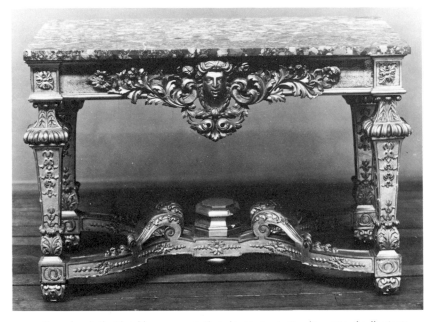

42. Carved and gilt side table, c. 1730, attributed to Benjamin Goodison (Royal collection); reproduced by gracious permission of Her Majesty the Queen

family to another leading craftsman, William Hallett – justify attribution of the main suite of furniture to Goodison. His 1740s work is often characterized by the large Greek fret, lion masks with handles and shells on the knees of cabriole legs. Some of the furniture in the royal collections can also be attributed to him. He made mahogany commodes and a library writing-table for Sir Thomas Robinson of Rokeby, Yorkshire, about 1740. Sir Thomas was Master of the Great Wardrobe, and was therefore responsible for paying Goodison what was due to him on the royal account; it seems natural enough that Robinson should commission Goodison to make furniture for him, for he already knew the high standard of the cabinet-maker's work.

Two other important private patrons whose confidence Goodison enjoyed were Sarah, Duchess of Marlborough, who employed him at many of her houses, including her London residence in Dover Street, and her son-in-law,

Charles, 3rd Earl of Sunderland, at Althorp, Northamptonshire. When Sarah's
granddaughter, Isabel, Duchess of Manchester, was left a childless widow in
1739 (she later married Edward, Earl Beaulieu), Sarah purchased the Dover
Street house, with Goodison's assistance, and gave it to her, completely

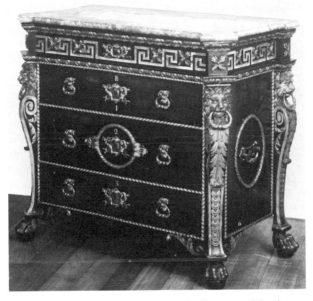

43 and 44. Commode, c. 1740 (Royal collection), and detail;
reproduced by gracious permission of Her Majesty the Queen

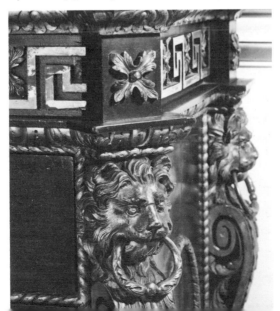

furnished. Goodison provided walnut elbow chairs at 18s. 6d. each, chimney-pieces, pier glasses, marble-top tables with walnut frames and, through the upholsterer Sherard Paxton, 275 yards of green damask and enough white damask for a bed.[28]

Another service cabinet-makers frequently provided was the drawing-up of inventories, and it has been argued, convincingly enough, that Charles Spencer, 5th Earl of Sunderland (and 3rd Duke of Marlborough) would not have asked Goodison to do this for him – in 1746 – unless he had recently been obtaining furniture from him.[29] Two white-painted tables in the entrance hall at Althorp, and possibly the stand for the terracotta bust of Van Dyck by Rysbrack (1743) may therefore be by Goodison.

The various fire insurance policies Goodison took out with the Hand in Hand Company, between 1741 and 1743, and the three apprentices he is known to have had (including his nephew, Benjamin Parran) are an indication of his success. He was also putting money into property. He seems, judging by phrases in his will, to have been an unusually pious man. He was not above taking small commissions – £22 worth of furniture to Lady Monson, for example, in 1751 – and he attended to many minor and major tasks at Holkham for the Earls of Leicester over several years.[30] In particular, a mahogany table press with wire doors for which Goodison charged £14 16s. od. in 1757 and '2 card tables for ye Gallery' with 'white Frett workt round the tops and frames and ye feet ornamented with carveing and gilding' relate to items still in the house.[31] The table press has applied foliated ovals that are usually regarded as a distinctive feature of furniture made by William Vile but they may have been supplied by the talented carver, Sefferin Alken, working for both Goodison and Vile on a subcontract basis.

Many cabinet-makers included undertaking among their services. Goodison was required to help with the funeral arrangements of Frederick, Prince of Wales, when he died in the late evening of Wednesday, 20 March 1751. The death chamber and the Henry VII Chapel in Westminster Abbey were set out with black hangings provided by the upholsterer William Reason and with eighty black sconces by Goodison, who also helped to embalm the body and lay the Prince in the lavish coffin provided by the joiner Henry Williams. The royal craftsmen who had served him faithfully in life – Goodison had been employed by the Prince of Wales at Kew and elsewhere from 1735 – were required to perform this one last service after his death.

IN FINEST FABRICS

There was a close relationship between upholstery and fashions in dress, particularly in the 1720s when skirts were voluminous and the Huguenot silk-weavers in Canterbury and at Spitalfields in London, were creating attractive patterns to rival those obtained from Genoa.[32] Sir Josiah Child, the son of a London weaver, became chairman of the East India Company; writing in the fourth edition of his *New Discourse of Trade* (1693) he noted 40,000 families as 'living by silk'.

In the 1670s, the walls of the Queen's Closet at Ham House, the Duke of Lauderdale's home, were lined with silk and two armchairs in the room were covered in it.[33] Silk was probably used by many other rich patrons at this time. The furnishings of the impressive state bedroom at Powis Castle – crimson

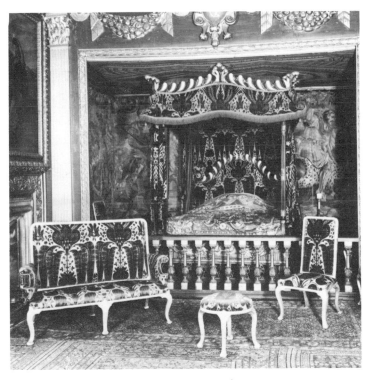

45. State bedroom (Powis Castle, Powys)

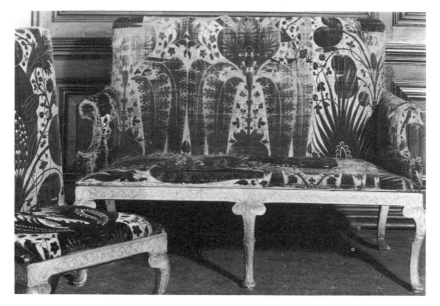

46 and 47. Settee and chair, silver gesso frame, *c.* 1723 (Erddig, Clwyd)

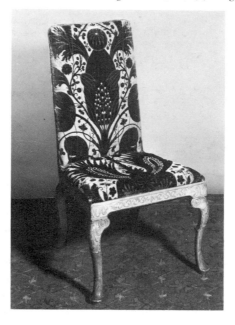

cut-velvet upholstery and hangings made at Spitalfields – were probably commissioned by one of William III's Dutch followers, William Henry van Nassau van Zuylesteyn, the 1st Earl of Rochford, who lived at the castle after 1696.

It is assumed that the upholsterer and furniture maker who worked at Powis also worked at Erddig, since identically patterned Spitalfields silk was used on the settees at both places and the houses are only a few miles apart. If this assumption is correct, the Powis furniture may be attributed to a liaison between John Belchier and Philip Hunt.

The setting of embroidered or woven fabrics on appropriate frames was well understood in the late years of the seventeenth century and in the time of Queen Anne. A fine settee at Montacute with parcel-gilt walnut legs and arms, *en suite* with eight chairs, is covered in tapestry which illustrates 'Adonis departing from Venus', from Ovid's *Metamorphoses* – a favourite source for designers of tapestry.[34] The same Mortlake factory made the tapestry used on the two-seater settee at Clandon. There was an equal demand for embroidered panels to cover backs, arms and drop-in-cushions on armchairs. With their short walnut cabriole legs, such chairs were sturdy and comfortable, and their

48. Settee, *c.* 1715–20 (Montacute House, Somerset)

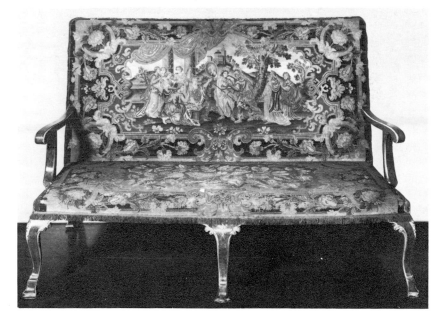

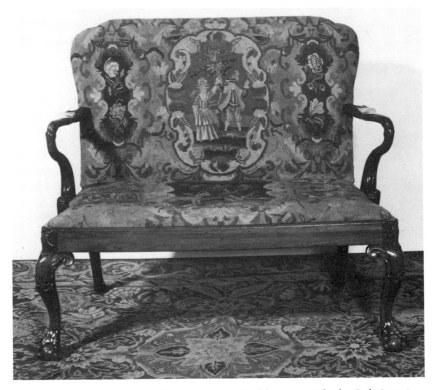

49. Settee, *c.* 1710, covered with contemporary Mortlake tapestry (Clandon Park, Surrey)

capacious wings helped protect the occupant against the whistling draughts of roomy, incommodious houses.

In 1685 the Great Wardrobe, supplying the court and royal palaces, had moved from Hatton Garden to Great Queen Street, Soho. It became the supposed source of most of the English tapestry weaving of any importance in the eighteenth century. Many of the Soho chinoiserie tapestries bear the signature of its manager, John Vanderbank (d. 1727), and there is much tapestry furniture in the 1750s signed by George Smith Bradshaw and his partner, Paul Saunders, who was chief arras-maker to the Royal Wardrobe, *c.* 1758–71.

Perhaps the most elaborate of the upholstered walnut settees were those bearing tapestries made by Joshua Morris of Soho. Morris specialized in 'arabesques' but obviously dealt in other subjects too. It was reported many

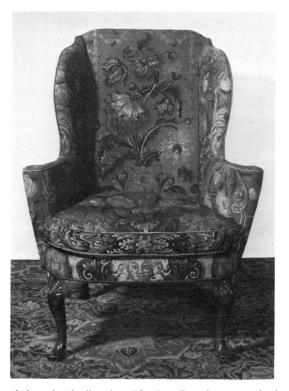

50. Armchair upholstered with silk and wool floral needlework, c. 1710 (Clandon Park, Surrey)

years after his death that he had commissioned William Hogarth to design a tapestry depicting the element 'Earth', based on the Gobelins tapestries of Le Brun but, disliking the result, he became engaged in a law suit in which Vanderbank gave evidence on behalf of Hogarth. The *Daily Journal* of 22 November 1726 advertised a sale of tapestries by 'Mr Joshua Morris, Tapestry-Maker, at his House in Frith Street, near Soho-Square' – some of which may well have been acquired by furniture makers; there are important tapestries by him in many collections, including Hagley Hall and Grimsthorpe Castle.

Tapestry and needlework are surprisingly durable, and it is often difficult to decide whether a particular piece is original to the chair.[35]

Tapestry is used on the top of a small walnut table in the Gubbay collection at Clandon Park; such lined tables are rare and they were not suitable for everyday use, although the table top provided a good surface for displaying the

needlework. Some of these panels may have been worked by ladies as a pastime, most were woven at English or foreign tapestry workshops – John Ogilby's *Virgil* (1658) was a popular source-book; sometimes panels of needlework were worked into new floral surrounds so as to fit chairs already in a patron's possession.

The most elaborate eighteenth-century needlework suite must be the twenty chairs, four settees and a day bed made in 1746 for Henry, 7th Viscount Irwin by James Pascall. These formed part of a larger suite, comprising, in addition, a pair of console tables, a pair of side tables and eight *torchères* (candle-stands). The set survives, almost complete, in the house for which it was made (Temple Newsam House, Leeds), and it has been established that the wool needlework covering, in tent-stitch (petit point) on canvas, was worked in England.[36] Sir Edward Gascoigne, a near-neighbour of Lord Irwin's, wrote in March 1745, from Cambrai in France, telling him that seat covers there were obtainable at half the London price, and advising him to send out a painted pattern to be worked; nevertheless, English coverings were chosen.

WILLIAM KENT

William Kent (1685–1748) spent ten years in Italy and returned to England in 1719 with Lord Burlington, who became his patron and friend. He became an influential architect and designer. He undoubtedly had connections with the royal cabinet-maker, Benjamin Goodison, and a number of other cabinet-makers who also worked in a heavy Palladian style.[37] It may never be possible to establish the precise nature of these links, but the influence which Kent and his noble patrons exerted on English decoration was considerable. All were eager to promote the ideas of form and decoration which they had seen on their Italian travels. In particular there was a revival of interest in the buildings of the sixteenth-century Italian architect, Andrea Palladio – whose importance Inigo Jones had recognized early in the seventeenth century. Kent also studied the baroque furniture made in Italy by Foggini and others.

There are a few pieces of eighteenth-century English furniture associated with Kent, but we have no details of their manufacture. Some have heavy scrolled legs and shell motifs, and may have been made by Matthias Lock – a table attributed to his workshop and possibly designed by Kent is illustrated overleaf. More Kentian furniture is attributed to John Vardy and Henry Flitcroft, who were primarily architects and decorators, and we must also reckon with Kent's involvement with Benjamin Goodison and William and

51. William Kent, by Bartholomew Dandridge, c. 1730 (National Portrait Gallery, London)

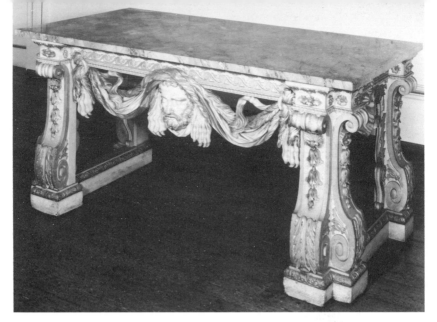

52. Pine side table, painted white with gilt details, *c.* 1740, attributed to Matthias Lock (Temple Newsam House, Leeds)

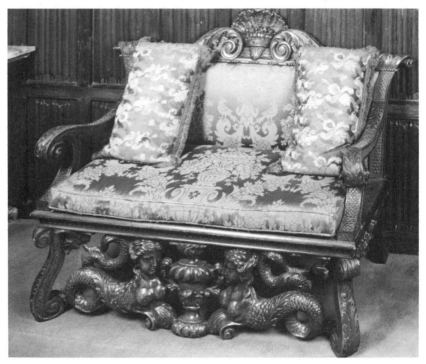

53. Settee, *c.* 1730, possibly designed by Henry Flitcroft; it may have been made by Benjamin Goodison (Anglesey Abbey, Cambridgeshire)

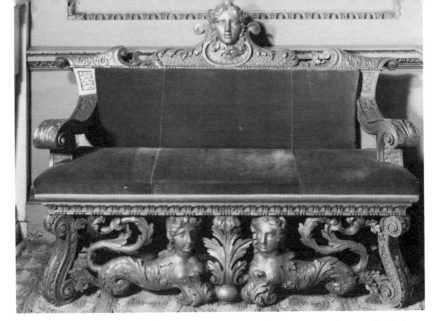

54. Gilded settee, c. 1740, in the Kentian style (Rievaulx Terrace Temple, N. Yorkshire)

John Linnell. Kent's drawing for one of Linnell's tables survives (at Alscot). The Victoria and Albert Museum has another of his drawings, dating from November 1731, for a splendid table. The table itself, by an unknown maker, is at Houghton, Sir Robert Walpole's Norfolk house, where Kent was involved with the decoration and furnishing.

In 1728 Sir John Dutton asked Kent to supervise the repair and partial refurnishing of his Gloucestershire house and his lodge at Sherborne. The accounts show payments to Kent for this, and, in November 1731, £30 to Moore for '2 Mahogany Settees for ye Dining Room at ye Lodge'.[38]

In 1744, John Vardy issued *Some Designs of Mr Inigo Jones and Mr Wm. Kent*. We know that the settee depicted in plate 42 of that book (see Plates 7 and 55) is one of a pair (at Temple Newsam House, Leeds) which were made to Kent's design by James Moore the younger. The Moore firm – James the elder died in 1726, his son in 1734 – had, under Kent's direction, provided furniture at Kensington Palace for their joint patron, Frederick, Prince of Wales. The heavy scrolled and shell-strewn furniture, with its unmistakable Kentian associations, dates from the mid 1730s; it may have been produced by the Moore family, by the talented Matthias Lock or even by the Carver to the Crown, James Richards. Richards's virtuosity in carving may be discerned on the royal barge Kent designed in 1731 for Frederick, Prince of Wales; much other carved work can be credited to him.[39]

A number of architects, including Robert Adam, saw Kentian-style decoration as a classical forerunner of what they were trying to do.

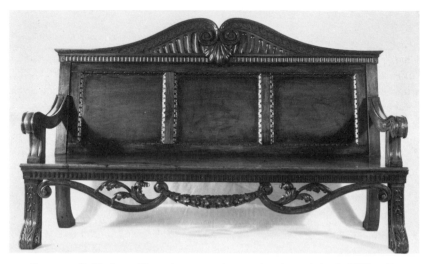

55. Settee supplied by James Moore the younger in 1731; based on a design by William Kent –
see Plate 7 (Temple Newsam House, Leeds)

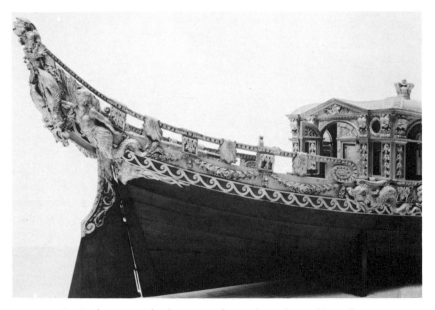

56. Carving by James Richards, 1731, on the state barge designed by William Kent
(National Maritime Museum, London)

JAMES STUART

The furniture supplied to the instructions of the talented but dilatory architect, James 'Athenian' Stuart, is heavy in style and shows an obsession with classical ornament. He liked to adapt Roman objects, such as the tripod, for household use. He was the co-author, with N. Revett, of *The Antiquities of Athens* (1762 and 1769) which helped to bring about the revival of interest in Greek architecture, and may have had some influence on Robert Adam. The Linnells (p. 153) worked under him at Kedleston for a short time before he was ousted in favour of Adam.

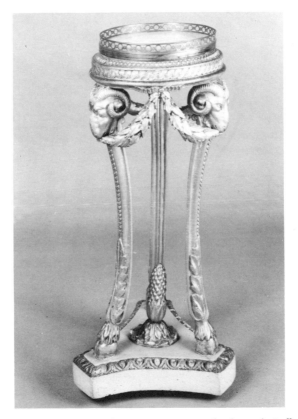

57. Tripod designed by James 'Athenian' Stuart, *c.* 1775 (Shugborough, Staffordshire)

THOMAS CHIPPENDALE THE ELDER – ROBERT ADAM

Chippendale may possibly have met William Kent in 1747, when he received a small payment from Kent's friend and patron Lord Burlington, but Kent died in 1748, before Chippendale was in any way well known.

Interest in the work of both Kent and Chippendale has survived because of its range, quality and influence, but much has been credited to Chippendale, in particular, which is unworthy of him. Gilbert's definitive study of Chippendale gives all the archival documentation and assesses carefully the furniture made by Chippendale and his large workforce.[40]

Thomas Chippendale was born in 1718 at Otley, Yorkshire, and after training under his father and the York joiner, Richard Wood, left the north in the early 1740s for the wider opportunities of London. We know little of Chippendale's early years, apart from a small commission – the first recorded – from Lord Burlington (1747), and his marriage, a year later, on 19 May 1748, to Catherine Redshaw. By 1753 the young man had prospered enough to take premises in St Martin's Lane, and a year later, in 1754, to publish his important pattern book, *The Gentleman and Cabinet-Makers' Director*. By this time he and his wife had two sons and two daughters, and five more children were born within the next seven years. The eldest son, Thomas the Younger, lived until 1822, forty-three years after his father's death, and he too became an accomplished cabinet-maker.

The success of the *Director* encouraged Chippendale to move, in August 1754, into larger premises in St Martin's Lane, which he called 'The Cabinet and Upholstery Warehouse', adopting a chair for his sign. Fire ravaged two of Chippendale's workshops on a windy Saturday night, 5 April 1755. It destroyed twenty-two chests of journeymen's tools – an indication of the strength of his workforce. However, the damage was less than feared and the insurance money from the Sun Office provided an opportunity to rebuild and enlarge the premises.

Chippendale's ability as a designer and maker, coupled with the competence of his workforce, enabled the business to expand further. From the mid 1760s he was producing his finest Neo-classical furniture, and, in the early 1770s, superb marquetry pieces made for Harewood House and elsewhere. Five years after his first wife's death, he remarried, in 1777, and had three more children, a total of twelve. He died of consumption, on 13 November 1779, without making a will, but survived by his second wife and at least four of his children.

The praise which came to Chippendale in his lifetime continued well into

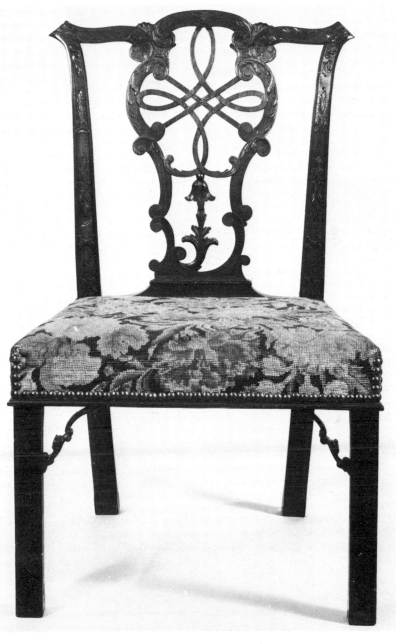

58. Chippendale-style chair (Dunster Castle, Somerset)

the nineteenth century. The cabinet-makers Ince and Mayhew, who published their own patterns in 1762, called him 'a very ingenious Artificer'. Thomas Sheraton alluded, in 1793, to 'Chippendale's extensive and masterly work', and George Smith in 1828 pronounced him 'the most famous Upholsterer and Cabinet-maker of his day'. What elements in Chippendale's work led to this high esteem? His pattern book was undoubtedly one important factor in his development.

A Book of Designs

When Chippendale issued the *Director* in 1754, with its fulsome dedication to the Earl (later the 1st Duke) of Northumberland, he took a commanding lead with new designs for almost every kind of furniture – even on the Continent there was nothing as comprehensive in a single folio volume. On the title-page it was announced that the book contained a 'large collection of the most Elegant and Useful Designs of Household Furniture in the Gothic, Chinese and Modern Tastes'.

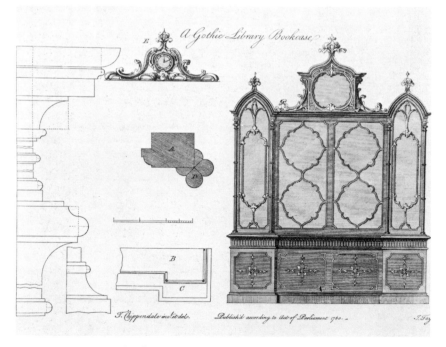

59. Plate from Chippendale's *Director*, third edition, 1762

English craftsmen who were engaged in the furniture trade made up about two thirds of the 308 subscribers, and most of them lived in London. Chippendale's old master, Richard Wood, ordered eight copies; twenty-eight noblemen also subscribed.

The *Director* contained many designs that were frivolously Rococo, and sixty-four plates were devoted to Chinese-type furniture. (The magazine *The World* had commented in 1753 on the fashion for lattice-work, domed beds with dragon finials, pagoda shapes, mandarins and tinkling bells – 'extravagancies that daily appear under the name of Chinese'. Contemporary engravings

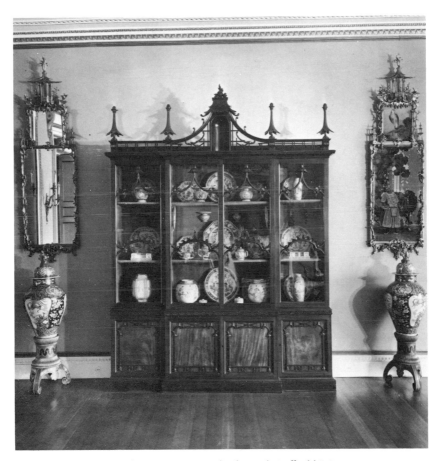

60. Chinoiserie, *c.* 1755 (Shugborough, Staffordshire)

tried to suggest that the most extravagant forms of Rococo could be fashioned into serviceable furniture.) Chippendale included all these exotic forms in his repertoire, but by the late 1760s he had changed to the Neo-classical style in order to be able to supply furniture to the patrons of the architects, and rivals, Robert Adam and Sir William Chambers.

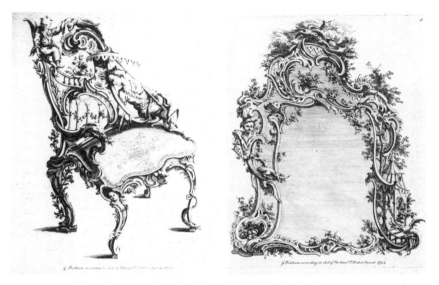

61 and 62. Two engravings from Pierre Babel's *A New Book of Ornaments*, 1752

Robert Adam

The Scottish-born architect Robert Adam (1728–92) who had trained in Italy in 1754–8, was concerned at his return to change everything to Neo-classical form. He regarded furniture as integral to his room schemes and was among the first to design pier glasses and pier tables, sideboard units, pedestals and carpets to harmonize with their setting. As presiding architect at a commission he often assumed responsibility for placing the order, overseeing the work and settling the bill. Alternatively the Adam drawing was handed over to the patron who then arranged independently for it to be carried out by a craftsman of his own choice. There is some evidence of commercial contact between Adam and Thomas Chippendale, and they both worked for the same patrons on at least a dozen occasions. When an owner did not require Adam to supply furniture designs the architect frequently recommended that Chippendale be engaged.

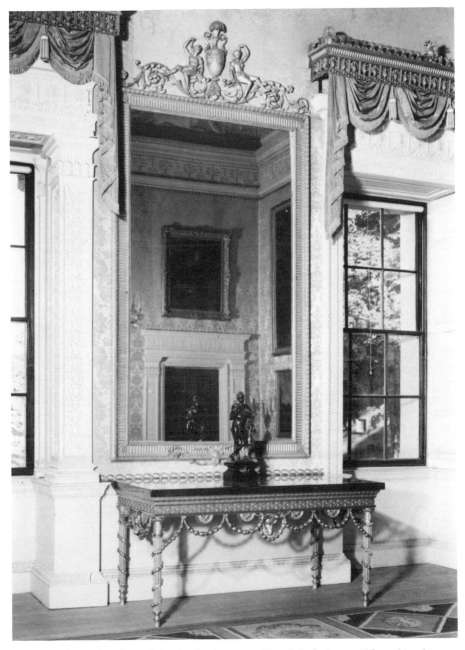

63. Robert Adam designed the pier glass in 1769 and Joseph Perfetti was paid for making the
table frame, presumably to Adam's design, in 1771 (Saltram House, Devon)

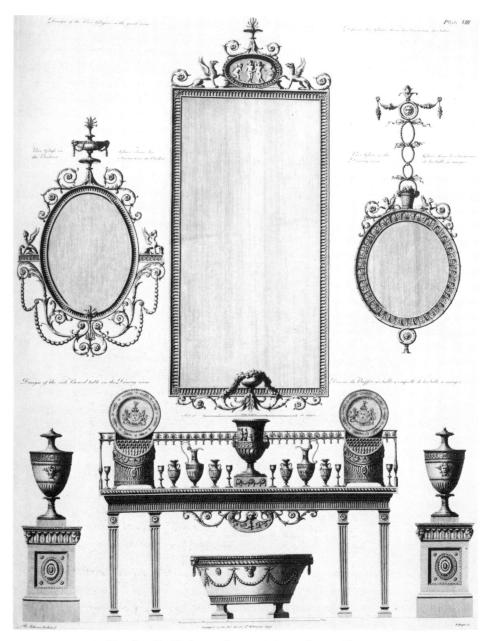

64. Plate from *The Works in Architecture*, Robert and James Adam, 1773

The development of 'Adam furniture' falls into three phases – the early style, 1762–4, when the architect was developing what he had learned of classical motifs in Italy, the transitional style, 1765–8, and the mature style, 1769–77.[41] This last was also promoted by the appearance of *The Works in Architecture* of Robert and James Adam (1773), with its many plates showing furniture and room settings in rich, linear pattern, proportioned and precise. Colour, Etruscan ornament, the lavish use of gilding and painted'surfaces, and the incorporation of Wedgwood plaques and marquetry roundels gave to 'Adam furniture' a distinction rarely equalled, and inspired cabinet-makers to rise above competence to near-virtuosity. Much of the best Adam-style furniture was made by Thomas Chippendale.

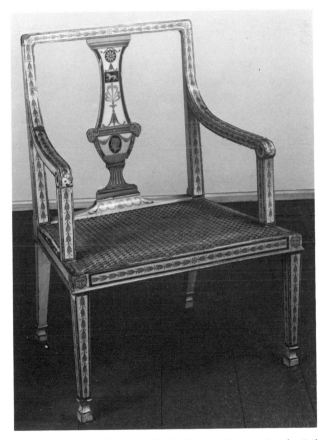

65. Armchair designed by Robert Adam for the Etruscan Room at Osterley Park *c.* 1776
(Osterley Park, Middlesex)

Chippendale – the Successful Years

Both Adam and Sir William Chambers had studied in Italy and had returned to England in the late 1750s intent on introducing a new repertory based on classical precedent, and on outdoing each other in its realization. Chippendale, however, had no first-hand knowledge of foreign collections and had to make do with a later visit to France and with looking at engravings.[42] The introduction of Neo-classical designs into the third edition of the *Director* (1762) is therefore the more remarkable. He was able, over the next few years and into the 1770s, to recast the sprightly curves and flourishes of Rococo shown in the first edition into the classical mode of the third. Chippendale worked for Adam's patrons in many of the houses designed by the architect; some, for example Newby, Nostell and Harewood in his native Yorkshire, contain furniture by him. It is of unrivalled excellence, with large-scale ornament, some inlaid into rich surfaces and flanked by elaborate gilded ormolu mounts.

Chippendale's output of furniture in the 1770s included some splendid pieces of marquetry furniture. The pier tables commissioned for various rooms at Harewood House, Yorkshire, together with the sumptuous 'Diana and Minerva' commode there, *c.* 1773, may indicate that he employed a specialist marquetry worker. London could provide the most accomplished craftsmen, who subcontracted their time and skills to established makers. The evidence for Chippendale's use of specialists is too sparse to permit firm conclusions, but with or without them, he produced some of the finest examples of English marquetry furniture. Let us examine three well-known items made by Chippendale in some detail, as a guide to varied aspects of his patronage and business. They are the library table and one of the library chairs made for Nostell Priory, Yorkshire (1767–8), and part of the upholstered suite made for Saltram House, Devon, about 1771–2.

The library table was made for Sir Rowland Winn of Nostell Priory, who succeeded at his father's death in 1765 and immediately engaged Robert Adam to work at his Yorkshire and London houses. Chippendale was probably introduced to Sir Rowland by Adam and formed part of the team of decorators from 1766. The commission spanned the next twenty years and gives, through the survival of both documentation and furniture, a valuable indication of working practices.

The mahogany library table was completed during the first year of work at the house, 1766. It has massive corner trusses in the form of lion-masks and

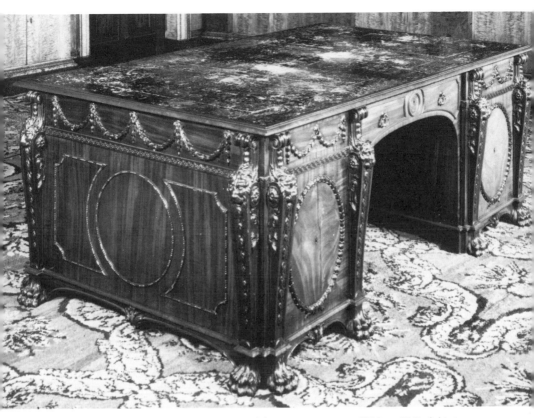

66. Library table invoiced by Thomas Chippendale, 30 June 1767 (Nostell Priory, W. Yorkshire)

incorporates two pedestal cupboards, one enclosing drawers and the other vertical divisions for folio books. It has Chippendale's usual S-shaped keyholes and the top was finished in black leather, which was normally protected by a baize cover. Chippendale's account for 30 June 1767[43] records the item:

> To a large mahogany library table of very fine wood with doors on each side of the bottom part & drawers within on one side and partitions on the other, with terms of ditto carvd & ornamented with Lions heads & paws with carvd ovals in the pannels of the doors & the top covered with black leather, & the whole compleatly finishd in the most elegant taste. £72 10.

Chippendale had explained to his patron in a letter of 27 December 1766 that he preferred to send the table (and other items) by land carriage from

London. The damp air on board ship (a cheaper form of transport) would affect 'the drawers and locks of good work which is made very close these are some of the best work that can be done'. We can only assume that Sir Rowland allowed the greater expense of using the regular London–Leeds carrier, for the table was to be the most expensive item Chippendale supplied for Nostell Priory throughout the many years involved in its decoration.

Also for Sir Rowland's library, Chippendale made six chairs, the seats of which were originally covered in green haircloth. The account for 22 January 1768 described them:

> To 6 Mahogany Chairs with arms for the library the carving exceeding rich in the antique taste the seats coverd with green hair Cloth £36.

The chair has a heavy lyre splat back and, with its rich display of 'antique taste' – circular and oval paterae and indented shells on the ends of the top rail – indicates the direction in which he was moving in the late 1760s. He needed to be always at the forefront of fashion, but these particular chairs show some hesitancy in moving towards the Neo-classical style and away from the bowed arms and fronded splats of the rococo. Eight beech-framed hall chairs made for Nostell in about 1775 (originally japanned, but since 1821 in grained finish) were equally fine.

In 1768, while Chippendale was busy at Nostell Priory, Robert Adam was asked by John Parker, 1st Lord Boringdon to remodel his Devon house at Saltram. Chippendale's name appears in John Parker's cash account book, but only for a portion of what he must have actually supplied. It is possible to attribute to Chippendale the salon suite of eighteen gilt armchairs and two sofas, made about 1770–71 when Adam was completing the first phase of his alterations.

Recent research on Chippendale's upholstery trade has established that there are a number of small constructional details, which, although no guarantee of Chippendale's involvement, do occur on many pieces of furniture known to be by him.[44] These are S-pattern key-holes, V-shaped cuts and slots under the seat rails to assist in holding the cramps used when glueing, and screw holes beneath the seat rails of high-quality chairs. These chairs, when packed, were suspended by screws – hence the holes – from cross-battens to keep the chair frames clear of the crate. The suite at Saltram has these cramp slots under the seat rails and matches stylistically two suites at Harewood House, in the use of a pierced foliate apron and a scrolled motif beneath the arm supports. Small design variations of this sort ensured a keen demand, persuading a patron he had acquired something individual.

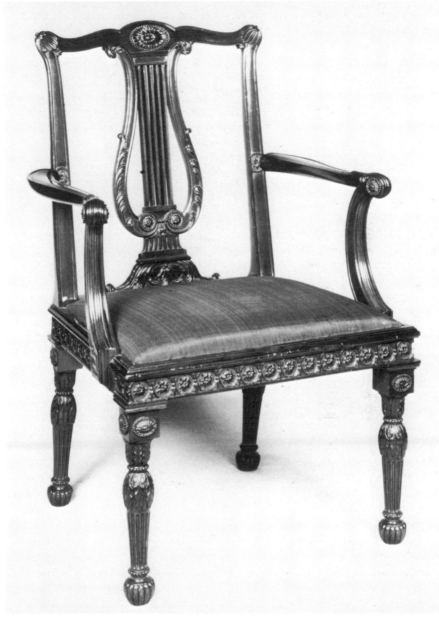

67. Library chair by Thomas Chippendale, 1768 (Nostell Priory, W. Yorkshire)

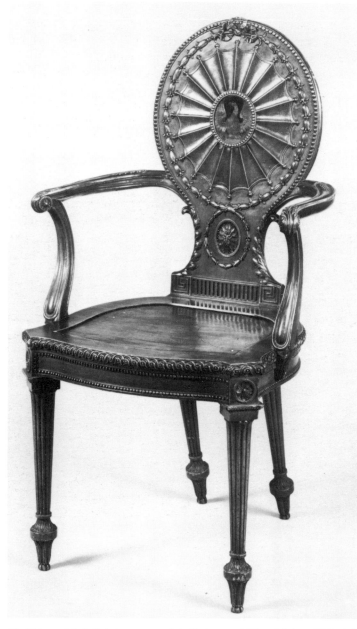

68. Chippendale hall chair, *c.* 1775, originally japanned (Nostell Priory, W. Yorkshire)

Despite Chippendale's eminence he seems to have worked for the royal family on only one occasion. He explained the delay in supplying furniture to Sir Rowland Winn in 1768 as being due to work 'mostly for the Royal Family' – and the revised *Director* was dedicated to Prince William Henry, 1st Duke of Gloucester. Two sofas and eight armchairs (and five single chairs of a different pattern) in the royal collection are indisputably from Chippendale's workshop. They have the usual system of cramp slots and show stylistic resemblances to the seat furniture made by Chippendale in the early 1770s for the 1st Viscount Melbourne for Brocket Hall, Hertfordshire.

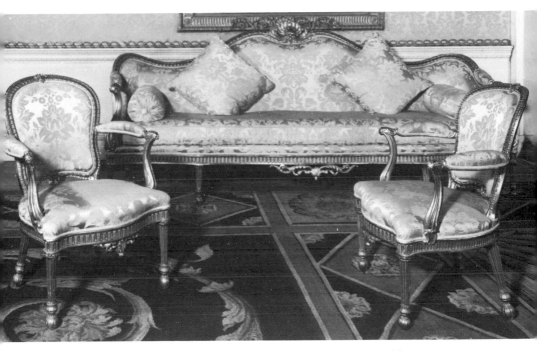

69. Settee and two chairs, 1770–71, attributed to Thomas Chippendale;
modern damask upholstery (Saltram House, Devon)

HALLETT, VILE AND COBB

If royal preferment on any scale eluded Chippendale, it came, but late, to his successful rivals, the partners William Vile and John Cobb. They had not bought the *Director*, so as to avoid any charge that they had copied (as many of lesser status did) its attractive designs. They had enough ability in any case to survive by their own merits.

Their senior partner, William Hallet the elder, was born in July 1707, probably in Somerset and had associations by marriage (1756) with Letitia Hallett of the wealthy Hallett family of Dunmow, which included the London goldsmith Sir James Hallett. He is known to have been a London cabinet-maker from the mid 1730s, having established himself in Great Newport Street, Long Acre, by Christmas 1732.[45] In 1745, he was able to buy the site of Canons, the 1st Duke of Chandos's great house at Whitchurch, Middlesex, and to build himself 'a house on the centre vaults of the old one'.[46]

At this time William Vile was either apprenticed to, or, more likely, was a journeyman with, Hallett – he called him 'my master' in 1748.[47] (Vile's allegiance to Hallett as late as 1748 is the main reason why work formerly attributed to him – in the royal collections, at Chatsworth and elsewhere – must, more firmly, be regarded as the work of the older Benjamin Goodison, who had set up on his own by 1727, and preceded Vile in the royal favour.) John Cobb had been apprenticed as an upholsterer to Tim Money of Norwich in 1729, implying a birth date about 1715. The names of William Vile and John Cobb first appear together in the records in 1751, and they had four premises by 1752.[48] On 5 June 1752, Hallett left Newport Street and, according to the rate books, took a house in St Martin's Lane, next to the newly established 'Wm Vile & Co'. By June 1755, Cobb had taken over Hallett's premises, probably because there was no room for an extensive upholstery shop in the partners' St Martin's Lane premises. A Sun Insurance policy records him in 1755 as having his 'Dwelling House . . . over a Gateway leading into the yard of Messrs Vile & Co in St Martin's Lane'.[49]

It seems that Hallett, after a successful career in the 1730s and 1740s, when he had an association with the wallpaper craftsman, Thomas Bromwich, came into money, acquired Canons and, content with being a landowner with a large estate, then became something of a sleeping partner in his furniture business, rather than an active executant. He therefore set up his former employee William Vile to carry on the 'Hallett style', with upholstery as an added skill when they took John Cobb as a third 'partner'. When William Hallett junior

married 'Miss Hopkins of Britons in Essex' on 15 December 1753 she brought as dowry 'a Fortune of upwards of £30,000' left by her father, a successful speculator in South Sea stock. Was any of it used in the Hallett–Vile–Cobb business?

There is firm evidence for Hallett's continuing financial support to Vile and Cobb in the London bank accounts of all three, at Drummonds Bank. There is an interdependence, with regular payments to Hallett from his two partners from about 1757. As these payments were at the rate of £150 to £300 monthly in 1757–8, and regular payments totalling £500 in 1760, £2,350 in 1761 and £1,000 in 1763, the payments to Hallett were probably a 'share percentage' of the takings for his backing. As the 1761 and 1763 payments are higher they may reflect Vile's success in making a number of important pieces of furniture in these years for Queen Charlotte. Finally the connection was not severed at death. Hallett acted as an executor to both Vile (d. 1767) and the very successful Cobb (d. 1778); he (or possibly the upholsterer, William Hallot) was recorded as bankrupt in April 1769; he died on 17 December 1781.

Samuel Norman (fl. 1732–82), William Hallett's nephew, was a very successful carver and gilder until he suddenly failed and went bankrupt in April 1768. Hallett seems to have shown little interest in him.

The speculation which surrounds the personal details of Hallett, Vile and Cobb's lives extends to some of the furniture credited to them. It may be too dogmatic to regard Vile solely as the 'cabinet-maker', and Cobb as the 'upholsterer'. The term 'upholsterer' was used very loosely, and we know that Cobb made fine marquetry furniture, though possibly only after Vile's death in 1767. The partnership's invoices – for example, those to Anthony Chute of The Vyne, Hampshire, or the 6th Earl of Coventry at Croome Court, Worcestershire[50] – are headed

To Messrs Vile & Cobb
Cabb[et] Makers, Upholders &c The Corner of Long Acre

and their content suggests that both could cross barriers in skill and aptitude even if they did oversee different parts of their workshops.

The embellishment of Vile's furniture in the late 1750s and early 1760s was probably entrusted to John Bradburn (d. 1781) who, from 1758, had a carving shop in Hemmings Yard, off St Martin's Lane. He and his later partner, William France (d. 1774) both worked for Vile and Cobb, but neither had been apprenticed to them. Bradburn and France succeeded their erstwhile employers, Vile and Cobb, in the royal service in April 1764.

Examples of oval beads on furniture attributed to Vile in the early 1750s

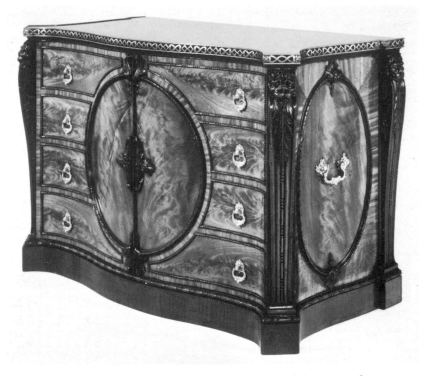

70. Commode, *c.* 1750, attributed to William Hallett (Toledo Museum of Art)

cannot be Bradburn's, but his carving on the case of a four-sided clock, now at Buckingham Palace,[51] is similar to that on the top sections of the King's coin cabinet which Vile invoiced in October 1761.

There is a need for caution in regarding applied foliated ovals as a guarantee of Vile's authorship – attribution by such a slender thread is a hazardous business – although he does make mention of such embellishments in some of his royal accounts. The mahogany table-press made by Benjamin Goodison for the Earl of Leicester at Holkham in 1757[52] also has applied ovals on each side, indicating, perhaps, that John Bradburn, or another freelance carver such as Sefferin Alken (whose abilities were well known to Vile), was supplying them to several makers.

Vile seems to have made some furniture with elaborate pierced frets;[53] here again the attribution rests on comparison, this time with the fret top to the bureau-secretaire (Plate 72) he made for Queen Charlotte in 1761.

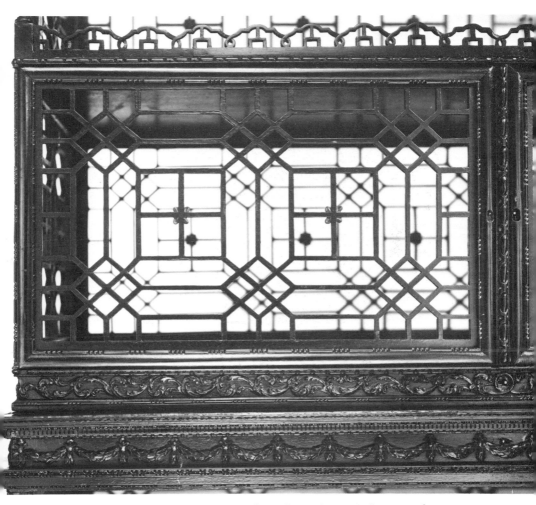

71. Detail of bureau-cabinet, *c.* 1760, attributed to William Vile (Terry collection, Fairfax House, York)

Vile and Cobb's royal service began late in their careers, in 1761, when they were probably both in their late fifties or early sixties. Their Warrant of Appointment to the Great Wardrobe was dated 5 January 1761, when the Master, Earl Gower, sent it to the Lord Chamberlain, the Duke of Devonshire. Significantly it described them only as 'Upholsters [*sic*] in Ordinary to His Majesty's Great Wardrobe', but the payments to Vile record fine pieces of

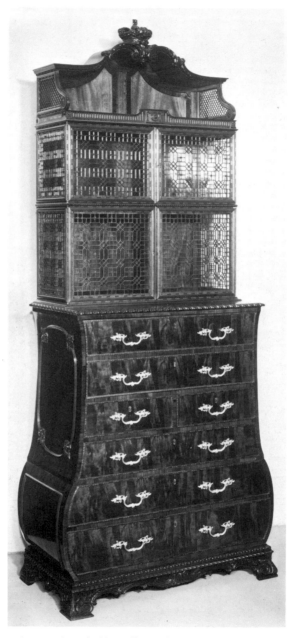

72. 'Secretary' supplied by William Vile in 1762 (Royal collection);
reproduced by gracious permission of Her Majesty the Queen

mahogany furniture, and some survives. It has often been described and illustrated.[54] In 1761 he supplied the King's coin cabinet, a bureau-secretaire with pierced fret top and *bombé* base for Queen Charlotte, her fine jewel cabinet and a pair of mahogany cabinets for the King's library. In 1762 he supplied the Queen with the large break-front bookcase of architectural form with four Corinthian pilasters, a broken pediment and, on the stepped base, distinctive ovals simulating laurel wreaths. The King also ordered a pair of writing tables. The following year, 1763, Vile refashioned an organ case of about 1735, probably by Benjamin Goodison, to form a cabinet. Again thick oval wreaths were applied to the base cupboard doors. The Queen was further provided in 1763 with a mahogany work-table described in the accounts as having:

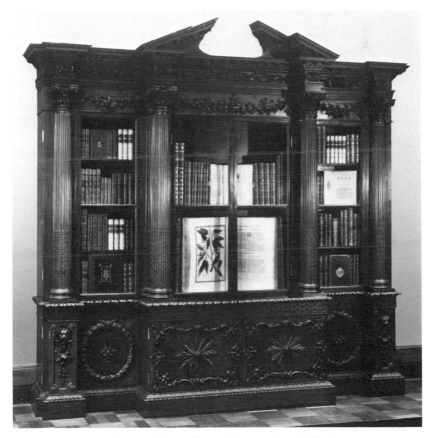

73. Bookcase made by William Vile in 1762 (Royal collection);
reproduced by gracious permission of Her Majesty the Queen

74. Detail of Plate 73;
reproduced by gracious permission of Her Majesty the Queen

. . . shape Legs neatly Carved and a Scrole on the foot and a Leaf on the knee, a Carved finishing to the rail, one half of the top divided into 12 compartments, the other half open and the top made to fold over behind, supported with two Sides made to draw out of the Rails, the whole on good Casters and a neat Link Plate Lock made to the Queen's Key £9 15s.[55]

(The compartments referred to in the accounts have been subsequently removed.)

The King and Queen had been crowned on 22 September 1761, and the carved crown on the bureau-secretaire (Plate 72) may have been a last-minute addition which did not form part of the original design, although the accounts record its provision. For the jewel cabinet, Vile, who normally used mahogany, combined, as the accounts declared, 'many different kinds of fine wood on a mahogany frame richly carved'. The cabinet has veneers of padouk, amboyna, tulip and rosewood. The fact that it cost £138 10s., together with £71 for the bureau-secretaire and £107 14s. for the large break-front bookcase, goes a little way towards explaining the £3,738 in Vile's bank account in 1762, and his ability to pay £1,000 to Hallett on 7 March 1763.

WILLIAM AND JOHN LINNELL

When Vile retired in 1765, the post of royal cabinet-maker went to his former assistants, Bradburn and France. Cobb had a late flowering as a maker of, in particular, fine commodes,[56] and died in 1778.

There were many other able contenders for a patron's interest and purse, in particular, William and John Linnell, William Ince and John Mayhew, and the French *ébéniste* resident in London, Pierre Langlois.[57]

William Linnell served his apprenticeship as a joiner but specialized in carving. Becoming a freeman of the Joiners' Company in 1729, he set up his own general furniture workshop and married; his eldest son John was born in 1729. By the time of his death in 1763 he had formed a successful business with some forty to fifty employees for John to inherit. John had assisted his father from the early 1750s at such important commissions as the carving at James Gibbs's Radcliffe Camera at Oxford, and he was also well known to influential clients such as the banker Richard Hoare, William Drake of Shardeloes, the Duke of Bedford and Lord Scarsdale of Kedleston. John headed the firm, based in Berkeley Square, until his own death in 1796, and became noted not only as a talented designer but as a competent businessman.

Many of John Linnell's designs and workshop drawings survive (they are now in the Victoria and Albert Museum) and a good idea of the scope of the firm's activities can be gauged from the 1763 inventory taken at William's death. They produced the usual ranges of mahogany furniture in William's lifetime, and were also employed in the making of architectural mouldings and carvings, and, as upholsterers, in supplying textile wall-hangings and curtains.

In the early 1750s John Linnell secured one of their most important commissions, to provide the 4th Duke of Beaufort with a japanned bed, eight armchairs, two pairs of standing shelves and a commode *en suite* for the Chinese bedroom at Badminton House, Gloucestershire.[58] The quality of this suite, now dispersed (the bed is in the Victoria and Albert Museum) once led historians to assume it was made by Thomas Chippendale, who did on occasion make superb lacquer furniture (as at Nostell Priory).

Most of the Linnells' upholstery was done in their own workshop, but seat furniture was often re-stuffed and re-covered at the patron's house. Such renewals are a continuing process – the mahogany armchair which the firm made for Sir Richard Hoare in 1753, one of a set of ten, *en suite* with a sofa (now at Montacute House), has modern upholstery and new brass nails. The legs, stretchers and arms are crisply carved with a skill which lifted the Linnells'

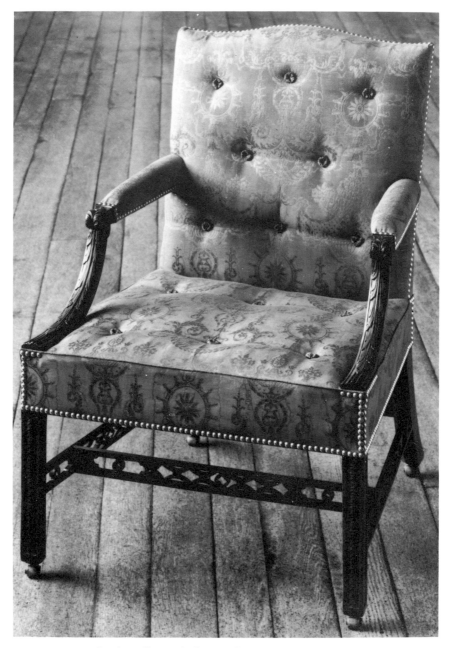

75. Armchair by William and John Linnell, 1753 (Montacute House, Somerset)

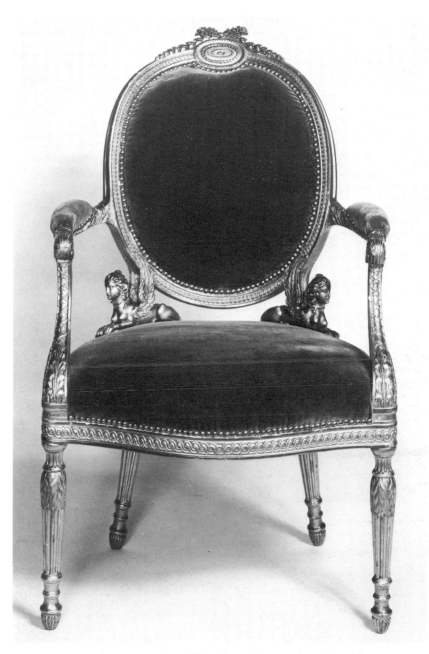

76. Armchair, c. 1777, designed by Robert Adam (Osterley Park, Middlesex)

work into a category above that realized by many of their contemporaries. That they were successful may be attested by the fact that the names of over one thousand clients of the firm have been listed.

The Linnell firm also produced furniture with marquetry decoration, which had been revived in England by Pierre Langlois in the early 1760s. They made a pair of marquetry card tables for Kedleston in 1765, but their more ambitious pieces of furniture were created after 1767 when they were joined by the Swedish cabinet-maker, Christopher Fuhrlohg, and perhaps, for a short time, by his brother-in-law, George Haupt.[59] The firm was now well thought of by Robert Adam, and their work in Neo-classical style for a number of his patrons includes some of their finest pieces.

One of the joint Adam–Linnell commissions was the work they did for the Child family at Osterley Park, Middlesex.[60] The pedestal desk they made for Robert Child's Library, 1768–9, was veneered with rosewood and satinwood, and had mounts and marquetry work which suggest the work of Fuhrlohg and Haupt. The quality of the marquetry roundels and mounts can be seen in the illustrations of a pair of commodes by Linnell, made in 1773–4. The

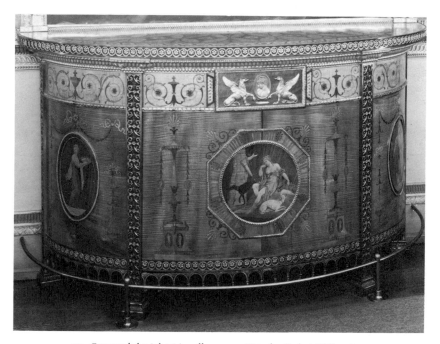

77. Commode by John Linnell, 1773–4 (Osterley Park, Middlesex)

roundels are framed by inlaid strips of green-stained wood, and set on the commodes which are veneered with harewood, satinwood, rosewood and other woods. Diana and her hounds (Plate 77) recline in nonchalant ease, and Venus entreats Cupid (Plate 78) to undertake some unwilling mission. The commodes have no opening doors and are purely ornamental. The ormolu tablet of a portrait medallion flanked by griffins (Plate 79), set into the top frieze of the commode, is repeated in the frieze over each of the doors in the drawing-room. Only French *ébénistes* and a handful of London makers could compete with the quality of the marquetry attained by the Linnell firm.

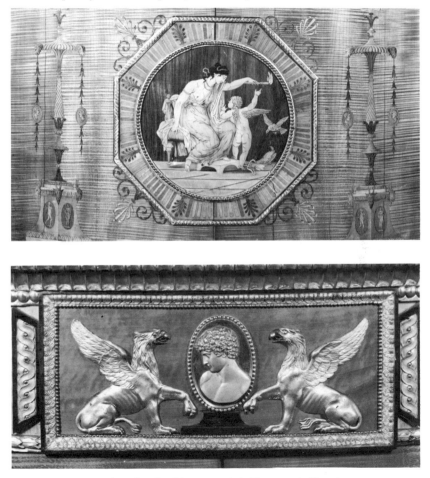

78 and 79. Details of the commode in Plate 77 and of its pair

INCE AND MAYHEW

Two competitors to John Linnell and Chippendale were William Ince and John Mayhew, who had set up a considerable business by the late 1760s. In 1759, with most of the money coming from Mayhew, they set up business together as 'Mayhew and Ince' at the upper end of Broad Street, Soho, near Carnaby Market. Ince was the designer – he had learned his trade as a cabinet-maker with John West – while Mayhew acted as manager, and dealt with the upholstery side of their activities; he had been apprenticed to William Bradshaw of Soho Square, an important maker and upholder.[61]

Once Ince and Mayhew had established the outline of a business, they decided, in 1759, to issue designs 'in weekly Numbers'. They imitated Chippendale's *Director* both in the intended number of plates (160) and in the use of Matthias Darly as engraver. Unfortunately they underestimated the amount of work required, and they had to compete with the build-up by Chippendale of his third editon of the *Director*; the venture foundered in the autumn of 1760, after the late appearance of Part 21. The astute Robert Sayer, one of the most successful eighteenth-century print-sellers, not averse to plagiarism when it suited him, then issued about ninety of the engravings in a large folio titled *Universal System of Household Furniture*. It was dedicated to George Spencer, 4th Duke of Marlborough, for whom the firm were later to work at Blenheim Palace, under the supervision of Sir William Chambers, Joint Architect to King George III.[62] Rococo, with Gothic and Chinese overtones, formed the main style of the designs. Some were unashamedly copied from the 1754 edition of the *Director*, and explanatory notes were printed in both English and French.

The firm's label on a mahogany china cabinet, now in the Museum of Decorative Arts, Copenhagen, proclaims that they had 'an Assortment of French furniture consigned from Paris'. The partners' output was considerable and of very high quality. Income in the years 1768–70 totalled £52,000, but their outgoings were a heavy burden and led eventually to discord and dispute. Lady Shelburne, engaged in 1768 in furnishing Shelburne (later Lansdowne) House, recorded in her unpublished diary that she had visited Mayhew and Ince's 'where there is some beautiful cabinet work'. She ordered 'two pretty glass cases for one of the rooms in my apartments, and which, though they are only deal, and to be painted white, he charges £50 for'. The high charges were a characteristic of the firm. The rate for being apprenticed to them was also the

highest of any comparable London business, £157 10s. in 1766, by contrast
to £50 at William France's. Notwithstanding their charges they enjoyed the
considerable patronage of the 6th Earl of Coventry in the late 1760s. Some
twenty bills survive recording their comprehensive services at Croome Court,[63]
and the Earl's town house, 29 Piccadilly. These included papering walls, laying
carpets and the ever-necessary disinfecting and stuffing of mattresses.[64]

The bills document the supply of some outstanding pieces of furniture – a
pair of satinwood and holly commodes, two settees and six armchairs *en suite*
for which two sets of dust-covers (and 'stockings' to protect the legs in transit)
were provided. The settees and chairs were covered with petit point Gobelins
tapestry in two shades of pink-red (*rose du barri*) which had been ordered,
together with a Boucher–Neilson set of wall tapestries depicting the Four
Elements, on Lord Coventry's visit to Paris in the summer of 1763. The
weaving of it took several years, for it was not until 1771 that Ince and Mayhew
charged for:

> Three Men's time at Croome putting up the Tapestry. Making Paper Case hangings
> for ditto, Stuffing and Covering 2 Settees and 6 Chairs, fixing Gilt Border and Sundry
> other Jobbs and Going and Coming.

Some idea of the complexity of the task may be gained from the fact that they
used 12,000 tacks and 2,000 'Clout Nails'.

The provision of tapestry-covered furniture to complement suites of
Gobelins wall tapestries was a feature of a number of commissions in the
1770s: tapestry-covered furniture supplied to William Weddell survives at
Newby Hall, Yorkshire; Richard Child's suite is at Osterley, Middlesex; Sir
Lawrence Dundas's suite is divided between the family seat, Aske Hall,
Yorkshire, Temple Newsam House, Leeds, and the Philadelphia Museum of
Art; Sir Henry Bridgeman's is at Weston Hall, Staffordshire. The background
colours varied, but the Croome and Osterley sets were worked in the same rich
rose du barri.

The range of furniture provided by a successful firm might be very extensive.
Chippendale's patrons were encouraged to 'order either a standard, refined, or
de luxe version', with subtle changes to each design. Ince and Mayhew provided
parlour chairs or 'deal benches covered with green baize' (in 1778, for the
Duchess of Beaufort), and, at the other extreme, a cabinet (probably to Robert
Adam's design) to display eleven marble intarsia panels created at Florence in
1709.[65] Commissioned by the Duchess of Manchester in 1775, the cabinet
(now in the Victoria and Albert Museum) is in mahogany, veneered with

satinwood and rosewood, and decked with ormolu mounts provided by
Matthew Boulton. The quality of work is outstanding, with classical sources
providing ideas for the decoration of the capitals and friezes.

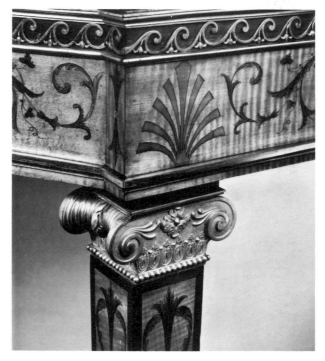

80. Veneered panels on a cabinet made by Ince and Mayhew, 1775,
with ormolu mounts by Matthew Boulton; probably designed by Robert Adam
(Victoria and Albert Museum, London)

PIERRE LANGLOIS

Ince and Mayhew's firm appears in London directories from 1759 until 1811.
By contrast, Pierre Langlois, the French *ébéniste*, who was born in Paris about
1738 and settled in London in the late 1750s, is known to us only by furniture
completed within a very short period of time.[66]

Not much is known about Langlois's origins, but when he set up business
in Tottenham Court Road at the 'sign of commode tables' he issued a
flamboyant trade-card with English and French texts stating that he made: 'all

81. Trade card of Pierre Langlois

Sorts of Fine Cabinets and Commodes made & inlaid in the Politest manner with Brass & Tortoiseshell . . .' His first known commission was for the 4th Duke of Bedford (1759), which suggests that by this time his reputation was established in London.

Commodes (which in this connection means a piece of furniture with drawers and shelves – a chest of drawers or clothes-press) were Langlois's speciality. He created them in bold *bombé* form, with doors or drawers, and

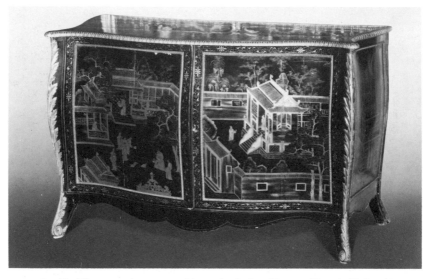

82. English commode, *c.* 1770, with panels of oriental lacquer (Uppark, W. Sussex)

decorated with coloured marquetry inlays of flowers and musical instruments set against light-coloured herringbone-pattern backgrounds. It was a type of commode made popular in France by Jean-François Oeben and Jean-Pierre Latz. The tops were inlaid with brass or marquetry laid on deal carcases. The deal was often in chamfered panels at the back, and painted black to hide its cheapness. The corner ormolu mounts, wreathing down the curved legs and terminating in a scroll foot and volute were presumably imported from France – some examples have a crown 'C' mark, showing that tax has been paid – or were cast from French examples. Many of these mounts have a characteristic 'Brussels sprout' type of nodule repeated, but the use of this does not confirm that a piece is by Langlois – this form of mount also appears on furniture known to be by other makers.

The pair of Langlois commodes at The Vyne, Hampshire, have tops inlaid with musical trophies, and one of the tops is inscribed 'Zurn', which may be the name of the specialist *marqueteur* Langlois is thought to have employed. The drawers have been divided off-centre because of the central Rococo escutcheons, but the keyholes and handles are in the usual positions.

The owner of The Vyne at the time of this work was John Chute, Horace Walpole's friend and a member of the Strawberry Hill 'Committee of Taste'.

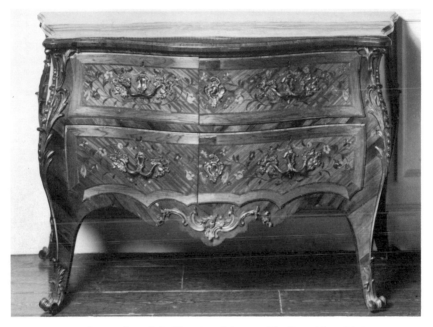

83. Commode made by Pierre Langlois, 1766 (The Vyne, Hampshire)

In a letter to Walpole of 12 March 1760, George Montagu wrote that Chute had taken him to Langlois's workshop to see his 'things', and this may have encouraged Walpole to purchase commodes from Langlois in 1763. Such visits by intending customers to workshops were not unusual.

GILLOWS OF LANCASTER

In the late eighteenth century, Gillows of Lancaster made up their own designs to such a degree of excellence that they soon had a very wide and successful practice. The firm was founded by Robert Gillow in about 1728; it was active in the West Indies trade and brought supplies of mahogany to Lancaster in its own ships, sending out all manner of goods in return (they were 'Licensed Dealers in Rum', for example). Their early work, in the 1750s, is now rare and poorly documented; an example is the fine mahogany cabinet on stand at Temple Newsam House, Leeds, carved in a florid, flamboyant style, with massive cabriole legs, apron with shells, and broken pediment. It illustrates the use by provincial cabinet-makers of a variety of pattern and instruction manuals. Much better known is the firm's later output, in the late eighteenth and early nineteenth centuries, in dark Cuban mahogany or exotic woods, veneers and inlays.[67]

Gillows opened up a London branch in 1771 at '176 Oxford Road'. Their charges were moderate (although the redoubtable Mrs Piozzi got their charges to her reduced in 1794) and they became a firm of good standing. In 1807, a German visitor to London, P. A. Nemmich, wrote that the firm were

the first grade salesmen and manufacturers in London; they deal widely in land and foreign trade and maintain employees in different parts of England; their work is good and solid, though not of the first class in inventiveness and style.

The firm's archives, now held by Westminster City Libraries, are the most extensive and the most informative in Europe for a furniture firm. They include a detailed list of the piece rates agreed in 1785 with their journeymen for different types of cabinet work. The range of the furniture they produced was very wide, from Carlton House writing-tables to coffins and from highly finished and expensive inlaid pieces to the simplest oak and deal furniture.

Gillow furniture is often stamped with an incised mark in small capital letters 'GILLOWS·LANCASTER' on a drawer edge or back of a seat frame. They were almost the only English maker to give a maker's mark consistently.

The firm was active throughout the nineteenth century (p. 178).

84. Lady's writing-table, 1797,
supplied by Gillows of Lancaster
(Dyrham Park, Gloucestershire)

GEORGE HEPPLEWHITE

George Hepplewhite is said to have been apprenticed to Gillows of Lancaster, but no record of this appears amongst the surviving registrations.[68] He was not well known during his lifetime, but his name has endured because his pattern book was published by his widow in 1788, two years after his death. *The Cabinet-Maker and Upholsterers' Guide* reached a third edition by 1794; it was a

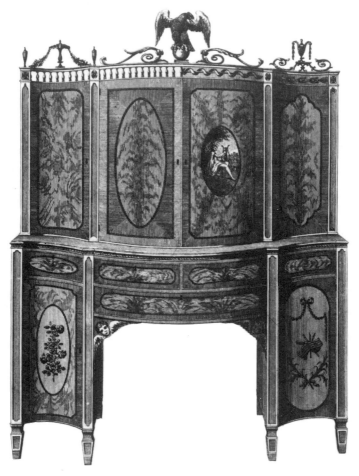

85. Hepplewhite wardrobe, 1788

'Repository of Designs for Every Article of Household Furniture – near Three Hundred different Designs . . .' and epitomized the Neo-classical style of the 1780s.

Hepplewhite 'book pieces' – that is furniture related directly to the book patterns – are rare. Leading makers were always nervous of reproducing published designs and were wary of following too closely one who had a shop in an unfashionable part of town, and to whom no reputation or furniture could be credited. Nevertheless, the Hepplewhite style was widely copied, especially by provincial makers.

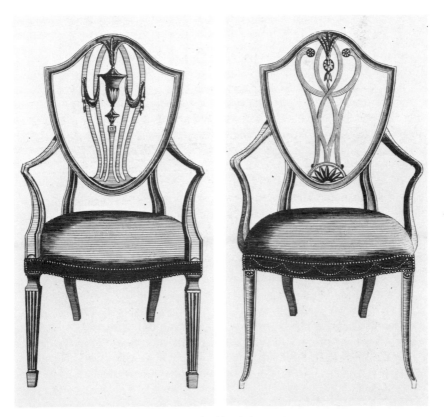

86. Hepplewhite chairs, 1788

THOMAS SHERATON

When Hepplewhite died in 1786 Thomas Sheraton was but thirty-five years old. He was born in Stockton-on-Tees in 1751 and he was (as Thomas Sheraton, junior, later recorded) without 'the advantages of a *collegial* or *academical* education'. He came to London about 1790, and is said to have then 'supported himself, a wife and two children by his exertions as an author'.[69]

His principal works were *The Cabinet-Maker and Upholsterer's Drawing-Book* (1791–4) and the *Cabinet Dictionary* (1803). The *Drawing-Book* was issued in forty-nine separate numbers, with Parts I and II devoted to geometry and perspective while Part III gave 'the present state of furniture' and provided 'some assistance' for the workman (Plates 99, 101 and 103). Sheraton had a complete mastery in the technical aspects of cabinet-making and his *Dictionary* is therefore of lasting value. It set out to explain '. . . all the Terms used in the Cabinet, Chair & Upholstery Branches, with Directions for Varnish-making, Polishing and Gilding . . .' and was illustrated with eighty-eight handsome copperplate engravings.

Sheraton advertised his readiness to provide designs to cabinet-makers and probably did find much business of this kind, but the range and volume of his business can only be surmised. The *Drawing-Book* was subscribed to by some seven hundred tradesmen, about two thirds of the subscribers living in London and most of the rest in the north and north-east of England.

Writing of Hepplewhite, Sheraton remarked that 'notwithstanding the late date of Hepplewhite's book, if we compare some of the designs, particularly the chairs, with the newest taste, we shall find that this work has already caught the decline, and perhaps, in a little time, will suddenly die in the disorder'. These sharp remarks may well have caused some of the plates of chairs in Hepplewhite's third edition of 1794 to have been redesigned.[70]

One of the firms which worked in the 'Sheraton style' was set up by George Seddon in London in the early 1750s – his first recorded apprentice joined him in 1757. By 1768, when his workshops in Aldersgate Street were ravaged by fire, he had eighty cabinet-makers in his employ; with much verve, he shrugged off the disaster and worked hard for success. He advertised in *The Public Advertiser* in July 1768 that he had moved to new premises and still had 'the same Hands who worked for him before' the fire 'retained in his Service'. By 1789 Seddon's stock-in-trade was valued at nearly £119,000, with timber to hand of over £20,000 in value. In 1786 he had over 'four hundred journeymen' at work 'connected with the making of household furniture'. The

firm made much 'Sheraton' and 'Hepplewhite' furniture, as well as some patent furniture (see p. 203), and could tackle large commissions which did not interest more specialized makers such as Thomas Chippendale the younger. It is praised by Thackeray in *Vanity Fair*. George Seddon, who was Master of the Joiners' Company in 1795, was said to be 'intimate with the quality of woods from all parts of the earth, with the chemical knowledge of how to colour them or combine their own tints with taste . . .'[71] From time to time the firm used a brass label to mark its products.

THOMAS CHIPPENDALE THE YOUNGER

Thomas Chippendale was the eldest son of the cabinet-maker and author of the *Director*. He was baptized at St Paul's, Covent Garden, on 23 April 1749. He trained under his father, and was present, presumably, at many of the firm's important commissions. We have letters written by him, in 1767, when he was eighteen, and in 1771, to Sir Rowland Winn about minor aspects of the work at Nostell Priory – making sure keys were sent, inquiring about India paper, putting in hand a child's chair, and so on.[72] As his father reached semi-retirement, a few years before his death in 1779, an increasing share of the administration and supervision in the London workshops and at various houses came the young man's way. It is probable that Thomas Chippendale junior designed some of the firm's late, Neo-classical work. After his father's death the firm became 'Chippendale and Haig' – Thomas Haig, his father's partner, did not retire until 1796.

Chippendale junior was friendly with Robert Adam's principal draughtsman, George Richardson, and must surely have discussed design and ornament with his friend; he moved slowly, as Adam himself did, towards an individual expression of the established linear forms of ornament. He favoured the use of reeded colonettes – a Neo-classical motif – in his furniture, and produced work in the 1790s for the Methuens of Corsham and for Harewood House (one of his father's principal commissions) which stood comparison with the best.

The pre-eminent collection of his work, of superb quality and in excellent condition, is the furniture he fashioned for Sir Richard Colt Hoare of Stourhead between 1797 and 1820. Sir Richard, a member of the wealthy banking family who had established their fine Palladian house and important landscape garden in Wiltshire in the 1720s, bought on a princely scale. Some quotations from Thomas Chippendale junior's accounts will serve to indicate the variety of the furniture he supplied, some of it in the new Egyptian taste. 'Egyptian'

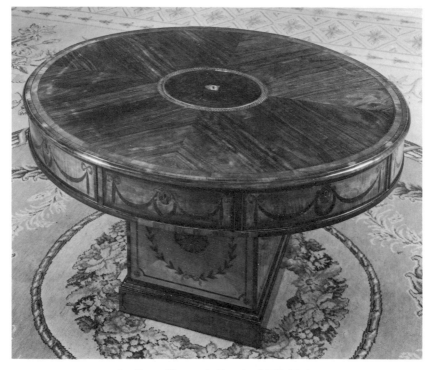

87. Rent table, *c.* 1780 (Stourhead, Wiltshire)

mahogany chairs were completed with quilted cushions of Athenian red cloth 'tied down with yellow and black tufts'. The Little Dining Room was given 'a large mahogany sideboard with sweep front . . . thermed feet with leopards' heads and lions' feet, a strong brass rail to ditto', with a large late-seventeenth-century silver-gilt dish by Heinrich Mannlich of Augsburg, depicting the death of Cyrus (Plate 91). It was placed in a wooden support which was carved with great dexterity by Sefferin Alken, a skilled craftsman who did much work for Robert Adam and Neo-classical cabinet-makers such as John Cobb. In the Italian Room are two very fine music stands, two armchairs and ten single chairs; the bills record many more:

6 sattin wood elbow chairs with black ebony bands broad panelling backs, caned seats, turned legs and on castors, £31. 10. 0. [Cabinet Room]

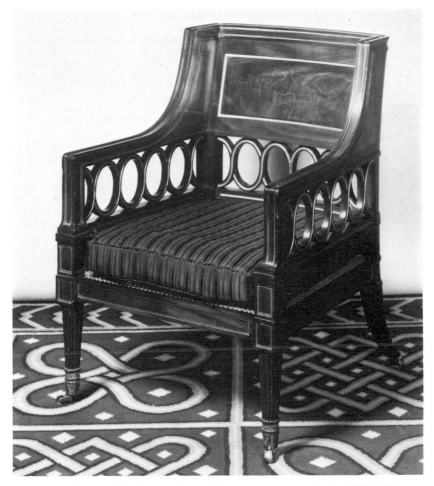

88. Armchair made by Thomas Chippendale the younger, 1812 (Stourhead, Wiltshire)

12 sattin wood Arm chairs with broad panell'd tops Ebony bands and carved Paturns with Cross Barrs. Caned seats turned legs and on brass socket casters £5. 10. 4. each

2 unique large Rosewood sofa tables . . . with flaps and 2 drawers to each, on quilled Claws with twisted Harp ends highly finished, on casters.

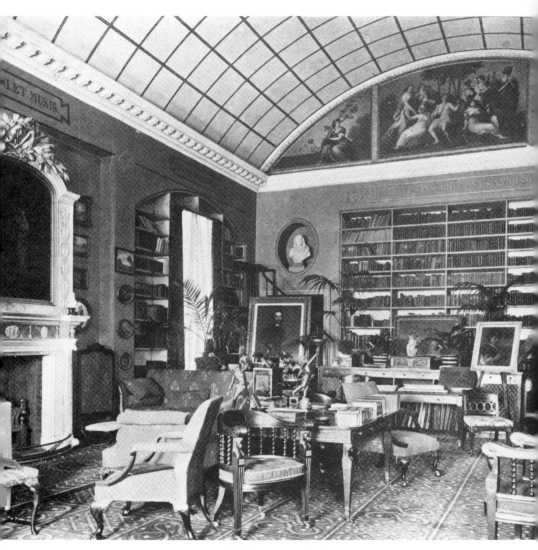

89. The library at Stourhead in 1901

The cornices of the North Pavilion Picture Gallery, built to balance the splendid library, were provided with 'round corners carved and finished in burnished gold and black with large Gilt Balls and Acorns' and the Brussels carpet was protected with 'green serge', an early instance of the drugget familiar to all country-house visitors.

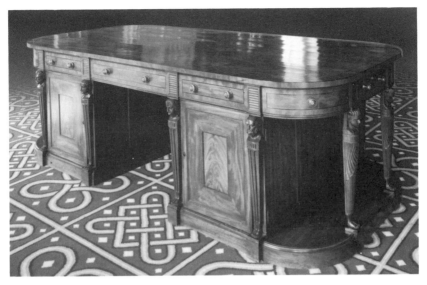

90. Library table, 1804, by Thomas Chippendale the younger (Stourhead, Wiltshire)

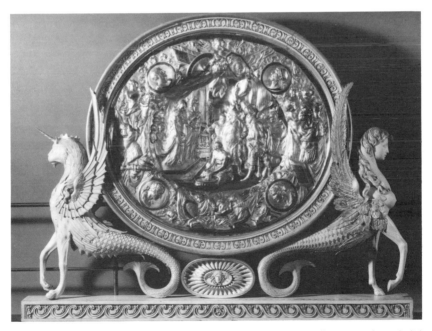

91. Stand carved by Sefferin Alken in 1783, supporting a late-seventeenth-century silver-gilt dish
by Heinrich Mannlich (Stourhead, Wiltshire)

Due to what has been called 'fifty years of dominance by Scottish financiers' (James Rannie and Thomas Haig) with sound contracts, the firm of 'Chippendale and Haig' went bankrupt, soon after Haig's death in May 1803. We hear little more of the younger Chippendale before his own death in 1822.

The younger Chippendale strove constantly after individual style and expression in his furniture. One is not sure whether he would have valued the opinion of George Smith, who in his *Cabinet Maker and Upholsterer's Guide* (1826) stated that he 'had taste as a draughtsman and designer'.

ROYAL PATRON

At the turn of the nineteenth century the Prince of Wales – he became Prince Regent in 1811 and King George IV in 1820 – started the extensive transformation of Brighton Pavilion. He had already experimented with the Chinese style in the drawing-room created for him by Henry Holland at Carlton House. The appearance of this room is recorded in Sheraton's *Drawing Book* (1793) and, although the room has gone, some of the furniture survives at Buckingham Palace. In particular, two ebony pier tables were given supports of bronze Chinamen and there were ornamental dragons on the frieze. At Brighton the Chinese mood was lavishly interpreted by the Crace family of decorators, in the wildest excesses of Oriental styling. Even royal families re-use what is useful, and Queen Victoria took many of the furnishings of Brighton Pavilion to the new east wing of Buckingham Palace, built by Blore in 1847.

SCHOLAR AND ARCHITECT

In 1807 a book of designs, with the title *Household Furniture and Decoration*, was published by the scholar and architect, Thomas Hope.[73] The designs related to his Surrey house at Deepdene, and reflected his wide travels – in Egypt, Turkey, Syria and Greece – and his extensive collections. Archaeology was one of Hope's main interests, and he tried to adapt his furniture designs to represent the objects of ancient civilizations. Griffins, winged sphinxes or lions and Egyptian heads or lyres were fashioned in wood or bronze with a pedantic discipline but with scant attention to comfort. And yet his work was fashionable and its creator lamented in his book that imitations of his furniture had 'started up in every corner of the capital' and that his designs were 'widely imitated in

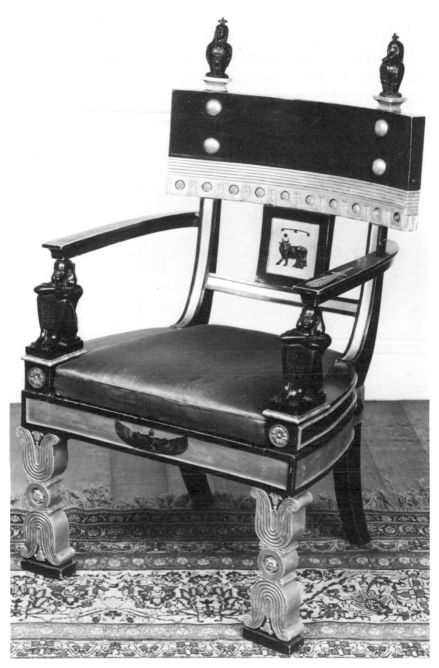

92. Armchair designed by Thomas Hope, *c.* 1807 (Buscot Park, Oxfordshire)

the upholstery and cabinet trades'. Hope opened his London house from time
to time and there had been many, obviously, who had gazed at the interiors
and furnishings with a view to emulation, albeit in a less scholarly mode.

One of the visitors to Thomas Hope's London house may have been the
fashionable cabinet-maker and upholsterer, George Smith. With premises off
Cavendish Square, Smith described himself as 'Upholder Extraordinary to His
Royal Highness the Prince of Wales'. In 1808 he endeavoured to join the ranks
of the successful compilers of pattern books and volumes of designs by issuing
A Collection of Designs for Household Furniture and Interior Decoration. The
knowledge of the Egyptian style shown in this collection is less exact than
Hope's, and Smith relies heavily on a French publication, Baron Dominique-
Vivant Denon's *Voyage dans la Basse et Haute Egypte*. Denon had accompanied
Napoleon Bonaparte on his Egyptian campaign at the end of the eighteenth
century, and in 1801 he introduced Egyptian motifs into the furniture in the
private apartments Napoleon occupied at the Tuileries. In England, Thomas
Chippendale junior supplied Egyptian furniture to Stourhead in 1804 and
Sheraton depicted Egyptian motifs in his *Cabinet Encyclopedia* (1804–6). Smith's
plates in *Household Furniture* are dated 1804 to 1807. While Hope's book is
mainly concerned with formal settings, Smith's was more practical and
suggested articles suitable for the whole of a domestic household. It also ranged
further in style, showing Gothic designs and designs in the Chinese and French
tastes; it shows a weakness for animal forms, console supports, divided columns
with lotus-leaf ornament and bold classical adornments.

In 1826 George Smith issued a second volume, *The Cabinet-Maker and
Upholsterer's Guide*. The text was 'flamboyant, captious and critical and
unctuously self-satisfied'.[74] He started by explaining that he had devoted forty
years to the study of furniture, and that his previous book (1808) had become
'wholly obsolete and inapplicable'. The position he saw as desperate – the
Egyptian style was now 'anathematized as barbarous' and the 'necessity of
economy' was, he thought, but one explanation for the morass into which
design had fallen. The survival of the archaeologically based styles had only
lingered because of the rare talents possessed by such as Thomas Hope.

Changes came, at odds with the moralizing tendencies of the age, and all
was overlaid by the ornamental excesses of gothic, Louis Quatorze or one of
the fashionable revivals. The principal nineteenth-century firms provided a
wide array of furniture in all the modes a patron could fancy or afford.

SOME IMPORTANT VICTORIAN FIRMS

Holland & Sons

This was one of the greatest furniture firms of the Victorian period, enjoying the distinction of being cabinet-makers and upholsterers to Queen Victoria, her government, and many London clubs. Recent research has established that they first appeared as 'Tapwell and Holland' about 1815, Stephen Tapwell being active until 1843, when William Holland took over. The firm's extensive archives[75] show that he was related to the important Regency architect Henry Holland. They set up in London in Great Pulteney Street, moved to their Ranelagh Works in Lower Belgrave Square in 1848, and then acquired 25 Mount Street.

The early history of any major firm is usually one of activities meshing with other similar firms or firms with needed specialized skills. Hollands formed a link with Thomas Dowbiggin & Sons of 23 Mount Street who had made the state throne at the Queen's accession in 1837 and an important set of thirteen mahogany tables, 150 ft (46 m) long, for St George's Hall. Supervision of the Duke of Wellington's funeral drew the two firms together, and from 1843 Hollands gradually assumed command. At the time of the 1851 census Hollands were employing 350 workmen.

The first important royal commission for the firm was to provide furniture for Osborne Castle, on the Isle of Wight, which Queen Victoria had acquired in 1845. She had new wings added to the house, which took some six years. Although most of the original furnishings for Osborne have been removed (some to Sandringham), one of the best Holland suites is still *in situ* in the Queen's Drawing Room. The suite consists of lavish satinwood and gilded sofas, tables, chairs and commodes; many of the items bear the incised name 'Holland & Sons'. By 1850, almost £10,000 had been spent (in the Day Books over a hundred pages deal with items supplied in 1849–50) and the firm was retained on and off at the house until 1869, providing much furniture in the Queen's favoured Louis Seize style. The Queen spent a considerable amount of time at Osborne, withdrawn from active public life after the death in 1861 of the Prince Consort, whose funeral Hollands arranged. Hollands were also allotted much work at other royal houses. They attended and supplied to Windsor, Sandringham, Buckingham Palace and the Scottish seat of Balmoral.

The country's political rulers also used Hollands, at the new Houses of Parliament. They shared the first commission with Gillows; the second

commission was given to Hollands and they were asked to provide furniture for the Office of the House of Lords and bookcases for its Library Corridor.[76] Their prices were highly competitive, for they had introduced machinery in 1855.

The blend of informed design and fine materials placed Hollands in a leading category. Their Day Books abound with notes of 'handsome amboyna', 'wainscot oak inlaid with malachite and Irish marble', 'tulipwood, Hungarian ash and thuya, decorated with ormolu and marquetry'. Whether it was the furnishing of a steam yacht for the Emperor of Austria, or providing chairs and tables for the Athenaeum Club (1846), the firm worked with great care and attention to detail. They won medals at the Great Exhibition of 1851 – for a carved bookcase, 'executed for Her Majesty' – Paris in 1855, with designs by J. K. Collings, and Paris, again, in 1867 for a large sideboard 'dressoir'. This was designed by Bruce Talbert and described as 'Gothic in every quoin, crocket and rib. The late Mr Pugin would have clapped his hands over it . . .'

Bruce Talbert, one of the most talented designers at work in the later nineteenth century, worked for Hollands from 1867 – the year they received an award at Paris – until his death in 1881. He was equally adept in the Gothic or the Jacobean style. Many of the firm's designs were inspired by study of late-eighteenth-century furniture and owed a debt to Neo-classical patterns in marquetry. Morris & Co, a firm dedicated to honest craftsmanship, bought Hollands' Pimlico workshops in 1890. The firm survived at its Mount Street premises until after the Second World War.

Gillows

Gillows, as we have seen (p. 164), was founded at Lancaster in about 1728. The firm's extensive archives survive, and their pattern books show a colourful range of their japanned, gilt and satinwood furniture.[77] The high reputation they enjoyed attended them throughout the nineteenth century.

Important English firms had to compete with each other, as well as against foreign cabinet-makers. They did this most effectively in the emotive arena of the large international exhibitions. If Gillows could carry off a prize at the Great Exhibition of 1851 – as they did – they could use the success to back up their daily commercial enterprise. One 'prize' Gillows were anxious to obtain was the acceptance of their tender to furnish the new Palace of Westminster, which had been gutted by fire. Unfortunately they had overcharged on an earlier job, their costings were queried, and the second commission was given to Holland and Sons.

At an early stage Gillows interested themselves in decorative wood-carving for some of their furniture, and they set up a school in London to train wood-carvers, a popular 'hobby' by the end of the nineteenth century.

In the Victorian period there was a strong interest in Georgian furniture. Gillows welcomed this – although much of what they made was fashioned by machinery and finished with applied hand-carving. As well as employing their own designers, they also used designs by E. W. Godwin, T. E. Colcutt and Bruce Talbert, and put a range of medieval-style furniture, which they had shown at the Paris exhibition in 1878, into general production. The firm made limited-edition pieces of a high standard and ran these alongside mass-production furniture at their many factories. They became very active towards the end of the nineteenth century and set up factories in Liverpool and London as well as Lancaster, and followed these by new establishments in Paris and Johannesburg.

Morris & Co.

Much has been written about the activities of this important firm. The first prospectus of Morris, Marshall, Faulkner & Co. was issued in 1861 and included the names of many Pre-Raphaelite painters (Edward Burne-Jones, Ford Madox Brown, D. G. Rossetti and Arthur Hughes) as well as William Morris, Philip Webb, C. J. Faulkner and P. P. Marshall; Morris was appointed manager and Faulkner book-keeper. They aimed to undertake, in the words of the prospectus, 'any species of decoration', including murals, carving, stained glass, metalwork and painted furniture.[78]

Morris was the catalyst to effective action and became adept at most of the crafts the firm advertised. They made their first important appearance at the International Exhibition of 1862, at which furniture by Philip Webb and a sofa by Rossetti were shown. The firm was awarded two prizes, but the group of judges preferred work 'in the style of the Middle Ages'. The firm's finances were unstable, despite changes of premises and the employment of a manager (Warrington Taylor). Much of what Morris and his friends made was not practical. By the mid 1870s it was obvious to some of the partners, especially Morris, that reorganization was overdue. The non-productive partners were asked to retire (although some resented this and insisted on generous compensation), and Morris became sole manager. Faulkner, Webb and Burne-Jones remained loyal and Morris & Co. was re-formed in March 1875.

The original prospectus of 1861 had stated that it was the firm's belief that 'good decoration, involving rather the luxury of taste than the luxury of

costliness, will be found to be much less expensive than is generally supposed'. This was the rock on which they almost foundered. When Warrington Taylor became manager he lamented that it was 'hellish wickedness to spend more than 15s. on a chair, when the poor are starving in the streets. Your Liverpool merchant only loves mahogany because it is heavy like his money and his head.' Morris & Co. made much expensive furniture which helped the firm survive, but it also needed to sell to the wider public at its Oxford Street showroom. Soon after 1865 they put the 'Sussex' chair – rush-seated and with a plain or ebonized frame – into production. The design was based on 'an old chair of village manufacture picked up in Sussex'. It cost only a few shillings (in 1900 the basic chair was 7s. and the armchair 9s. 6d.) and it was in great demand.

By 1890 the company's chief furniture designer was George Jack (1855–1932) who was born in America and had trained as an architect. In 1900 he took over Philip Webb's practice. His carved and inlaid dinner table was one of the first designs he produced for the firm, about 1880. It was available in mahogany or Italian walnut, with or without inlays of stylized flowers, and remained available until a little after 1910. Jack was a founder member of the Arts and Crafts Exhibition Society, and he turned Morris furniture back towards eighteenth-century prototypes, rather than earlier medieval ones.

Morris was now concerned increasingly with his socialist programme of publications and lectures, and recognized the frustration of 'ministering to the swinish luxury of the rich'.

Liberty & Co.

Liberty's, founded in 1875, only became interested in making furniture late in Queen Victoria's reign, but what they did was important. The firm took a leading part in the Art Nouveau Movement (the name is derived from the shop opened by Samuel Bing in Paris in 1895). They sold furniture, Cymric silver and appropriate textiles, pottery and glass; it also, like William Morris, looked to those customers who wanted simple rustic furniture. Some of this was made for them by William Birch of High Wycombe.[79] They were also into the business of 'historic revivals' and their London premises reflected this, with honest panelling and stained glass in considerable evidence. There were few great country houses at the end of the nineteenth century which did not have a corner of Liberty chintz, an oak or mahogany rush-seated 'Argyle' chair, and an 'Anne Hathaway' dresser. Style was still important to Liberty's, as it had been throughout the century to other leading firms. Their aim was to produce 'useful *and* beautiful objects at prices within the reach of all classes'.

STYLES AND CHAIRS

The effect of the various nineteenth-century styles may be traced more effectively if we consider, briefly, one important category of furniture essential to any room – chairs. Loudon had set out the styles that were current at Queen Victoria's accession, and these provided ornamental motifs and variations which could be overlaid on the standard format of four legs, stretchers, seat and back rails. Loudon's 'Grecian Style', which he thought most suitable for dining-rooms, had a broad shoulder-board with straight turned front legs and backward-splayed rear legs, all in mahogany.

The 'Elizabethan Style' was displayed early in the pages of Rudolf Ackermann's *Repository of Arts* ... which appeared in monthly parts from 1809 to 1828. In an autumn issue of 1817 an Elizabethan chair with tall back, spiral-turned components and rich upholstery showed what became a characteristic of this style – that it had turned components which could be produced cheaply on a lathe. Chairs with bobbin-turned parts stayed popular into the 1880s.

Loudon thought the gilding and scrolled carvings of the 'Old French Style' not suitable to the state of public taste in his day. Nevertheless, the style was in demand, was still competitive at the time of the 1851 Exhibition and lasted late into the century for drawing-room furniture.

The Gothic, with its archaeological and architectural overtones, allowed A. W. N. Pugin, a designer of rare ability, to show his skills, and suited the many houses and villas erected in the Gothic style.

Two of the most fashionable Victorian chairs in the 1850s were the balloon-back and the devotional chair known as a *prie-dieu*. The curved backs and the round backs of furniture made in the Grecian and French revival styles were easily lightened and given a new shape, making a balloon-back with a sweep incorporating the top and bottom rails in one oval. The *prie-dieu* had an upholstered seat on short legs, and a high back. It was possible to kneel on the seat and rest the arms and bent head on the top of the T-shaped back. They were popular in many drawing-rooms and were soon the objects of the loving application of needlework and Berlin wool-work.

We have already commented on the rush-seat chairs of Morris & Co. This firm also made upholstered armchairs for the drawing-room. These were often accompanied, incongruously, by the thin, linear chairs E. W. Godwin was producing, based on the Japanese art he had studied from the early 1860s, or the lavish Neo-classical chairs known as 'Adams' – the nineteenth-century revivals of Chippendale, Sheraton and Adam.

Crown and Court had been served over a long period with much furniture of quality, but it might be held that the products of the late nineteenth century alternated too widely between 'fanciful and flimsy' and 'serious and solid'. At the Queen's death in 1901 unity of style had vanished, and within a few years 'Crown and Court' would cease to be the dominant factors in establishing taste in decoration and furniture.

∾ SIX ∾

FOR GENTLEMEN

In this chapter we shall examine some of the types of furniture to be found in the family rooms of smaller country houses – the source of most of the furniture acquired by modest collectors.

GENTLEMEN'S FURNITURE

Among the two and a half thousand London cabinet-makers listed in 1953 by Sir Ambrose Heal – ten times that number will be listed in the Furniture History Society's forthcoming *Dictionary of English Furniture Makers 1660–1840* – were many who worked slightly below the standards set by the leading one hundred makers. They provided sound furniture to the landed squirearchy and the nineteenth-century industrial magnates, who in their eager quest for wealth had created a whole new language – 'about 4,450 acres: an annual rental of £10,603 exclusive of the mansion: the perpetual advowson and next presentation to the Rectory: extensive manors or lordships with all the rights, privileges and emoluments appertaining thereto' – the language of the scramble towards the elevated, and occasionally untruthful, accolade of a place in Burke's *Landed Gentry*, red and fat, on every respectable landowner's shelf.

Ignoring for a moment those with origins deep in post-Conquest lineage, who may have had the benefits of inherited wealth and favourable marriage alliances, there were many who made money through their own abilities and by astute management of their assets. House-building, which went with their new-found affluence, was described by Maria Edgeworth as one of 'those objects for which country gentlemen often ruin themselves'. The small country house became the hub of the owner's existence; it was the place which gave his family status, a sense of identity and achievement and, perhaps, a sense of permanence.

The changes which came about in the nature of furniture during the reign of Charles II (Chapter 5) were described by John Evelyn. Writing in 1690 he noted that ladies of fashion were acquiring light tea-tables for their dressing-rooms. He contrasted this with the conditions in the home in which he had

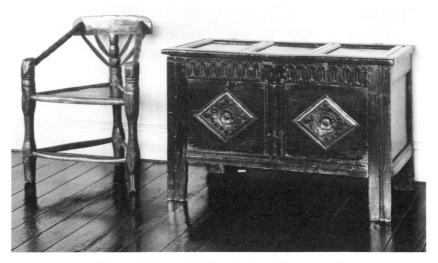

93. Turned fruitwood chair and oak chest, both probably seventeenth century
(Gawthorpe Hall, Lancashire)

spent his youth, where 'the shovel board and other long tables, both in hall
and parlour, were as fixed as the freehold'. In smaller country houses, by 1690,
chairs of oak with pegged joints copied those of the rich, the lack of cane panels
and simple styling declaring their country origin. Upholstery, so prevalent in
a grand household, played a lesser role, the long-case clock was by a provincial
rather than a London maker, the day-bed and gilded looking-glass were rare,
and the predominant timber was oak.

With the accession of King George III in 1760 there was a reaction from the
excesses of Rococo, and the important Neo-classical phase popularized by
Robert Adam and others set in. Dining-tables which extended were made
popular by a number of makers, amongst whom Gillows were pre-eminent,
and cabinet-making was at a high level. The range of woods and veneers was
wide, and brought forth better work from provincial makers, who were avidly
copying the current fashions in the pattern books.

After the death of the architects Robert Adam in 1792 and Henry Holland
in 1806 the interest in classical precedents, which they had encouraged,
increased. There was a considerable interest, too, in what was happening in
France, where Percier and Fontaine sought to achieve the same kind of
synthesis as Adam – to harmonize architecture, decoration and furniture, and
to achieve an effect of dignified simplicity.

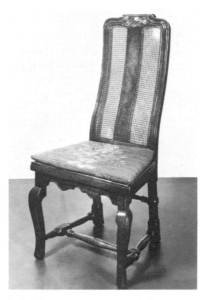

94. Cane-backed chair, *c.* 1700 (Victoria and Albert Museum, London)

95. Mahogany sideboard, *c.* 1800 (Victoria and Albert Museum, London)

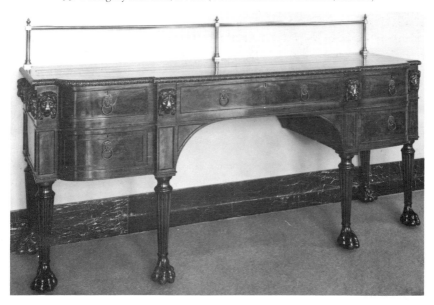

In the early nineteenth century, as we have noted (p. 70), various styles were current; Loudon described what was available in his *Encyclopedia* in 1833, and many contemporary pattern books also chart what was happening.

In 1864, Robert Kerr (1823–1904), an architect, published his study of *The Gentleman's House*, which Mark Girouard has described as 'an influential and much-read publication', noting at the same time that Kerr 'had little experience to build on' and that his book was 'essentially a capable analysis of the plans of others'.[1] Kerr considered the arrangement and contents of a country house in the early 1860s under three main headings: 'Family Apartments', 'State Rooms' and 'Domestic Offices'.

An English gentleman would probably have agreed with Kerr that his home should have 'quiet comfort for his family and guests, thorough convenience for his domestics, and elegance and importance without ostentation'. Kerr noted furniture as though its style and design were of no interest – although he took exception to ostentation – but he listed some ten architectural styles the house itself could be built in.

Kerr laid considerable stress in his book on the appearance of the dining-room. The sideboard was to be placed at the back of the master's chair, and preferably away from the windows in its own recess. This was to avoid the glare from displayed plate – the precedent was medieval – irritating dinner guests. When no meal was taking place Kerr stated that all dining chairs should be set against the walls (a nicety observed in the earlier drawings of Robert Adam). He asserted that dining-room furniture should be 'somewhat massive and simple (what is called heavy)' and that in smaller houses the dining-room might also serve as a family sitting-room. Then it would need to contain a bookcase, pianoforte, a couch and a card-table in addition to the sideboard, dining-table and chairs.

Kerr emphatically approved of the sideboard, 'which demands one end of the room for itself'. George Smith had written in *Household Furniture* (1808) that a good sideboard contained 'three drawers, for holding naperies etc.' and that they should be made in mahogany. The sideboard had evolved from a sideboard table, flanked in the Neo-classical period by pedestals and urns (Plate 64), but by Kerr's time opinions were divided about them. Charles Eastlake in his *Hints on Household Taste in Furniture, Upholstery and other Details* (1868) wrote:

> The general arrangement of an ordinary English sideboard is reasonable enough. It consists of a wide and deep shelf fitted with one or two drawers, and resting at each end on a cellaret cupboard. If this piece of furniture were constructed in a plain and straightforward manner, and were additionally provided with a few narrow shelves at

the rear for displaying the old china and rare porcelain ... what a picturesque appearance it might present ...

He warmed to his theme, stating that, unfortunately, the sideboard was now

bowed in front and 'shaped' at the back; the cupboard doors are bent inwards; the drawer fronts are bent outwards; the angles are rounded off; tasteless mouldings are glued on; the whole surface glistens with varnish ...

Eastlake's conclusion was that the sideboard was 'eminently uninteresting', and other contemporary writers felt that corner cupboards could replace them.

The drawing-room Kerr considered to be a lady's apartment, with furniture contrasted to that of the dining-room – it would include many different sorts of tables, chairs, whatnots, chiffoniers and 'fancy cabinets'. Something of what he had in mind, with exuberant overtones, could have been seen in many a drawing-room around 1900. The library, Kerr noted, was a place of retirement for gentlemen, as well as housing books and providing a place for conducting correspondence. The smoking-jacketed members of the family could also go to the billiard-room or the smoking-room. Kerr was scathing: 'the pitiable resources to which some gentlemen are driven, even in their own houses, in order to be able to enjoy the pestiferous luxury of a cigar, have given rise to the occasional introduction of an appartment specially dedicated to the use of Tobacco'.

TABLES

The growing fashion from the 1660s was to dine in small parties at different tables, a fashion which revived in the 1870s. These were probably of the gate-leg type, oval in form, and taking little space when the flaps were lowered. Inventories refer to a gate-leg table as 'an ovall Table of wanscote with falling sides'; they are frequently embellished by the art of the turner. Early in the seventeenth century a fixed centre section to the table was flanked by a gate on either side. The joints between the hinged flaps and the top of the table were neatly made and iron hinges were fitted on the underside. It was the province of joiners to make 'all tables of wainscotte wallnut or other stuffe glewed with frames mortesses or tennants', and they frequently decorated the frieze below the top. Gate-leg tables continued to be made in the first half of the eighteenth century but by the 1730s they were no longer fashionable, though some, of light, thin construction with slender turned legs of mahogany, were made in the 1760s and 1770s – these were often known as 'spider leg' tables.

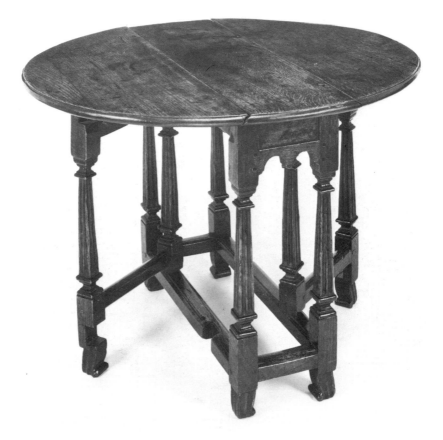

96. Oak gate-leg table, *c.* 1680 (Temple Newsam House, Leeds)

Gate-leg tables were supplemented from the late seventeenth century by the use of small tables to hold china, or to take tea or supper from. These did not come into general use until tea-drinking itself became more popular towards the end of the seventeenth century. Roger North in his biography of Lord Keeper Guilford, who died in 1685, observed that it was always his custom after dinner to retire to a withdrawing-room 'and the tea-table followed'. Many thousands of tea-tables were imported into England by the East India Company, but no lacquered examples seem to have survived. English makers made tea-tables to compete with these imports and supplied them to the many tea-

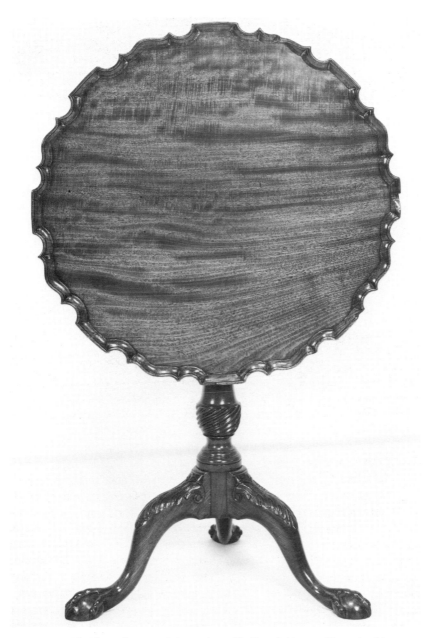

97. Mid-eighteenth-century 'pie-crust' tea-table (Temple Newsam House, Leeds)

gardens which sprang up when tea-drinking became fashionable. Some eighteenth-century tea-tables are illustrated – as 'China tables' – in Chippendale's *Director*; with their elaborate stretchers and pierced galleries they are fine examples of Rococo craftsmanship.

Many tea-tables in the latter half of the eighteenth century had a 'pie-crust' edge, and were made to tilt and revolve. They were supported by a turned pillar and tripod base; the baluster shaft often had spiral fluting as decoration. Tea-tables have very often been stripped and repolished, as they are particularly vulnerable to damage from spillages.

Tables for use in libraries and for writing were intended to grace ground-floor, public rooms and care was therefore given to their design. In the sixteenth and seventeenth centuries, writing was done at a small portable desk or a cabinet enclosed by flaps. When Charles II returned from France in 1660, writing-tables and bureaux from France became fashionable. ('Bureau' denotes a desk fitted with small drawers and pigeon-holes enclosed by a sloping or fall-down front.) Late-seventeenth-century writing-tables had folding tops which were supported on swing legs. The finest walnut and inlaid examples were made by Gerreit Jensen, but other makers also specialized in providing elaborate tables with seaweed marquetry on kingwood veneer, with scrolled or tapered legs and drawers set either side a kneehole. Great houses might have a library writing-table by makers such as Benjamin Goodison, but the more modest house was furnished with a mahogany writing-table on cabriole legs, or a lady's writing-table similar to those shown in *The Cabinet-Makers' London Book of Prices* (1788) or Sheraton's *Drawing Book* (1791–4). Sheraton's 'Harlequin Writing and Dressing Table' was based on two slightly variant designs in the London *Book of Prices*. The harlequin, operated by two coiled springs, could be raised or lowered and secured in either position by a catch.

Some of the most elegant writing-tables made in the late eighteenth century came from the Gillows workshops at Lancaster. They made many superb rosewood tables, which were more robust than those made in satinwood. In 1797 they supplied a 'neat Sattin wood Ladies writing table, the top to fall over a private Drawer', costing £3 10s. od. (Plate 84) to William Blathwayt and his wife Frances Scott at Dyrham. Chaste, but feminine, it is stamped 'Gillows Lancaster'. Fanny Burney writing to her father in September 1801 noted:

no room looks really comfortable, or even quite furnished, without two tables – one to keep to the wall and take upon itself the dignity of a little tidyness, the other to stand here, there, and everywhere and hold letters and *make the agreeable* . . . a sort of table for a little work and a few books, en gala – without which, a room always looks forlorn.[2]

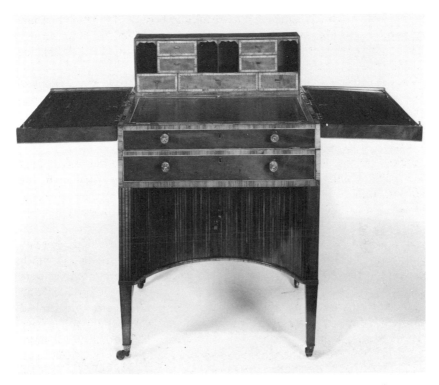

98. Harlequin writing- or dressing-table, c. 1790 (Temple Newsam House, Leeds)

Hepplewhite, not to be outdone by Sheraton, also contributed a design to the London *Book of Prices* for a 'Knee-Hole Kidney Library Writing Table', below a convivial 'Gentleman's Social Table' with holes for five bottles. An expensive refinement was to make the writing flap 'to rise with four stems' and, when not in use, to lie flush with the top surfaces. Two popular forms of writing-table also evolving in the late eighteenth and the early nineteenth centuries were the 'Carlton House Table', which had a raised superstructure of small drawers, and the circular table with a revolving top. The latter was, however, more properly a library table, as it had an ample leather-lined top, useful for laying out large folio books. These circular tables are also sometimes known as rent tables, and usually have small ivory initial letters inset into the drawers in the drum top. Another refinement was the 'writing fire-screen', which, as its name denotes, served two purposes. It had a fall front which

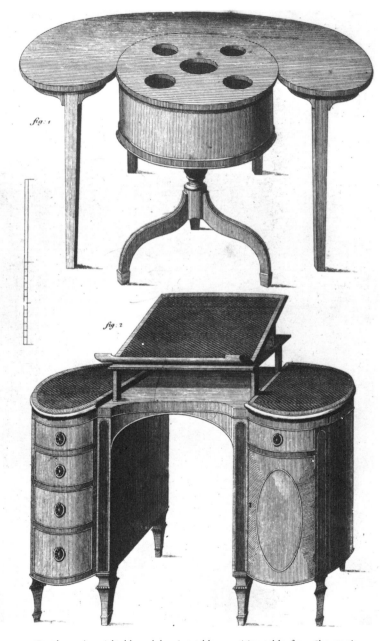

99. Gentleman's social table and dressing-table or writing-table, from Sheraton's
The Cabinet-Maker and Upholsterer's Drawing-Book, 1793

enclosed a shallow arrangement of small drawers, pigeon-holes and vertical slats to hold paper and envelopes. The base was usually enclosed by two inlaid doors. The whole was only about four inches deep. The form probably owed a little to the seventeenth-century chair-tables, in which a carved top formed both the back and (when lowered forward) the table-top. It was also similar to the 'Horse Dressing Glass and Writing Table' depicted by Sheraton.

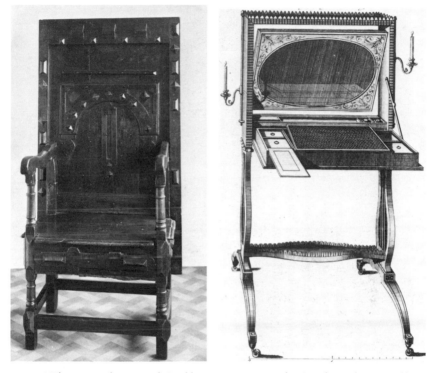

100. Mid-seventeenth-century chair-table; the back swings over on a pivot to make a table

101. Horse dressing glass and writing-table, from Sheraton's *The Cabinet-Maker and Upholsterer's Drawing-Book*, 1793

Most country-house visitors are familiar with the Pembroke and sofa tables. According to Sheraton, the Pembroke derived its name from 'the lady who first gave orders for one of them, and who probably gave the first idea of such a table to the workmen . . .' This was probably the Countess of Pembroke and Montgomery (1737–1831) from Wilton. In June 1766 Chippendale supplied 'A mahogany pembroke table, wt writing drawer' for £3 10s. to Sir Rowland Winn of Nostell; from the 1770s, however, Pembroke tables were usually

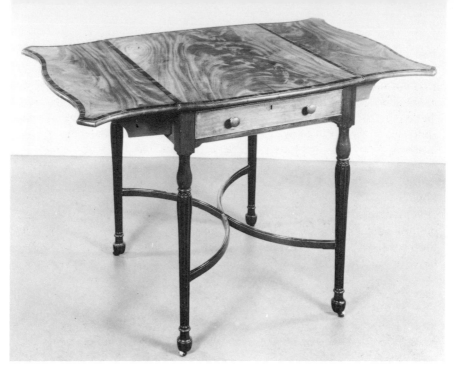

102. Pembroke table, *c.* 1790 (Victoria and Albert Museum, London)

103. Two lady's writing-tables, from Sheraton's *The Cabinet-Maker and Upholsterer's Drawing-Book*, 1793

made of inlaid satinwood. These tables were suitable, as Sheraton said, 'for a gentleman or lady to breakfast on'. The 'harlequin Pembroke' had, like the 'harlequin dressing-table' (p. 191), a box-like structure of drawers which was concealed in the body of the table when not in use. He explains that it is called 'harlequin' 'for no other reason but because in exhibitions of that sort, there is generally a great deal of machinery introduced in the scenery'. George Smith in *Household Furniture* (1808) regarded them as 'an appendage to the Ladies' Boudoir'.

Pembroke tables had flaps on either side of the centre, which were supported on hinged brackets, while the later sofa tables used various means of support for the flaps, such as ends drawing out below the top. Pembroke tables usually have thin tapering legs, while sofa tables have wonderfully decorated carved or lyre supports with ormolu-decked and inlaid stretchers, or are set on elaborate columns rising from four inward curved legs terminating in brass

104. Work-table, c. 1790
(Osterley Park, Middlesex)

105. Mid-nineteenth-century table
in Tunbridge-ware marquetry
(Victoria and Albert Museum, London)

106. Wheelback Windsor armchair, *c.* 1850 (Victoria and Albert Museum, London)

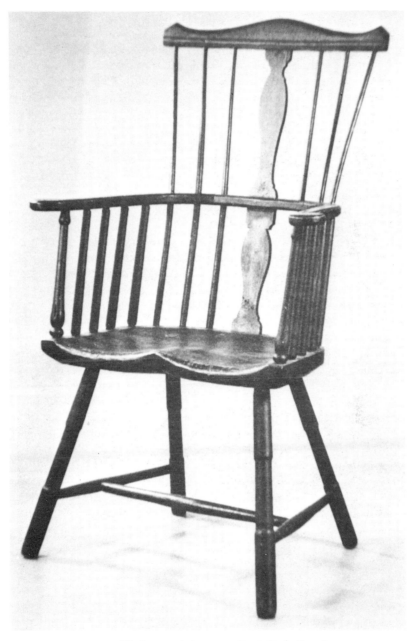

107. Windsor armchair, c. 1773 (Powis Castle, Powys)

lion-paw feet. George Smith recommended that sofa tables could be fitted with a chess-board, concealed by a sliding panel in the top. They were most versatile tables and were suitable for drawing-room, breakfast parlour or library.

Side, console and pier tables were made for grand interiors (Plates 42 and 63), and some had carved and gilt gesso decorations. More modest are the convivial wine tables, of horseshoe shape, with metal coasters sliding in a railed well. They were an awkward alternative to the social table (Plate 99). There was also an endless profusion of small work-tables, many with pleated silk bags suspended beneath a hinged top to hold needlework; they are frequently inlaid or painted with figure or flower subjects.

VARIOUS CHAIRS

In any country house, large or small, large numbers of chairs survive. Old-fashioned or damaged chairs might cross the boundary between the state rooms and the back-stairs. The removal of damaged chairs from a large set may be one reason why they are in almost every auction sale or antique shop. It can be confusing to find that chairs of humbler origin, but of the same classical proportions, were made solely for use in the servants' quarters. Chairs made in elm, with mildly Gothic backs, reminiscent of designs in the first edition of Chippendale's *Director* (1754) and therefore called 'country Chippendale', and 'ladder-back' chairs with rush seats and painted beech frames were common. The Windsor chair was perhaps the most versatile of all.

The stick type of turnery associated with the Windsor chair is depicted in the art of ancient Egypt; the type is also shown in medieval psalters and early German, Flemish and Dutch paintings. The art of turning developed considerably in England in the late seventeenth century and led to the development of the Windsor chair in a recognizable form.[3] The landscape-gardening writer Stephen Switzer provided the first reference to Windsor furniture in 1718. In his account of William Blathwayt's garden at Dyrham, near Bath, in his *Iconographia Rustica* (1718), he wrote:

... a Mount ... in the Middle of a Warren; on the Top of which is a large seat, call'd a *Windsor* Seat, which is contrived to turn round any way, either for the Advantage of the Prospect, or to avoid the Inconveniences of Wind, the Sun &c.

The first Windsor chairs were swivel, or revolving chairs; they were described in some early-eighteenth-century inventories as 'forest chairs'. As the demand for cane chairs waned the Windsor chair grew in popularity. The origin of the

name remains obscure, although there are many theories – the chairs were made around High Wycombe, where there is a ready supply of beech wood, and were then taken to Windsor and brought to London by water. The first use of the name occurred in 1727, when 'Windsor Garden Chairs of all sizes, painted green or in the wood' were referred to. The genesis of the chair was linked to the development of the English landscape garden.

The earliest forms of Windsor chair were made with a high back, plain crest rail, large D-shaped seat and plain stick legs. Examination of eleven dated paintings by Arthur Devis of the early 1750s show a fan-back side chair with stick legs and shaped crest rail; the backs of some chairs are braced by the use of additional turned spindles and all have circular seats. About this time also, splats were introduced into the backs of the chairs and solid splats were quickly supplanted by the ornamental pierced type made popular by the first edition of Chippendale's *Director* in 1754. The round top or bow-back chair with sawn or bent arms and turned or cabriole legs joined by H-shaped stretchers also came into use in the 1750s.[4]

The use of mahogany for English Windsor chairs spans the period almost from its appearance in the mid-1720s until well into the nineteenth century. The earliest extant examples (Ham House) should probably be dated, however, to the late 1750s or early 1760s. Yew, beech and cherry wood were popular; the Gillow firm often used elm wood for the seat and the supple cherry for other parts. The High Wycombe makers, active in the late eighteenth century, used ash, steamed or heated, to form the outer rail of the back, and painted or stained it to resemble mahogany. The Wycombe chair was declared by Loudon in his *Encyclopedia of Cottage, Farm and Villa Architecture and Furniture* (1833) to be 'one of the best kitchen chairs in general use in the midland counties of England'.[5]

A well-provenanced set of Windsor chairs, c. 1773, at Powis Castle, was originally painted grass green. They were made for Claremont, Surrey, built by Lord Clive of India in 1772–3, and came to Powis as a result of the marriage of the 2nd Lord Clive to Lady Herbert in 1784. It is rare to find such well preserved, firmly provenanced Windsor chairs together with evidence of their date and function; these have an old inscription painted beneath the seat: 'GARDEN CHAIRS FROM CLAREMONT'. A number of drawings for Windsor bow-back armchairs in the Gillow *Estimate Sketch Books* of c. 1798 show that an elm and cherry tree chair cost about 9s., of which the materials amounted to 5s., and the making to 4s.

As the nineteenth century progressed the Windsor chair had to compete with many other forms of chair, made in wood and cast in metal. A manuscript

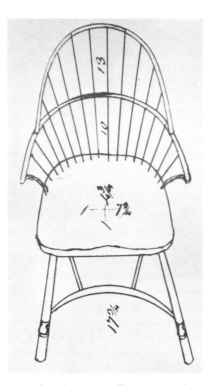

108. Windsor armchair shown in a Gillows estimate sketchbook, 1798

pattern book of the High Wycombe firm, Charles and Edwin Skull, *c.* 1849 contains over one hundred and fifty elegant watercolour designs for Windsor, slat-, lath- and balloon-back chairs, smoker's bows, Grecian, Roman, child's, rocking and fancy chairs. Many were grained to imitate mahogany, rosewood or maple, and the majority have wooden, rush or caned seats. Travelling salesmen would show retailers albums of this kind and take orders.[6]

Also found in profusion are three-legged or four-legged stools, with defined characteristics but of almost ageless appearance. The 'Windsor' stool had four splayed turned legs linked by swelled side-stretchers and a long, turned cross-stretcher. They were made in elm and yew of a height of about 18 in (45 cm), and are less common than tall office or bar stools. Special types of low stool were used in a variety of Victorian trades; these were made in pine and often had clumsily attached base stretchers to increase stability. Low stools were also used as milking-stools, foot-stools and children's stools.

During the Regency period splat-back patterns were superseded by yoke-back chairs with strong curved horizontal 'yokes' to support the sitter's back. Such chairs were strong and durable and were widely used in cottages, farmhouses and servants' quarters. Examples with square legs are likely to be earlier than those with turned supports.[7] Stained chairs of ash wood, called 'Liverpool chairs', made by Gillows from 1801, had rush seats, and backs formed from vertical turned spindles supported across the centre to form a simple grid. The name gives some support to speculation that many Lancashire towns may have produced distinctive chair types.[8]

Another well-known chair, devised to help the finances of William Morris and Co., was the Sussex armchair. It had a very simple frame of turned legs, arm supports and stretchers, with four turned spindles in the back. The chair was made of ebonized beech, had a rush seat, and was in production by 1865. It had a long life, and was illustrated and commented on approvingly by R. W. Edis in his *Decoration and Furniture of Town Houses* (1881). The use of turned spindles in the backs of chairs continued into the 1880s, and characterized much 'Art Furniture'. The 'Morris chair' was an upholstered armchair which had padded arms resting on turned spindles. The rectangular back was adjustable, and the front and side stretchers were also turned on the lathe.

Hall chairs, decorated with the arms or crest of the family, were intended, according to Sheraton's *Cabinet Dictionary* (1803) 'for the use of servants or strangers waiting for business'. They were set in the great hall of a country house, had wooden seats and were not intended to be comfortable resting-places for long periods. It was pointed out in 1876, by R. and A. Garrett in their *Suggestions for House Decoration*, that

the hall seat may be taken as the protest of the well-to-do classes against undue luxury in those below them; for it is generally constructed in such a manner as to form a stool of repentance for the unfortunate servant or messenger who is destined to occupy it . . .

Upholstered chairs, on the other hand, were found in many rooms. During the early years of Queen Victoria's reign Berlin wool work became popular and was used in upholstered furniture. Designs were worked in coloured wools, dyed in Berlin, on a square-meshed canvas, working from a coloured pattern printed on squared paper. Soon thousands of patterns were available; floral designs and sentimental or historical episodes were popular. In 1845 Henry Wood issued instructions for mounting Berlin needlework on pole screens chairs and settees; the pastime reached a high point of popularity in the 1860s and then slowly declined as art needlework took its place.

The search for comfort led to the development of the 'easy-chair'. Writers like Loudon (1833) contended that both the cottager and the rich man had a

right to the comfort such chairs afforded. They were rendered possible in manufacturing terms by the introduction in the late 1820s of the coiled spiral spring. Over these springs, which were held in place by interlaced webbing, strong canvas, curled horsehair and an outer cover were set. The Yorkshire woollen mills provided the upholstery materials and the Birmingham brass-founders provided various kinds of casters for the short thick legs.

It is difficult to say when deep-sprung easy-chairs were firmly introduced. The prolific author Thomas King illustrated designs in 1835, and in 1840, in

109. Detail of an advertisement by Gillows of Lancaster in a ladies' magazine, *c.* 1904

his *Original Designs for Chairs and Sofas*, he published six designs for easy-chairs with upholstered sides, arms, and rounded backs. This became the norm in the second half of the century. The framework of the chair, except for its legs, was hidden, the only exception being the Morris upholstered armchair of 1866 (p. 201). By the turn of the twentieth century the firm of Gillows, now associated with Lord Waring, were illustrating comfortable, plumped-up cushioned chairs and sofas in every lady's magazine. These would find their way to the servants' sitting-room and the housekeeper's room, re-covered in 'loose covers', when the family front-of-stairs had weakened the springs to the point of noisy, squeaking protest.

The library chair, often Gothic in form in the early years of the nineteenth century, was frequently upholstered in leather. The usual form of library chair at the start of Queen Victoria's reign had a semicircular back of black leather, and well padded arms. This gradually gave way to chairs with turned spindles beneath a heavy curved yoke rail. The library might also contain a number of chairs known as 'reading chairs', fitted with a swivel reading board and a candle-holder. The backs were deeply curved and well-upholstered. In terms of comfort they were surpassed by the reading-seat, a form of day-bed, illustrated by the prolific Thomas King as 'reading or lounging seats' in 1840. The reading-chair of eighteenth-century type where the sitter faced the rear (p. 279), made a slight comeback in the 1870s, but was soon supplanted by upholstered chairs.

Great comfort was also to be found in rocking chairs; there was an early-eighteenth-century Windsor form, but they first became popular in America. They were promoted on medical grounds, as 'Dr Calvert's digestive chairs'. The greatest fillip to the rocking-chair's acceptance, however, was the perfecting of the bentwood process by the Austrian firm of Thonet; bentwood rocking chairs were found in English drawing-rooms from the early 1860s.

PATENT FURNITURE

Many gentlemen in the eighteenth and early nineteenth centuries indulged in periods of hypochondria. They took the waters for real and imaginary illnesses and conditions, and Georgian and Regency spa towns grew rich on their indulgence. Enterprising cabinet-makers soon realized that these weaknesses of the flesh could be catered for; many patents were also taken out for furniture designed to ease common tasks.

'Patent furniture' was introduced about 1760,[9] and between that year and

1830 some ninety-six furniture patents were registered. Specialization became the rule, and from 1780 onwards a number of cabinet-makers concerned themselves solely with portable furniture, with some examples combining two or more functions. The best-known makers by 1780 were Gillows of Lancaster. They had already achieved a splendid reputation with the quality and range of their mahogany furniture. In 1800, they patented several 'telescopic' or extending dining-tables and stimulated other firms to make mechanical pieces too. Thomas Butler and his erstwhile employees and subsequent rivals, Morgan and Sanders, were by the early nineteenth century the leaders in this competitive and challenging area of the furniture market. The most famous piece for which Morgan and Sanders were responsible changed from an armchair into a pair of library steps; many other examples are illustrated in Ackermann's *Respository of the Arts* (1809–13). It called the Morgan and Sanders chair 'a novel and useful article' and several survive at Trinity College, Oxford. Morgan and Sanders themselves called it their 'Patent Metamorphic Library Chair' and this title, denoting the 'changing of form', is used to categorize such furniture, and the allied ranges of invalid and campaigning furniture.

Thomas Sheraton, mindful of the needs of travellers, especially soldiers away on campaign, had written, that in such circumstances

every article of an absolutely necessary kind must be made very portable, both for package, and that such utensils may not retard a rapid movement . . . And it is to be observed that most of the things which are of this nature, will also suit a cabin or sea voyage.

James Hakewill patented tables, chairs and stools in 1809 for 'domestic, military and naval service' and Samuel Pratt made (1826) a special bed to prevent sea-sickness. Pocock's of Southampton Street, Strand, issued a large advertisement headed 'Improvements in Furniture and Various Inventions for Invalids' including patent Boethema (rising) mattresses, chairs to ease gout and sofa beds.

An exhibition of 'Patent Metamorphic Furniture, 1780–1830'[10] held in 1978 showed the Morgan and Sanders chair, mahogany tables and cabinets which turned into library steps, adaptable four-post beds, extending dining-tables, and dining-tables with five legs which could be detached from a folding top. Exercise chairs with deep leather boxes containing boards and wires which bounced one up and down were illustrated in Sheraton's *Drawing Book* (1793). Thomas Butler's patent chair bed, c. 1790, had an underframe which could be pulled out, and seat cushions which served as a mattress. Other recumbent

easy chairs similar to Butler's, with sliding footrests and adjustable backs, were patented. These appeared in the invaluable *Encyclopedia of Cottage, Farm and Villa Architecture* by J. C. Loudon (1833), and survive in labelled pieces from the London workshop of Robert Daws. He was so satisfied that his chair would go on working with efficiency that his 1833 label claimed he was willing, on oath, to say that, on average, over the last five years, less than one in five hundred chairs had had the least derangement of the mechanism.

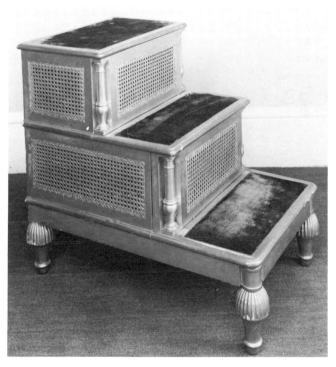

110. Bed step/night-table, *c.* 1825 (Osterley Park, Middlesex)

The use of ingenious arrangements and mechanisms – a French skill – had reached a high point in England in the late eighteenth century. Sheraton had demonstrated in his *Drawing Book* how effective a design for combined library steps and table could be. (Robert Campbell had patented the idea in 1774, 'first made for the King', and this source was acknowledged by Sheraton.)[11] Sheraton's 'Harlequin Pembroke Table' (p. 191) was a combined writing and

breakfast table, with a till which was raised and lowered by turning a fly-bracket supporting the flap – 'yet the bracket is made to lose this effect by the turn of a key'. There are also mechanisms for a sofa-writing-table in Sheraton's *Cabinet Dictionary* and brass-jointed patent bedsteads. The preoccupation with hygiene increased and with it the development of furniture specially for invalids.

Much patent furniture combined effortless performance with a feeling for shape, form and proportion that persisted despite the nineteenth-century mechanization of the furniture industry. Patent furniture is a rewarding subject for researchers and can provide much enjoyment for collectors.

TRAYS

Trays were used by butler and serving staff and some – those of Neo-classical form – were elegant enough to be left on the sideboard in the dining-room. Few trays dating from before 1750 survive, but they were in use in the Middle Ages, and pewter 'voyders' are mentioned in sixteenth-century inventories. Most eighteenth-century trays were devised to be used in connection with tea-drinking. In the early years of the century they were known as 'tea tables', and appear as such in the 1710 Dyrham inventory.[12]

In the first edition of the *Director* (1754) Chippendale illustrated 'Four Plans or designs for Tea-Trays or Voiders', and Ince and Mayhew in their *Universal System of Household Furniture* (1759–63), showed similar trays and used the traditional term of 'voider' to describe them. By this time mahogany was the usual material, and great skill was displayed in giving trays pierced and shaped edges and scrolled handles. In 1762 William Vile supplied to 'the Queen's House in the Park at St James' two 'Neat Mahogany Tea Boards with rims all Round' and also in 1762 he charged 'For a mahogy Tea board with a Cutt ffrett, £2 4s. od'.[13]

The finest trays and tea-caddies were produced during the period when patrons, architects and craftsmen were committed to the reintroduction of classicism – say from 1760 to 1790, the active years of Robert Adam's career. There was also a revival of marquetry at this time, and some of the most exquisite trays have fan-shaped centres of sand-burnt holly set around with wide borders of inlaid rosewood or satinwood. George Hepplewhite in his *Cabinet Maker and Upholsterers' Guide* (1788) wrote:

> For Tea trays a very great variety of patterns may be invented; almost any kind of ornament may be introduced. Several very good and proper designs may be chosen

from the various kinds of inlaid table tops ... Tea Trays may be inlaid of various coloured woods, or painted and varnished. This is an article where much taste and fancy may be shown.

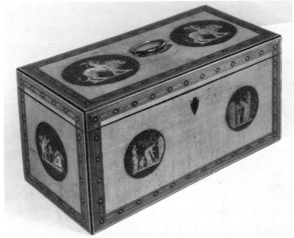

111. Tea-caddy, *c.* 1790; transfer-printed medallions on side and top
(Temple Newsam House, Leeds)

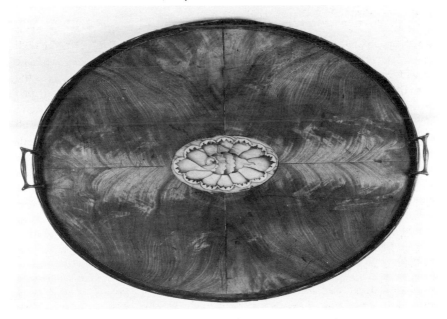

112. Tea-tray, *c.* 1790 (Temple Newsam House, Leeds)

Sheraton makes no mention of trays in his *Drawing Book* (1791–4) but devotes much space to them in his *Cabinet Dictionary* (1803). He also noted the use of trays mounted on legs or folding stands 'as a sideboard for the butler, who has the care of the liquor at a gentleman's table', and went on to describe them:

> These trays are made of mahogany, half inch Honduras will do for the sides, but the bottoms ought always to be made of Spanish, or other hard wood, otherwise the glasses will slop and will leave such a print, on soft wood, as cannot be easily erased.

He gives the measurements for dinner-trays as a maximum 32 × 24 in. (81 × 61 cm), and standing trays as from 27–30 in. (69–76 cm) long and 20–22 in. (51–56 cm) wide, and says that one end should be made nearly open 'for the convenience of having easy access to the glasses'. The corners were sometimes brass bound, and the folding stand had webbing straps to support the tray.[14]

PAPIER MÂCHÉ

In the nineteenth century, many trays were made of papier mâché, which had been made popular when Henry Clay of Birmingham took out a patent in 1772 for papier mâché panels which could be used in sedan chairs, coaches and cabinets. For years there was little change in the basic process of pasting sheets of paper over each other, but from about 1820 the Birmingham firm Jennens and Bettridge utilized the material to form a wide variety of articles, marked with their name.

Papier mâché is characterized by its intense black shiny surface and its effective painted patterns or inlaid decoration. Jennens and Bettridge took out a patent in 1825 for inlaying mother-of-pearl and twenty years later were inlaying glass beads and 'jewels' as well. By the time of the Great Exhibition of 1851, papier mâché furniture was at its richest and most splendid; tables and tea-trays were painted with flowers or architectural scenes, glove boxes, pole-screens, work-boxes, tea-caddies, chairs and even complete bedroom suites were all covered with decoration. A patent had been taken out in 1812 for the scattering of powdered metals on the surface of papier mâché and many Wolverhampton firms excelled in this. In the mid nineteenth century Jennens and Bettridge, anxious to maintain their lead, advertised the use of aluminium inlays too. They had sixty-four men working as decorators. A report of their products at the Great Exhibition said that they demonstrated 'the success which may attend the manufacturer who fearlessly carries out conceptions in any material however discouraging it may appear in the outset'.

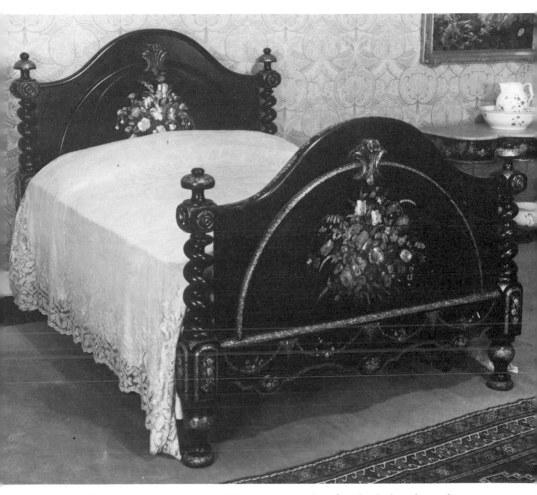

113. Bed, c. 1851, of pine and papier mâché inlaid with mother-of-pearl and coloured enamels
(Temple Newsam House, Leeds)

NURSERY FURNITURE

The children's rooms were usually on the top floor, out of earshot of parents
and guests. Children's chairs were direct replicas in miniature of adult chairs.
Many references occur in Tudor inventories to chairs made specially for

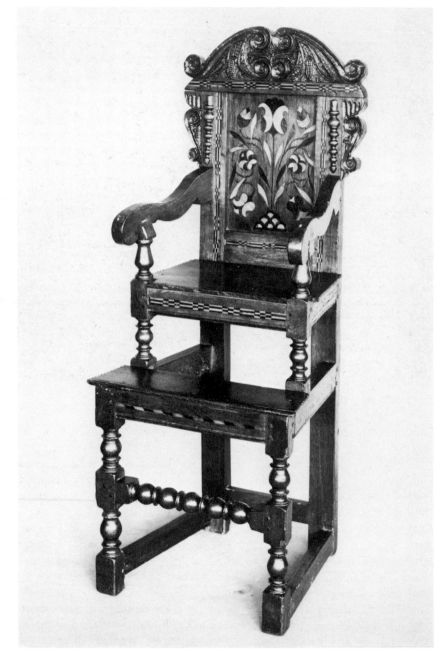

114. Child's armchair of the mid seventeenth century (Victoria and Albert Museum, London)

115. Late-Victorian nursery (Wallington, Northumberland)

children, but the earliest extant examples date from the first half of the seventeenth century. They were made of oak, with the legs and uprights inclined at an angle. They copy contemporary adult chairs in having cresting and brackets; some are provided with steps and retaining bars across the arms. Some chairs of later date were also intended to correct posture. An example is the high deportment chair designed about 1800 by the surgeon Sir Astley Cooper (1768–1841), which had a tall back and cane seat, and was intended to train children to sit up straight. Loudon illustrated a variant of Cooper's chair – not the original because some medical men did not approve of deportment chairs – which had a low back and a cane seat, with a bar passing through the ends of the arms to prevent its occupant falling out. Most of these early children's chairs were a combination of chair and table, and were to be used in the nursery, and in the dining-room when the children were permitted to join their parents. Windsor chair makers saw a ready market in high chairs for

children, as well as children's rocking chairs and smaller versions of other forms of Windsor chair. An unusual late-eighteenth-century nursery stool, made in oak, pegged and stained, is in the Bradford City Museums and Art Gallery collection. A tall handle rises from one corner, obviously intended to make the low stool easy to move.[15]

The nursery was also the home of toys, including the doll's house, with its miniature furniture.[16] Eighteenth-century examples at Nostell and Uppark reflect the grandeur of classical architectural forms.

Cradles, whether for sleeping dolls or for children, could be elegant and ordered, with carved standing angels at the head, or of simple pine mounted on rockers. According to the *Nottingham Cabinet-Makers' Book of Prices* (1795), 'a deal Cradle with arch'd head' cost 6s. Most Elizabethan and seventeenth-century cradles had hoods of wood or fabric, were set on curved rockers to produce a sideways swing, and were made of oak. Wicker-work cradles supported from posts became popular in the eighteenth century. Sheraton in his *Cabinet Dictionary* (1803) shows a design for a 'Swinging Crib Bed' which was operated by means of a clock spring.

FOR THE SERVANTS

VERNACULAR TRADITIONS

The subject of vernacular furniture has hitherto been somewhat neglected by furniture historians and much more research is needed. Vernacular furniture is characterized by the use of native timbers, pegged construction (except in turned chairs), a bold simplification of current styles, often with throwbacks to earlier styles, sound craftsmanship and a strong utilitarian character. Mahogany and other fashionable woods were not used. The term 'country furniture', although often used in this context, can be misleading; 'vernacular' is less ambiguous and more versatile.

Vernacular furniture evolved from the long tradition of working in oak; it became more refined during the eighteenth century and lasted until the early twentieth century, when it was ousted by a flood of cheap furniture – bamboo furniture and mass-produced cottage-style furniture for middle-class homes – which hastened the demise of the authentic craft workshops.

In the seventeenth century, provincial furniture was mainly of oak, of traditional joined construction, conservative in style, but with regional variations in form and decoration. By around 1700 the influence of the designs and techniques used in London was spreading to many of the provincial centres, and pattern books illustrating the currently fashionable styles were being published. This meant that there were now three categories of furniture being made: the trend-setting London pieces, the less accomplished provincial versions and the vernacular. At this time, vernacular furniture included a substantial proportion of archaic pieces: heavy oak hall cupboards, panel-back chairs, gate-leg tables and framed chests, demonstrating how the Jacobean style had become embedded in the native tradition; it also included belated versions of William and Mary designs. As the eighteenth century advanced, simple versions of Queen Anne, Chippendale and Hepplewhite styles were absorbed into the vernacular idiom. (But the advanced, near-Baroque pieces of cabinet-makers working in the style of William Kent were never copied.)

There were distinct regional variations in style in vernacular furniture, and research is currently being done to establish the regional characteristics.[1]

Of course, ordinary functional objects, such as dressers, benches, settles, corner cupboards, kitchen tables, cradles and so forth, are common to houses great and small, and certain chairs – ladder-backs, spindle-backs and the highly successful Windsor chairs – were acceptable at every level of society.

BACKSTAIRS FURNITURE

With the help of inventories, pictorial sources and fieldwork, we can learn a good deal about backstairs furniture.[2] It is clear that old-fashioned or damaged furniture from the family apartments was often used in the domestic quarters and the servants' bedrooms. On the other hand, the robust backstairs furniture of elm, ash or painted pine – particularly that from the kitchen – represents an independent branch of furniture making. Fitted storage cupboards, dressers, shelving and wall furniture could have been constructed by master carpenters working under the direction of a builder, or by the estate joiner, or may have been provided by local tradesmen. It is likely, however, that the massive tables, long forms and many-shelved dressers found in servants' halls and kitchens required the skills of a qualified joiner rather than a house carpenter. Much of this simple furniture was of pine, not always painted; during the nineteenth century, pine furniture with a grained finish was the commonest. Lesser households appear to have favoured oak.

Little backstairs furniture has survived from any period before the late eighteenth century; most is Victorian or Edwardian. It has received little scholarly attention, and needs to be researched in greater detail.

The Victorian house plan underpinned 'superior' country-house society and enabled it to achieve its most elaborate expression.[3] More attention was now given to the organization of the domestic offices in house planning; the function of every department and the status of all the servants were strictly defined. The owners of the great nineteenth-century houses were keen to introduce labour-saving devices; although labour was cheap, it was helpful to have gas, electricity, plumbing, lifts (including service lifts) and kitchen gadgets, even if they were of tortuous complexity, weight and size. In his fascinating book *The Victorian Country House* (1979), Mark Girouard writes:

> It is the organization of the plan of Victorian country houses which remains perhaps their most fascinating aspect. They were enormous, complicated and highly articulated machines for a way of life which seems as remote as the stone age, served by a technology as elaborate as it is now obsolete . . .

From numerous contemporary letters and accounts it is possible to learn something of the working conditions of servants. In the early-eighteenth-century household of the 1st Duke of Chandos, at Canons in Middlesex, tables in the dining-room were socially graded from the Duke's own table down to the 'kitchen table' where the humblest servants were seated. As late as 1936, a manual of household management recommended that the kitchen should have a baize door 'to keep noise and cooking odours from the front of the house', and stipulated that the kitchen should contain an easy-chair for every member of the staff.[4] In her autobiography, describing her early days at Clumber, the great Nottinghamshire house of the Dukes of Newcastle, Lady Diana Cooper writes of servants who fetched hot water, prepared hip baths, lit fires and oil lamps, cleaned shoes and silver, kept their place and were never seen.

THE KITCHEN

As well as cooking apparatus, the kitchen usually contained a centre table, one or more deal dressers with shelves, a side dresser, chopping blocks, a meat screen to stand round the fire when spit-roasting, and a haster (a large racked cupboard for keeping dishes of meat warm). One wall would have shelves displaying an impressive array of copper pans and jelly moulds.

The scullery, used for washing dishes and the preparation of vegetables, fish and game, led directly off the kitchen and had sinks and a hot water copper, with a large table, chairs, shelving and more plate racks. The cook's pantry, or dry larder, reserved for cooked meats was often fitted out with a broad dresser around three sides of the room, a centre table, and marble shelving. The wet larder, for raw meat, was provided with hooks, bacon racks, a table, chopping block, scales, and stone shelving. In larger houses game and fish larders were also common, and these would often have marble slabs inset into wooden shelves. Marble and tiled surfaces were also found in the dairy, which had an adjacent scullery for scalding milk vessels. There would also be outhouses for wood and coal, rooms for cleaning shoes, sharpening knives, cleaning plate and attending to oil lamps, china and plate cupboards and safes, and, in a large house, a bakehouse for fresh bread.

116. The kitchen (Wallington, Northumberland)

The Dresser

The dresser was particularly popular. The name is derived from the old French *dresseur* – a sideboard or table in a kitchen on which food was dressed – but it has come to mean a kitchen sideboard surmounted by rows of shelves on which plates and dishes are ranged. In the medieval hall the dresser was always in a prominent position, as plate was displayed on it. Early in the seventeenth century, however, dressers were generally found in the servants' quarters; shelves in the scullery were so described, and there was invariably a stout dresser in the kitchen, a humbler counterpart to that in the hall and parlour. Early Stuart dressers were almost always without a superstructure, and had geometrically panelled drawers, with cupboards below them. The front supports, three to five in number, might be shaped or spirally turned, while the back legs were merely flat posts, and rarely exceeded two in number.

117. Nineteenth-century kitchen table and dresser (Uppark, W. Sussex)

Dressers continued to be made on traditional lines for farmers and yeomen long after they had been supplanted by mahogany and walnut tables in the more fashionable houses. In the early eighteenth century the superstructure of shelves reappears, recalling the medieval pattern. These examples often have plain cabriole legs, and were decorated with motifs, such as dentilled cornices and fret friezes, in the style of fashionable furniture. The dresser now belonged to the kitchen and the adjacent areas. When J. C. Loudon wrote about them in 1833 he stated that the lower enclosed drawers were used for storing clean table cloths, towels, dusters and cutlery, and the central cupboard held wine, biscuits, sweetmeats, groceries or tea cups and glasses.

On some dressers the upper plate rails were arranged so that the pewter plates or pottery slipware dishes could lean forward, protecting their surfaces from dust. Dressers were usually made of oak, with brass handles, or, in the nineteenth century, of pine. Carved dates should be regarded with some suspicion, unless there are good pointers to provenance and authenticity.

The Kitchen Table

Large, workmanlike kitchen tables followed fashionable tables in style.[5] Early examples were usually of oak or elm; they were supported on trestles, united by rails and stretchers which passed through the uprights and were secured on the outside by stout pegs. Tudor inventories abound in references to tables of the trestle-type, as well as to tables which were not intended to be moved, and were presumably joined. Joined tables came into general use in the middle of the sixteenth century and were used in dining-rooms and backstairs. The bulbous form of leg which was fashionable in the late sixteenth and the seventeenth centuries did not, however, influence the style of kitchen tables. Sycamore was often used for the top as it is a white-yellow wood of tight grain, able to withstand hard wear and scrubbing.

Other Kitchen Equipment

The 1792 inventory of the contents of Newby Hall in Yorkshire records that the kitchen contained a plate rack. This is still at the house; it was designed to stand against the wall, and had graduated divisions for eighty plates in four tiers. It was made of painted pine, of pegged and nailed construction.

The dishes of meat prepared in the kitchen were kept warm in a large open deal cupboard called a 'haster'. This was on casters so that it could be wheeled to stand in front of the kitchen fire. The shelves, lined with tin, were open at the front and had doors at the back.

In about 1780 the contents of the kitchen at Appuldurcombe were listed in a detailed house inventory.[6] Sir Richard Worsley had inherited the house, on the Isle of Wight, in the late 1760s, and the state room furniture was supplied by Thomas Chippendale. The kitchen contained 'A large table, a small round do', two beech chairs, two deal dressers with drawers, a plate warmer and a press with folding doors, and an impressive array of spits, pots, pans, kettles, mortars and chopping boards.

UPPER SERVANTS' OFFICES

The butler's responsibility for the wine and plate meant that he had cellars, a safe, and a plate-cleaning room under his control. His 'pantry' was near the dining-room, and usually contained a small dresser with sinks beneath folding

covers, a glass closet, table, napkin press, linen drawers, shelving and a plate closet with baize-lined sliding trays.

The housekeeper supervised the female domestic staff from cook to scullery maid, and her parlour served as both a comfortable place to relax and a room for business. It was the social centre for the upper servants, and was furnished as a sitting-room. It had spacious presses containing drawers and shelves for china, glass, linen, tea, coffee, spices and fancy groceries. Adjoining the parlour was a still-room, used for preparing drinks, and for making jam, jellies, pickles, bottled fruit and pastry. It had a small range, oven, sink, dresser, table and large storage cupboards, either glazed or with solid doors. A china closet with spacious lockable cupboards was located near the housekeeper's room.

The house steward was in charge of the male servants. He paid wages, dealt with tradesmen and purchased supplies. His office usually had a high desk made with a sloping lid, with the interior fitted with letter holes and an ink-well block at the top: in addition, it might contain a dresser and bookshelves or a cupboard for the storage of files and minor valuables or expensive equipment. The steward also had a room which acted as a dining- and common-room for all the upper servants. The butler, head cook, housekeeper, valet, head lady's maid, and strangers' servants of equal rank dined with the steward, on the same fare served 'above stairs' to the family. The steward's room was therefore comfortably furnished with a dining-table, sideboard, presses, sofas and chairs. Near by might be the gun room, with lockable presses, glass-fronted cabinets and a strong table.

THE SERVANTS' HALL

The servants' hall was near to the kitchen, had a comfortable fireside and usually contained a wall clock with a large octagonal face and an eight-day movement. Good time-keeping was an essential to householding management and cooking, and there was often a similar clock in the kitchen. The servants' hall was furnished with long ash tables and forms, a dresser, Windsor chairs, a cupboard and perhaps even private lockers. In the eighteenth century the room was common to all the lower servants but in the nineteenth century it became common to segregate the women domestics in a maids' sitting and workroom. In 1859 the servants' hall at Chatsworth contained '3 Large Ash tables on carved pillars' and '10 long painted forms'.

In the medieval hall benches and settles were the ordinary seats; Gothic forms and chairs are now scarce, but many oak 'joyned' forms survive from

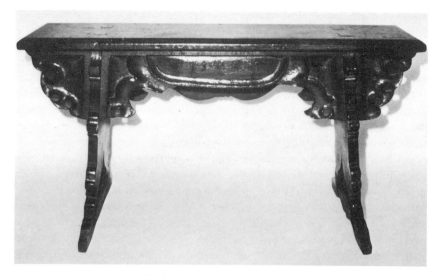

118. Late-Elizabethan oak form (Sizergh Castle, Cumbria)

the sixteenth and seventeenth centuries. They are generally supported by turned legs and low stretchers. In early inventories the terms 'bench' and 'settle' are interchangeable; grand settles were readily adaptable to a variety of purposes and were the nearest approach to a comfortable seat in most houses – there was usually one adjacent to the kitchen in the servants' hall. Settles were made in oak with a back of several chamfered (or 'fielded') panels and the seat was made to open as the lid of a chest. Some have dates carved into the wood.

A variation of the hall chair, known as a 'square-back' kitchen chair, was similar to the Regency yoke-back chair and was often found backstairs. In the early nineteenth century it was normally made in elm, ash, beech and (slightly dearer) cherry wood, and had simple vase-shaped splats in the back, flanked by tapered back-posts. In a common East Anglian pattern, it had simple square rails horizontally set in the back (rather than vertical splats) separated by small turned balls.

THE LAUNDRY

To prevent unpleasant smells and steam penetrating to the family rooms, the kitchen and the laundry offices were often situated in a building some distance

from the main house. The wash-house was generally sited under the laundry. At Broughton Hall, Yorkshire, the early-nineteenth-century laundry is almost perfectly preserved, complete with patent washing and wringing machines, a box mangle, a long ironing table fitted under the windows, an iron stove, spare table and drying closet with sliding racks.[7]

The Gillow *Estimate Sketch Book* shows a mangle of 1791 which took five or so days to make from oak and deal. It was an area in which patents abounded. The Leeds firm of Robert Bullman supplied to Sir Charles Tempest of Broughton Hall (on the Lancashire–Yorkshire border) in 1831 a 'Large size Patent washing machine £4; Wringing Apparatus complete £4 16.'[8] The 'Baker Patent' machine was made of beech, with a mahogany base board, and of pine and oak. A chain-driven wheel and pinion moved a box filled with stones to and fro over three loose wooden rollers around which the washing was wound. Loudon stated that 'the common mangle with the improved reversing mechanism known as Baker's Patent' was the best model. Box mangles remained useful until the time of the First World War – there was one in the new laundry at Sledmere in 1913. At Dungavel Lodge, Lanarkshire, a seat of the Duke of Hamilton and Brandon, the laundry still had a staff of seven at this time to process 1,800 articles a week.[9]

The drying of wet clothes was always carried out backstairs. Clothes which had got wet in the rain or towels used for bathing would be hung on a Towel Horse or clothes rail in use by the second half of the eighteenth century. Often made of pine and painted, it consisted of turned uprights supported by cross feet, and three or more horizontal turned rails. Loudon, in his invaluable *Encyclopedia* (1833), illustrates the types he knew[10], and Eastlake, approved of the use of turning for 'minor articles of household use which have been allowed to escape the innovations of modern taste. Among these may be mentioned the common Windsor chair, and the bedroom towel horse.'

The linen press was used for pressing linen while still damp. The clothes were placed between two oak boards and downward pressure was exerted on the top one by a spiral beech screw turned by means of a cross handle. The press was frequently mounted on a chest of drawers, but few survive in this complete state. Similar presses are still used by bookbinders.

SERVANTS' BEDROOMS

The chief officers of the household were entitled to separate rooms, the butler sleeping next to his pantry, the housekeeper and cook near their own domains,

and the lady's maid near her mistress. Maids who were required to live in usually shared bedrooms in the attic, while the men servants slept on another side of the house. In the mid eighteenth century a large-country-house owner managed with about fifty indoor and outdoor staff, but in the 1890s the first Duke of Westminster employed over three hundred at Eaton Hall, Cheshire.[11] The peak year for servants was 1871, when the Census revealed that 12.8 per cent of the female population was in domestic service.

Sophisticated painted pine bedroom suites were socially acceptable in country villas as early as the 1770s. Thomas Chippendale supplied refined chinoiserie pieces for David Garrick's house at Hampton on the Thames.[12]

119. Bedroom formed c. 1864; the furniture was painted white between the two World Wars
(Cragside, Northumberland)

During the Regency period, when such furniture had ceased to be fashionable in the family apartments, it was relegated to the servants' domain. A survey of backstairs furniture reveals some items little different from 'yeoman' pieces – oak chests and bureaux and elm chairs for example. However, the country-house examples seem bigger and plainer, with no evidence of lavish decoration.

Most servants had their own travelling lodging-box or kist, and were given the use of a chest of drawers in their bedrooms. Surviving wood lodging-boxes are usually of pine and are fitted with an internal till, lifting handles and a lock. They were the forerunners of tin trunks and the imitation leather trunks used by students. These kists held working and Sunday clothes, sheets, towels, knitting wools and so forth, and the till or 'shottle' was for keeping knitting needles and other small personal possessions. One type of chest of drawers was constructed in two stages, often with a pine carcase and oak drawers, veneered in burr elm; larger versions of the mahogany chests of drawers in the family

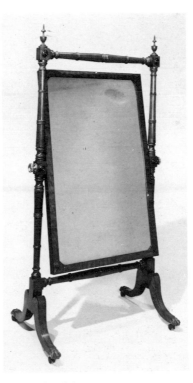

120. Cheval dressing mirror, *c.* 1820
(Victoria and Albert Museum, London)

apartments would also be found backstairs. It has been noted that 'farmhouse' specimens are often styled with cross-banding and corner collonets, while those which can be provenanced to country houses are generally plain.[13] Regency examples are often painted and have simulated bamboo mouldings. All these are described in inventories as 'wainscot chests of drawers'.

The inventory which William Vile and John Prestage prepared in 1754 of Anthony Chute's house at The Vyne in Hampshire listed the contents of sixty-two rooms, including a small beer cellar, a cheese room and a strong beer cellar.[14] The cook's room contained:

A half Canopy bedstead & furniture, a feather bed, bolster, 3 blanketts & a Cover lid.
A Do bedstead blew Stuf furniture, a feather bed & bolster, 3 blanketts & a Coverlid.
A wainst table & 2 chairs, a paire of Doggs.
A Shovel, tongues, bellows & brush, two iron rim'd Locks with brass nobs.

[Valued at £3 5s. 0d.]

By contrast, the Green Damask Bedchamber contained:

A 4 post bedstead with green Damask furniture a feather bed, bolster, 2 pillows, 3 blanketts, a Check Mattrass, an India quilt, a Counterpane, & two Draw up Damask Window Curtains, 6 mohog Chairs cover'd with green Damask, 2 arm Chairs covered with Do, a Mohog Corner table, a glass in a gilt frame, a Deale toylet table with quilted Silk peticoat & Cover and an India shade, a Dress Glass in a Japan frame, a Square Japan'd box, 10 Small boxes of Japan, 2 brushes & a tray, Cabt on a frame, a plaister figure, a Large Willton Carpet, a grate, a fire Shovel, tongues, poker & fender, bellows & brush, 2 brass Locks, the Damask hangings of ye Roome.

[Valued at £96 17s. 6d.]

Chippendale supplied Nostell Priory with beds for servants:[15]

[1766] 2 four post servants bedsteads £2 16. 0.
[1767] A 4 post servants bedstead for
 the cook's room 1 10. 0.

Very few early servants' bedsteads have survived, owing to the Victorian enthusiasm for hygienic iron beds. Gillows made both 'buroe bedsteads' and 'turn-up bedsteads', which conserved space, but the common form for servants was the 'stump bed' which had rope or canvas slats. These are occasionally found with the rope replaced by wood slats.

The bedroom would also have a wash-hand stand for personal hygiene. This was a development from the basin-stand in use in the late eighteenth century, of which there were many sophisticated Neo-classical versions. Backstairs wash-stands were frequently painted and incorporated a splash- (or wash-) board.

The flat table surface was often of marble, now that steam-sawing made it cheaper. Stands were supplied with a basin and jug, a sponge dish, soap-tray, toothbrush tray, soap-cup, foot-bath and water jug. Charles Eastlake, in his *Hints on Household Taste* (1868), praised the 'common bed-room wash stand . . . as will be found in the upper bedrooms of a moderately-sized house'. He described them as fitted with two shelves, the upper to hold the basin, and the lower one boxed to receive a drawer. There was a splash-board, and the four supporting legs were turned and shaped. Eastlake regarded a marble-topped wash-stand as superior to a French-polished one, which grows 'shabbier with every drop of water spilt upon it'.

In the late nineteenth century, wash-stands became more elaborate. Cheap ones had many shelves and toilet glasses, and decorative tiles in the splash-

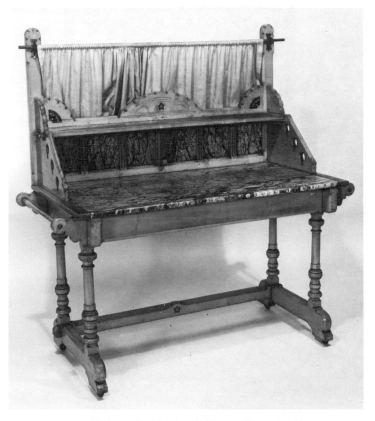

121. Wash-stand, 1865 (Temple Newsam House, Leeds)

board. Many were made in pine stained to look like satinwood. The fashion to make cheap woods look like more expensive ones was well advanced in the 1870s, and the London firm of Dyer and Watts popularized staining and graining as the best method of achieving this.

Bedroom furniture backstairs was usually made of deal; an alternative was bamboo (*Bambusa*), introduced from China in the second half of the eighteenth

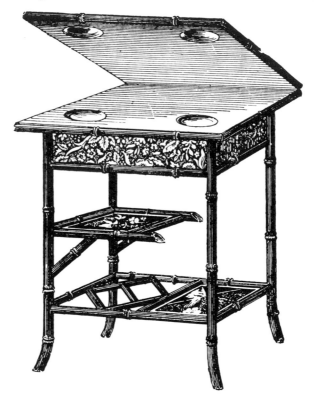

122. Folding bamboo card-table from a Liberty & Co. catalogue, 1898

century.[16] The architectural writers P. and M. A. Nicholson stated in the *Practical Cabinet Maker, Upholsterer and Complete Decorator* (1826) that bamboo was frequently used to make bedroom chairs. Sheraton noted in the *Cabinet Dictionary* (1803) that turned beech was painted to simulate bamboo. Birmingham became an important manufacturing centre. Metal was used to strengthen some of the joints.

Victorian extravagances were banished by about 1900 when the London firms of Liberty and Heal showed simple, well-designed wash-stands at the Paris Exhibition – exhibited only yards away from the flowing curves of the Art Nouveau displays. The designer C. F. A. Voysey (1857–1941) expressed the new mood in an interview of 1893: 'Simplicity requires perfection in all its details, while elaboration is easy in comparison with it.'[17]

∼ EIGHT ∽

OUT OF DOORS

The English landscape garden was pioneered in the 1720s by Stephen Switzer and Charles Bridgeman. In total contrast to the enclosed formal garden, the landscape garden was, although carefully contrived, designed to be naturalistic, a glimpse of Arcadia. The poet Alexander Pope took a great interest in garden design and adopted the new style for his riverside garden at Twickenham; he suggested improvements to the seventeenth-century garden owned by his friend, Robert, Lord Digby, at Sherborne in Dorset:

> Little paths of earth, or sand, might be made, up the half tumbled walls, to guide from one view to another on the higher parts; and seats placed here and there, to enjoy those views, which are more romantic than imagination can form them. I could very much wish this were done, as well as a little temple built on a neighbouring round hill that is seen from all points of the garden . . . It would finish some walks, and particularly be a fine termination to the river to be seen from the entrance into that deep scene I have described by the cascade.

Much attention was given to the contriving of vistas. In Pope's 'Epistle to Lord Burlington, Of Taste', published in 1731, he describes the making of such a garden, with its dusky groves, spreading lawns and vistas terminated with classical statuary or distant obelisks:

> To build, to plant, whatever you intend,
> To rear the Column, or the Arch to bend,
> To swell the Terras, or to sink the Grot;
> In all, let Nature never be forgot . . .
> Consult the Genius of the Place in all,
> That tells the Waters or to rise, or fall.

William Kent (see p. 126) designed landscape gardens for his patrons, including the garden of Carlton House in London. Kent, who had started life as a painter in the style of Claude and Poussin, was no gardener, but he had a good eye for the strategic placing of buildings and trees, the management of water in glades and the distant siting of artificial ruins as a focal point. One of these was the 'Merlin's Cave' he designed in 1735 for the royal gardens at Kew, for Queen Caroline; an engraving of it in John Vardy's *Some Designs of Mr Inigo*

Jones and Mr William Kent (1744) shows two rustic bookcases, with broken pediments, built of tree trunks, which matched those supporting the vaulted roof.

The English landscape garden had no more ardent amateur exponent than William Shenstone (1714–63), the poet. The precepts governing his Worcestershire garden, the Leasowes, were followed well into the nineteenth century. His garden was visited by everyone of pretension or consequence from Samuel Johnson to Horace Walpole, as well as by Sunday starers from the neighbourhood. He copied, on a small scale, the ideas of William Kent.

The best description of Shenstone's garden is that written by his publisher Richard Dodsley in 1764. The house stood on a lawn, protected by a dense shrubbery and a sunken fence – a ha-ha. From it a gravel path turned and twisted around and across the hilly estate. There were no fewer than thirty-nine seats to rest on and admire the distant prospect of the medieval Halesowen Abbey and the slopes of Hagley Park. Some seats were 'common benches' placed so that the contrived view could be observed or in 'natural bowers'; some were lofty Gothick seats; octagonal or pyramidal seats were set between the urns, obelisks and trophies that strewed the pathway, many engraved with memorial verses to a host of friends. 'Most of the seats were rustic affairs made of wood, which Thomas Hull, one of Shenstone's friends described as "very near as Costly & well finished, as a common Windsor Chair".'[1]

The compilers of the Gothick pattern books and manuals of instruction to carpenters and joiners were anxious to provide ideas and new designs for garden furniture. Principal among them were William and John Halfpenny, and Charles Over. Their lengthy titles set in Baskerville type bit dark into the hand-made paper. The Halfpennys' book was called *New Designs for Chinese Temples, Triumphal Arches, Garden Seats, Palings &c.* (1750–52), while Over (1758) waxed lyrical in his subtitle:

Ornamental Architecture in The Gothic, Chinese and Modern Taste . . . (Many of which may be executed with roots of trees) for gardens, parks, forests, woods, canals &c. containing palings of several sorts, gates, garden-seats both close and open, umbrellos, alcoves, grottoes, and grotesque seats, hermitages, triumphal arches, temples, banqueting houses and rooms, rotundos, observatories, icehouses, bridges, boats, and cascades . . .

A general interest in the rustic style evolved in the 1750s, and the Halfpenny and Over publications were joined by *A New Book of Ornaments* by Matthias Lock and Henry Copland. They emphasized the rustic element in furniture, but the designs were really Chinese and, as with Thomas Johnson's furniture designs of the late 1750s, appear to be intended for carvers' work for stylish

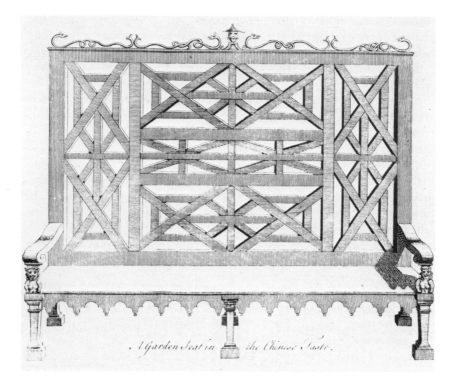

123. 'A garden seat in the Chinese taste', from William Halfpenny's
New Designs for Chinese Temples, 1750

household furniture, not garden furniture. However, Edwards and Darly's
New Book of Chinese Designs (1754) did include etchings of four chairs and a
table intended for use in garden buildings and 'created out of the most
outlandish contortion of tree roots'.[2]

On 13 July 1754, an advertisement appeared in Jackson's *Oxford Journal* for
'Garden Seats, Windsor and Forrest Chairs and Stools, in the modern Gothic,
and Chinese Taste . . .' made by William Partridge. It seems to be (with the
Edwards and Darly book) among the first to promote seats 'that looked as if
they had been constructed, with studied rustic intent, from logs and branches
of trees'.[3] In the third edition of the *Director* (1762), Chippendale illustrated a
seat and two chairs, recommending them for 'arbours, summer-houses and
grottoes'. The materials were not specified, but 'the backs may be cut out of
the Solid Board'. In the *Cabinet and Chair Makers' Real Friend and Companion*

(1765), Manwaring illustrated fourteen rustic seats, which he claimed were 'the only ones of the kind that ever were published'. They were to be made 'with the limbs of Yew and Apple trees, as Nature produces them', but well seasoned, the bark being peeled off and pieces of appropriate shape being selected.

Not to be outdone by Manwaring, the third edition of Chippendale's *Director* (1762) contained nine designs of chairs after the 'Chinese manner'. They were recommended for Lady's dressing-rooms or for Chinese temples. 'They have commonly Cane-Bottoms, with loose cushions; but if required, may have stuffed Seats, and brass nails.' The mood for things Chinese had been kept alive in the late 1750s by the appearance of Sir William Chambers's *Designs of Chinese Buildings* (1757) and, in the following years, by the buildings he designed at Kew, including the famous pagoda. The last eighteenth-century publication in which rustic chairs were depicted to the exclusion of other types was in the anonymous *Ideas for Rustic Furniture*, c. 1790. The wooden elements of the designs were intended to be made of 'thin untrimmed branches', although they all showed unmistakable Neo-classical characteristics in shape.

Mid-eighteenth-century paintings by Thomas Gainsborough, Arthur Devis, and others show wooden and metal seats placed at the focal point of a view,

124. Garden armchair in wrought iron, c. 1790 (Victoria and Albert Museum, London)

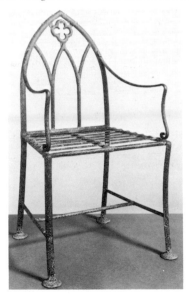

although it is obvious that some are chairs of the Windsor type taken out of doors for the occasion.[4]

The period after 1840 provides clear evidence of growing material wealth and a steady improvement in the standard of living – conditions which favoured the production of commercial furniture and provided for some the leisure to spend in gardens. The growing interest in the garden, or pleasure-

125. Late-eighteenth-century trade card

ground, as opposed to the more distant vistas of the landscaped park had been encapsulated by William Gilpin, in 1791: 'Here the lawns are shorn . . . elegant gravel walk; and knots of flowers, and flowering shrubs are introduced . . . Here too, if the situation suits it, the elegant temple may find a place.'[5] The 'higher polish' he advocated for this area, and the fact that the Birmingham and Coalbrookdale factories were soon producing umbrello temples and garden seats in wire-work or durable cast iron led to a new style of garden ornament. It replaced what had gone before, which was made in wood, and which we know only from engravings and paintings.

Cast iron received the approval of the writer and encyclopedist J. C. Loudon. He advocated its use on the basis of economy, for chairs in halls, porches, lobbies, public houses and gardens. Among those he illustrated in 1833 was a

'Gothic chair wholly of cast iron', and an Etruscan lobby chair. He pointed out that cast iron was cheaper than wood, but provided instructions for painting the lobby chair to imitate oak. Cast-iron furniture was normally registered with the Patent Office, and from 1842 until 1883 many wares were marked with a diamond-mark, which, using a simple code, gives the day, month and year of registration, and often the maker's name. A rocking chair made of

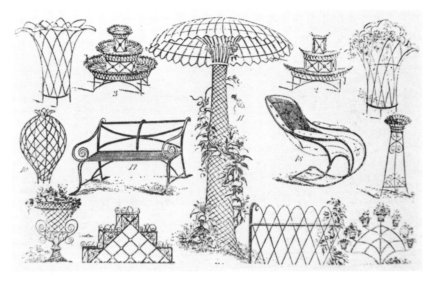

126. Advertisement by John Porter for his park and garden furniture, c. 1839

brass, and suitable for garden use was made by the Birmingham manufacturer R. W. Winfield (who was noted for making beds) and shown by him at the Great Exhibition of 1851.

Rigaud's view of 'The Queen's Theatre from the Rotunda at Stowe', in Buckinghamshire, 1733–4 'shows a man and woman seated on chairs of Windsor design mounted on platforms fitted with wheels and tillers', while an etching by James Gillray of 1808, 'Delicious Weather', shows a bench-type garden seat with handles at one end, wheelbarrow style, and a pair of wooden wheels at the other. As the landscape gardener Humphrey Repton (1752–1818) wrote, 'the spot from whence the view is taken is in a fixed state to the painter; but the gardener surveys his scenery while in motion . . .'

The work of Gertrude Jekyll, who designed gardens in the early twentieth

century to complement the houses of the architect Edwin Landseer Lutyens, is well known. For these gardens Lutyens designed garden seats and tables, often in oak, using traditional craftsmanship and materials. Equally fine was the garden furniture produced in the Cotswold workshop of the Barnsley brothers at Sapperton.

Deck-chairs, in all their finger-pinching complexity, were to be seen on every Victorian lawn, and have continued almost unaltered to the present day. There have been, from the late nineteenth century, revivals of Chippendale-style lattice garden seats by firms such as Gillows, and presently the Chatsworth and Erddig estate workshops.

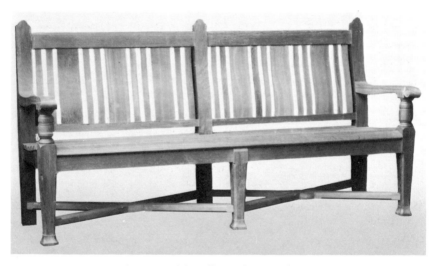

127. Garden seat made by Gillows in large numbers, c. 1905–10

APPENDICES

1. WOODS IN COMMON USE

See F. L. Hinckley, *Directory of Historic Cabinet Woods*,
New York, 1960.

ACACIA (*Robinia pseudacacia*). Dull yellow with brown veins and markings. John Evelyn (*Sylva*, 1664) refers to its use by inlayers. It ranks second to oak in durability.

ALDER (*Alnus*). Flesh tinted when dry. Used for country-made furniture; polishes to a fine figure similar to curled maple.

AMBOYNA (*Pterospermum indicum*). West Indies: warm brown-honey tone. Used for veneers as whole surfaces, and in inlays and bandings, as it has a pronounced burr figure.

APPLEWOOD (*Malus*). Hard, light, warm wood employed for inlays and applied carvings in seventeenth-century work.

ASH (*Fraxinus excelsior*). White, with yellow-brown streaks. Used for chairs, including the Windsor type, but subject to worm.

BEECH (*Fagus sylvatica*). Soft, white to pale brown. In popular use from the mid seventeenth century, but subject to worm. Often covered with gilded gesso, upholstered, or painted.

BIRCH (*Betula alba*). White, shaded and tinged with red. John Evelyn (*Sylva*, 1664) regarded it 'of all others the worst of Timber'.

BOXWOOD (*Buxus sempervirens*). Light brown when polished. Hard, used for moulds, inlay and marquetry, and for border lines.

BRAZILWOOD (*Caesalpinia brasilensis*). Reddish, with strong markings. Heavy, hard, rich when polished. Seldom used in the eighteenth century.

CALAMANDER (*Diospyros quaesita*). Light brown, mottled and striped with black. Used for Regency-period veneers and banding.

CEDAR (*Juniperus virginiana*). Red cedar, used for drawer linings, trays, boxes, etc. on account of its pleasant aroma.

CHESTNUT, Horse (*Aesculus hippocastanum*). Yellowish.

CHESTNUT, Sweet (*Castanea vesca*). Almost white. Similar grain to satinwood and used in solid and as veneer, 1750–1800.

COROMANDEL (*Diospyros melanoxylon*). Bombay ebony; resembles black rosewood; intermingled with light stripes.

CYPRESS (*Cupressus sempervirens*). Hard, reddish, close grain. Resistant to worm. Evelyn in *Sylva* (1664) is poetic about it: 'resisting the worm and moth and all putrefaction to eternity'.

DEAL, *see* Pine.

DOGWOOD (*Cornus sanguinea*). Light yellow sap wood with yellow-red heart. Used as inlay in sixteenth and seventeenth centuries.

EBONY (*Diospyros* species). Black, of close texture, very hard, free from shrinkage and warping, smooth and resistant to decay. Used as veneer and for clock cases.

ELM (*Ulmus procera*). Brown, fibrous, liable to warp, subject to worm. Wych elm (*U. glabra*) was preferred, having a straight, fine grain, suitable for steam bending. Commonly used for seats of Windsor chairs. Burr elm valued for veneers.

FIR, *see* Pine.

FUSTIC (*Chlorophora tinctoria*). Yellow, also produces yellow dye. Used by inlayers; Chippendale used it as a veneer. Sheraton (1803) noted that air and sun turned it a dead brown; its use thereafter declined.

HAREWOOD. Sycamore or maple stained greenish grey with iron oxide. Often referred to in seventeenth- and eighteenth-century accounts as 'airwood' or 'silverwood'.

HOLLY (*Ilex aquifolium*). White, flecked grain, hard. Used for inlays on oak and walnut and by marquetry cutters; sometimes stained. Evelyn (*Sylva*, 1664) – 'the whitest of all hard woods'.

KINGWOOD (*Dalbergia* species). Light tone, as rosewood (to which it is related); sometimes called 'prince's wood'. Used as a veneer, or for parquetry, cross-banding, etc.

LABURNUM (*Laburnum vulgare*). Yellow tint, varied brown streaks, popular for parquetry (geometrical marquetry) veneer.

LARCH (*Larix decidua*). Yellow-white, reddish brown, liable to warping, straight grain. Extensive eighteenth-century Lake District plantings deplored by William Wordsworth.

LIGNUM VITAE (*Guaiacum officinale*). Dark brown, streaked with black, extremely hard, used for oyster-shell parquetry and for turned bowls and cups.

LIME (*Tilia vulgaris*). Yellow or white, close-grained, smooth. Favoured by carvers for picture and mirror-frames as it cuts well with or across grain.

MAHOGANY (*Swietenia* species). Introduced to England from the West Indies in quantities after 1724, noted for straight grain and dark red colour. The Cuban variety is dark and richly figured; mahogany from Honduras, imported in later eighteenth century (known as baywood), is lighter in colour with little figure. Remained in use for fine furniture until well into the nineteenth century.

MAPLE (*Acer campestris*). White, veined, polishes well. Bird's eye maple (American sugar maple) was used as a veneer in the Regency period, and for nineteenth-century and Edwardian bedroom suites.

MULBERRY (*Morus nigra, M. alba*). Golden-brown, with dark streaks, hard, heavy. Used as a veneer in the Queen Anne period.

OAK (*Quercus* species). White-brown, hard and heavy. In use from medieval times, but restricted to carcase work and drawer linings from seventeenth century (apart from Art and Craft revivals).

OLIVE (*Olea europaea*). Yellow-green, close grain, used as veneer and for cross-grain mouldings.

PADOUK (*Pterocarpus dalbergiodes*). Golden-brown to deep red or crimson. A variety of rosewood, reserved for exceptional pieces.

PARTRIDGE WOOD (*Andira inermis*). Brown, red, shades in streaks resembling bird's feather, straight grain; used – rarely – as a veneer.

PIGEON WOOD. Name given to the wood of various tropical or subtropical trees or shrubs – so-called from marking or colouring. See Zebra-wood.

PINE OR DEAL (*Pinus*) – Scots pine (*P. sylvestris*), spruce fir (*P. picea*). White, pale yellow. Often gilded, having a smooth surface; also much used for carcase work. Sheraton, *Cabinet Dictionary* (1803): 'from Deel, Dutch for a part, quantity or degree of. Hence fir or pine timber being cut into thin portions they are called deals.'

PLANE (*Platanus acerifolia*). Very white, close grain. Used in early nineteenth century as alternative to beech for painted chairs.

PLUM (*Prunus domestica*). Yellowish heart, brown-red, resembles mahogany, hard and heavy.

POPLAR (*Populus* species). White-yellow to grey, close, firm. Used in inlays, stained, liable to shrinkage.

PRINCE, PRINCE'S WOOD, *see* Kingwood.

PURPLEHEART (*Peltogyne* species). Name describes colour when freshly cut, similar to rosewood; used for veneer banding, line inlays.

ROSEWOOD (*Dalbergia* species). Dark purplish brown with variegated figure. Heavy and durable. Used in the seventeenth century for inlaying and in the Georgian period as a veneer.

SATINWOOD – East Indian (*Chloroxylon swietenia*), West Indian (*Xanthoxylun flavium*). Yellow toned, largely supplanted by rosewood after 1800. Used as veneer, rarely in the solid. Cabinet-makers according to Sheraton (1803) preferred the West Indian variety 'because of its breadth and general utility'.

SILVERWOOD, *see* Harewood.

SNAKEWOOD (*Colubrina* species). Deep bright red, with dark rings and spots. Used as veneer.

SYCAMORE (*Acer pseudoplatanus*). White, yellows on ageing, fine, tight grain, takes good polish. When polished known as harewood (q.v.). Used in solid and as veneer.

THUYA (*Tetraclinis articulata*). Warm brown, wavy line marking and birds' eyes, resembling those in amboyna (q.v.). Liable to disintegrate when used as a veneer.

TULIP WOOD (*Dalbergia* species). Yellow, shading to red. Used as banding in the eighteenth century.

WALNUT (*Juglans regia, J. nigra*). Pale brown with brown and black veinings. *J. nigra* has deep brown colour. Used for quality cabinet work. Often of native origin, but also imported from Virginia and Maryland in the eighteenth century. Almost supplanted in use by mahogany (q.v.).

WILLOW (*Salix*). Pale brown, flecked, polishes well, often dyed black to simulate ebony. The saplings (*osiers*) used for wicker-work.

YEW (*Taxus*). Reddish brown. When burred similar to amboyna (q.v.). Used for country chairs and as veneer.

ZEBRA WOOD (*Pithecolobium raceiniflorum*). Light brown, marked with wide bands of deep brown. Hard, heavy. Used as veneer in cross-bands but some bureaux and tables wholly surface-veneered. Its use had declined by 1820.

2. A LIST OF CABINET-MAKERS AND DESIGNERS

This list includes only the more important names encountered on labels, in guide-books and in general books on English furniture. The standard list, available in 1986, will be the Furniture History Society's *A Dictionary of English Furniture Makers, 1660–1840*. See also Ralph Edwards and Margaret Jourdain, *Georgian Cabinet-Makers* (3rd ed., 1962) and Sir Ambrose Heal, *The London Furniture Makers* (1953). Full details of books referred to in brief are given in the Bibliography. 'Gilbert, *Catalogue*', indicates Christopher Gilbert's *Furniture at Temple Newsam House and Lotherton Hall*, 2 vols., 1978.

ADAM, Robert (1728–92) Plates 11, 63–5 and 76
Architect and Neo-classical designer of outstanding ability and influence. Trained in Italy, 1754–8. Important furniture to his design, or inspired by him, was made by Thomas Chippendale, John Linnell and Samuel Norman.
 See Beard, *Robert Adam*; Gilbert, *Chippendale*; Harris, *Furniture of Robert Adam*; Musgrave, *Adam and Hepplewhite Furniture*.

ALKEN, Sefferin (fl. 1744–82) Plate 91
Worked as a carver for Robert Adam at several houses, also for Sir William Chambers. Collaborated with John Cobb in carving chairs for the 6th Earl of Coventry (1763) and did other carving for him at Croome Court and in Croome D'Abitot Church. Provided a stand (1783) for a Mannerist silver-gilt dish at Stourhead.
 See Beard, *Craftsmen and Interior Decoration*, p. 241.

BALDOCK, Edward Holmes
Fashionable London art dealer, furniture maker and restorer until his retirement in 1843. Married the daughter of Sir A. Corbet. Family vault, Buxted, Sussex. Various commissions for the royal family and members of the nobility (e.g. Duke of Buccleuch).
 See Geoffrey de Bellaigue, 'Edward Holmes Baldock', *Connoisseur*, August, September, 1975; Gilbert, *Catalogue*, no. 395.

BARNSLEY, Ernest (1863–1926) and Sidney (1865–1926)
Life-long friends of E. W. Gimson (q.v.). The brothers were articled as

architects, but in 1893 they moved to the Cotswolds, and in 1903 to
Sapperton. Sidney Barnsley concentrated on furniture-making and became
the best of the Cotswold School of furniture makers. The work of the two
Barnsleys, much of it in unstained oak, is best studied at Rodmarton Manor,
Gloucestershire, which Ernest Barnsley designed for the Hon. Claud
Biddulph from 1909.

See Lionel Lambourne, *Utopian Craftsmen . . .*, 1980; Comino, *Gimson and
the Barnsleys*.

BECKWITH, Samuel (fl.1774–1810)
In partnership with William France (q.v.) to 1774; worked as royal cabinet-
maker 1784 to 1810, latterly in partnership with Edward France.

See Edwards and Jourdain, *Georgian Cabinet-Makers*.

BELCHIER, John (d. 1753) Plates 1 and 35
At Ye Sun, St Paul's Churchyard. Supplied furniture to John Meller of
Erdigg in the 1720s.

See Edwards and Jourdain, *Georgian Cabinet-Makers*.

BELL, Philip
Cabinet-maker at The White Swan, St Paul's Churchyard, into the 1770s.
Succeeded his mother, Elizabeth, widow of Henry Bell (d. 1740). There are
labelled pieces by him at Colonial Williamsburg (Virginia).

BENNETT, Samuel (d. 1741)
Early-eighteenth-century London maker in Lothbury. Labelled bureau-
bookcase in Victoria and Albert Museum.

See Edwards, *Shorter Dictionary*, p. 644.

BOSON, John (fl. 1727–43)
Carver and furniture maker. Provided mahogany writing-table to Chats-
worth, and base for Florentine cabinet at Stourhead.

See Beard, *Craftsmen and Interior Decoration*.

BOULTON, Matthew (1728–1802) Plate 80
English manufacturer of silver and ormolu.

See Goodison, *Ormolu*.

BRADBURN, John (d. 1781)
Carver and cabinet-maker of Long Acre, employed by Vile and Cobb,
whom he succeeded as royal maker on 31 May 1763. In partnership with
William France (q.v.).

See Edwards, *Shorter Dictionary*, p. 645.

BRADSHAW, George Smith (d. 1787?)

In partnership with Paul Saunders in Soho until 1758. Continued on his own account and provided furniture to the Crown, 1764–74.

BRADSHAW, William (fl. 1736–50)

Possibly related to George Smith Bradshaw (above). Active in commissions for 2nd Earl Stanhope and 4th Earl of Cardigan in the late 1730s. Also worked at Holkham and provided upholstery for Longford Castle.

See Edwards and Jourdain, *Georgian Cabinet-Makers*.

BULLOCK, George (d. 1818)

Of Liverpool and London. Worked in the Grecian style; his name is associated with brass inlaid furniture mounted with ormolu.

See Joy, *English Furniture*; V. Glenn, *Furniture History*, xv, 1979.

BUTLER PATENT FURNITURE

See this book, p. 204.

CHAMBERS, Sir William (1727–92)

Architect to George III and rival of Robert Adam (q.v.). In his youth had stayed in Italy and China and was an important designer at an early stage in the development of the Chinoiserie and Neo-classical styles. Fancied himself as a connoisseur of furniture (see this book, p. 50).

See J. Harris, *Sir William Chambers*, 1970; J. Harris, *Furniture History*, II, 1966, pp. 1–6.

CHANNON, John (fl. 1740–55)

Of Exeter and London. Probable author of an impressive group of brass inlaid furniture made in the 1740s. Moved to London c. 1737 from Exeter. Signed bookcases at Powderham Castle, Devon, provide evidence of style. Subscriber to Chippendale's *Director* (1754).

See Gilbert, *Catalogue*, no. 222; J. F. Hayward, *Victoria and Albert Museum Bulletin*, January 1965, April 1966.

CHIPPENDALE, Thomas (1718–79) Plates 59 and 66–8

The most important eighteenth-century cabinet-maker; published an influential pattern book in 1754.

See Gilbert, *Chippendale*, and this book, p. 132.

CHIPPENDALE, Thomas, junior (1749–1822) Plates 88 and 90

Eldest son of Thomas Chippendale (above). Traded as Chippendale and Haig until Thomas Haig's retirement in 1796. Went bankrupt in 1804. Principal commission for the Hoare family at Stourhead, Wiltshire.

See Edwards and Jourdain, *Georgian Furniture*; J. Kenworthy-Browne, *National Trust Yearbook 1975–6*; and this book, p. 169.

COBB, John (1715(?)–1778)
Presumed to be from Ashby, Norfolk; apprenticed in 1729 as an upholsterer. Partner of William Vile (q.v.) 1751/2–1767. Married twice, first to a daughter of Giles Grendey (q.v.). Imperious but talented. Made some fine Neo-classical furniture for the Methuen family (Corsham, Wilts.).
See Edwards and Jourdain, *Georgian Furniture*, and this book, p. 146.

COXED AND WOSTER (fl. 1690–1736)
Labelled bureau-bookcases by this firm (Temple Newsam House, Leeds; Colonial Williamsburg) survive; made in mulberry and burr elm inlaid with pewter. Woster provided furniture to Stourhead, and died in 1736. His premises were later occupied by the Bell family, and by Philip Bell's successor, Henry Kettle.

CULLEN, James (fl. 1755–79)
Premises at 56 Greek Street, Soho. Worked extensively in Scotland for the Earl of Hopetoun and the Duke of Atholl. Had some business connections in the 1760s with Samuel Norman (q.v.) from whom he purchased a state bed (1768) for Hopetoun.
See Coleridge, *Chippendale*.

DARLY, Matthias (fl. 1741–60)
Print-seller, engraver and publicist of the Chinese style. May have trained as an architect. Engraved many plates for Chippendale's *Director* (1754) and lived adjacent to the cabinet-maker.
See C. Gilbert, *Furniture History*, XI, 1975; Gilbert, *Chippendale*, vol. I, 1978.

DOWBIGGIN, Thomas (1788–1854)
Founder of one of the most successful early Victorian firms, which later became Holland & Sons (q.v.). Before and after the merger, worked for the Crown and shared responsibility for the arrangements of the Duke of Wellington's funeral (1852).

DRESSER, Christopher (1834–1904)
Active designer and author of several books on design. Approached his design work through a study of natural forms and disliked false work such as graining.

EDWARDS, Edward (1738–1806)
Worked for William Hallett (q.v.) in the 1750s; better known as teacher of drawing to artists and cabinet-makers. Associate of the Royal Academy, 1773; frequent exhibitor there.
See Edwards, *Shorter Dictionary*.

EDWARDS AND ROBERTS
A fashionable London firm founded in the early nineteenth century; made many high-quality reproductions. They were based in Wardour and Oxford Streets, and their work is often stamped on drawer edges with their name or bears their label.

ELLIOTT, Charles (1752–1810)
Supplied furniture to George III and the Duke of York. His furniture was elegantly made in satinwood in a late Neo-classical style – much survives at Langleys, Essex – and he enjoyed a late partnership with Edward France (q.v.), his brother-in-law, who took over the business (104 Bond Street) at Elliott's death.

ELWICK, Edward. *See* Wright and Elwick.

FLITCROFT, Henry (1697–1769) Plate 53
Started life as a joiner, and became architectural assistant to Lord Burlington. He had a special aptitude for designing decorative features such as chimney-pieces and furniture.

FRANCE, Edward and William (?–1774)
William France was appointed, with his partner John Bradburn (q.v.), to succeed Vile and Cobb as royal cabinet-makers on 31 May 1763. Employed by several of Robert Adam's patrons, including the 1st Earl of Mansfield (Kenwood). His son (?) Edward continued the business after William's death, in partnership with Samuel Beckwith (q.v.), as his father (?) had been. The firm survived into the early nineteenth century.

FUHRLOHG, C. (fl. 1759–85)
Swedish cabinet-maker who came to London in 1768 and later described himself on his trade cards as 'Ébéniste to his Royal Highness the Prince of Wales'. May have supplied marquetry panels to other cabinet-makers.
See J. F. Hayward, *Burlington Magazine*, November 1969, pp. 648–55; ibid., October 1972, pp. 704–12; ibid., July 1977, pp. 486–93. Summarized in Hayward and Kirkham, *William and John Linnell*, pp. 63–7.

GATES, William (fl. 1777–83)
Succeeded John Bradburn (q.v.) as tradesman to the Great Wardrobe in 1777. He specialized in making inlaid furniture. Sometime partner of Benjamin Parran (q.v.).

GILLOWS of Lancaster and London Plates 84, 108, 109 and 127
One of the most successful eighteenth-century firms, founded by Robert Gillow (1703–73); survived in its original form until 1932.
 See this book, p. 164.

GIMSON, Ernest William (1864–1919)
Joined the Arts and Crafts movement after meeting the Barnsley brothers (q.v.), with whom he formed the firm of Kenton and Co. (Gimson, Sidney Barnsley, W. R. Lethaby). Gimson and the Barnsleys moved to the Cotswolds in 1893, and by 1903 all three had settled at Sapperton. Gimson produced furniture of fine proportions and excellent construction. He employed professional cabinet-makers, unlike his friend Sidney Barnsley, who executed his own designs. There are important collections of Gimson's work at Leicester, Cheltenham and Bath (Holburne of Menstrie Museum).
 See S. Baker, *Apollo*, January 1979, pp. 42–9.

GODWIN, Edward William (1833–86)
Architect and designer. He created the Anglo-Japanese style. His furniture was much admired in Austria and Germany, where it was praised as progressive.

GOMM, William (*c.* 1698–1780) and Richard (*c.* 1729–94)
Set up in 1736 in London near to Giles Grendey (q.v.), and worked with the eminent cabinet-maker Abraham Roentgen at this time. Little is known of the firm's production but a collection of their furniture designs survives at Winterthur (Henry Francis du Pont Museum) showing them to be most adept in the current Gothick and Chinese styles.
 See L. O. J. Boynton, *Burlington Magazine*, June 1980, pp. 395–402.

GOODISON, Benjamin (*c.* 1700–1767) Plates 40–42
Apprenticed to James Moore, senior (q.v.), and succeeded him in royal service in 1727. From the fact that he was still calling James Moore 'my master' in 1720 he was probably born about 1700. He was probably one of the main providers of Kentian-style furniture characterized by Greek frets and gilt enrichments, such as survives at Longford Castle and Chatsworth.
 See Geoffrey Beard, *Burlington Magazine*, July 1977, pp. 479–86.

GORDON, William and John (fl. 1748–96)

Later as Gordon and Taitt. John and William Gordon may have been brothers. They provided furniture to the Duke of Atholl for Blair Castle (1753) and worked with John Vardy at Spencer House in the late 1750s. They appear as Gordon and Taitt in 1768 – the Taitts, Richard and John are noted in London directories until 1799 – and supplied furniture for Audley End in 1771.

See Coleridge, *Chippendale*; Edwards, *Shorter Dictionary*.

GRENDEY, Giles (1693–1780)

Had extensive workshops in Clerkenwell and one of the largest work-forces; active export business in scarlet-japanned furniture. His label is found often (Gilbert, *Catalogue*, no. 61, colour plate). His daughter Sukey married John Cobb (q.v.) in 1755.

See C. Gilbert, *Antiques*, April, December 1971.

GUIBERT, Philip (fl. 1697–1705) Plate 6

One of the small group of Huguenot craftsmen working in London in the style of Daniel Marot (q.v.). Guibert worked at Windsor Castle and Kensington Palace and, in about 1703, provided an upholstered day bed and sofa to the 1st Duke of Leeds, now at Temple Newsam House, Leeds.

See Gilbert, *Catalogue*, nos. 322–3.

GUMLEY, John (? 1729) Plates 37 and 39

Son of Peter and Elizabeth Gumley. The firm specialized in japan cabinets and looking-glasses. Gumley seems to have taken James Moore (q.v.) as a partner about 1715. Signed Gumley mirrors survive at Hampton Court and Chatsworth.

See Geoffrey Beard, *Burlington Magazine*, July 1977, pp. 479–80, and this book, p. 113.

HAIG, Thomas (1727–1803)

Partner of the elder Thomas Chippendale from 1771–9, and to his son Thomas until his own retirement in 1796. Acted as a business partner, keeping the books and attending to correspondence.

See Gilbert, *Chippendale*, vol. 1, p. 14.

HALLETT, William (1707–81)

Of Great Newport Street, London, where he started a successful business (from 1732). In 1753 he became a business partner of William Vile (q.v.) and John Cobb. He spent more of his time in middle life on rebuilding

Canons, Middlesex, formerly the seat of the 1st Duke of Chandos. His career is intermingled with that of his son, William (d. 1767). He became a rich man and retired in 1769. His grandson William, and his grandson's wife, are the subjects of Thomas Gainsborough's *The Morning Walk*, 1786.

See this book, p. 146, and Geoffrey Beard, *Burlington Magazine*, July 1977, p. 485; Geoffrey Beard, *Furniture History*, XI, 1975, pp. 113–15.

HAUPT, Georg (fl. 1747–69)

Brother-in-law of Christopher Fuhrlohg (q.v.). Born in Sweden. In London by early 1768, and probably introduced to John Linnell (q.v.) by Sir William Chambers (q.v.). He made an important contribution to the development of Linnell's marquetry furniture. Returned to Sweden in 1769.

See Hayward and Kirkham, *William and John Linnell*, pp. 63–6; Edwards, *Shorter Dictionary*, p. 659.

HEAL, Sir Ambrose (1872–1959)

Showed that well-designed furniture could be made available at a reasonable price. Entered the family firm of Heal & Son in 1893, and issued his first catalogue of oak bedroom furniture in 1898. He designed hand- and machine-made furniture.

HEPPLEWHITE, George (?–1786) Plates 85–6

Said to have been apprenticed to the Gillow firm (q.v.). His reputation is based on the designs in his *The Cabinet-maker and Upholsterer's Guide*, published posthumously in 1788 by his wife Alice.

HERVÉ, François (fl. 1780–96)

Hervé described himself as a 'cabriolet chair-frame maker', although the extensive commission he was awarded at Chatsworth in the 1780s shows that he did make other items, including a large state bed and sofas. As a French immigrant working in England he was not 'in the first rank of fashion' but his work obviously suited a francophile such as the 5th Duke of Devonshire. He also worked at Carlton House for the Prince of Wales.

See Ivan Hall, 'A neo-classical episode at Chatsworth', *Burlington Magazine*, June 1980, pp. 400–414; Edwards, *Shorter Dictionary*, p. 660.

HOLLAND, Henry (1746–1806)

Architect, largely responsible for introducing Graeco-Roman detail into England. He was architect to the Prince of Wales in the 1780s and supervised work for him at Carlton House. He also worked at Southill, Woburn and Althrop.

See H. M. Colvin, *A Biographical Dictionary of British Architects, 1600–1840*, 1978.

HOLLAND & SONS

One of the most important London furniture firms of the Victorian period, a separate firm from 1843. They had a fashionable clientele, working for Queen Victoria at Osborne and furnishing the Athenaeum Club in Pall Mall. From about 1867 until his death in 1881 Bruce Talbert was employed as the firm's designer.

See Simon Jervis, *Furniture History*, VI, 1970, pp. 43–7.

HOPE, Thomas (1769–1831) Plate 92

Author, traveller, collector. Published *Household Furniture and Interior Decoration* (1807) in which he showed his scholarly adaptations of Greek and Egyptian motifs to furniture.

See Irwin, *Thomas Hope*.

HUNT, Philip (fl. 1680–1730) Plate 35

One of the group of late-seventeenth-century cabinet-makers working from the St Paul's Churchyard area. The maker of the state bed at Erddig. His trade card (in the British Museum) bears the interlaced cypher of William III and Mary with royal supporters and announces that he could make 'Cabenetts, Looking Glasses, Tables and Stands, Scretois, Chests of Drawers, and Curious inlaid figures for any worke'.

INCE, William (fl. 1738–1804) and MAYHEW, John (fl. 1745–1808)

These two successful makers – Mayhew served his apprenticeship with William Bradshaw (q.v.) as an upholsterer, and Ince with John West – entered into partnership in 1759. They produced some splendid Neo-classical furniture, and issued their folio design book *The Universal System of Household Furniture* (1759–62), modelled on Chippendale's *Director*, and dedicated to one of their principal patrons, the Duke of Marlborough. They also worked for the 6th Earl of Coventry and the Countess of Shelburne, both patrons of Robert Adam (q.v.), and in 1775 provided a wonderful cabinet to his design for the Duchess of Manchester (Plate 80).

See *Furniture History*, X, 1974, for two articles on this firm.

JENSEN, Gerreit (Gerrit) (fl. 1680–1715) Plate 36

A Dutch craftsman working in England. He provided marquetry furniture in the style of André-Charles Boulle, and from 1689 was principal supplier to the Royal Wardrobe 'of writing-desks, pier-glasses, stands and card-tables'.

His work can be seen at Hampton Court, Boughton, Chatsworth, Deene Park, and Clandon.

JOHNSON, Thomas (1714–c. 1778)

One of the most accomplished carvers of his generation, if the suites of engravings of the late 1750s bearing his name are any guide to his abilities. He was described in 1763 as 'Carver, Teacher of Drawing and Modelling . . .' but by then his main achievements were done. A set of four candlestands (c. 1758) by him, formerly at Hagley, are now dispersed to public collections (Philadelphia (2); Victoria and Albert Museum; Temple Newsam House, Leeds).

See Hayward, *Johnson*; Gilbert, *Catalogue*, no. 355.

KAUFFMANN, Angelica (1741–1807)

Her name is attached to many ceiling paintings and much painted furniture with which she had no connection. She was, however, employed by Robert Adam, along with her second husband, Antonio Zucchi, and provided coloured engravings to Matthew Boulton for his 'Mechanical Paintings' process. Many of these may survive on commodes, chair backs, etc.

See Beard, *Georgian Craftsmen*.

KENT, William (1685–1748) Plates 7, 51 and 55

An architect, painter, designer and landscape architect of excellent ability who was brought back from his years of Italian training (1709–19) by the 3rd Earl of Burlington, and patronized thereafter by him and by the talented circles of the 'Age of Pope'. Certain heavy pieces of gilded furniture (some illustrated in the 1744 John Vardy edition of Kent's designs) are credited to him (many at Chatsworth) and were probably made by Benjamin Goodison, Matthias Lock, Paul Petit and others.

See Geoffrey Beard, 'William Kent and the cabinet makers', *Burlington Magazine*, December 1975, pp. 867–71.

KETTLE, Henry (fl. 1777–96)

A cabinet-maker upholder and undertaker based at The Swan in St Paul's Churchyard, in premises which had been successively occupied by Coxed (q.v.) and Woster and the Bell family. Kettle was for a time in partnership with William Henshaw, and then he succeeded Philip Bell at The Swan. His work is often labelled (see Heal) and there is a pair of labelled Pembroke tables and a mahogany secretaire bookcase by him at Saltram.

LANGLOIS, Pierre (fl. 1738–c. 1770) Plates 81 and 83
A talented French cabinet-maker who settled in Tottenham Court Road, London, and became famous for commodes and writing-tables. His trade card announced that he made 'all Sorts of Fine Cabinets and Commodes, made & Inlaid in the Politest manner with Brass & Tortoiseshell . . .' The earliest dated reference to his work in England is 1759.
 See Peter Thornton and William Rieder, 'Pierre Langlois, ébéniste', *Connoisseur*, December 1971, February, March, April, May 1972; Rieder, *Connoisseur*, September 1974.

LAPIERRE, Francis (d. 1717) Plate 3
A French upholsterer who worked in England, particularly on state beds, and who provided the state bed for Chatsworth (the tester is now at Hardwick), in 1697. His main employer was William III's Great Wardrobe, but he worked for a number of private patrons, including the 1st Duke of Devonshire (Chatsworth) and his brother-in-law, the 5th Marquess of Exeter (Burghley House).

LIBERTY & CO. Plate 122
Founded in London in 1865. Important in popularizing Egyptian-style furniture, Arts and Crafts and Art Nouveau work ('Stile Liberty').

LINNELL, William (c. 1702–63) and John (1729–96) Plates 75 and 77–9
This accomplished father and son had a successful business in two stages – sound work in the Rococo years, including an important commission from the 4th Duke of Beaufort (Badminton), and very competent Neo-classical work under John's supervision after his father's death in 1763. Their careers have been researched in detail.
 See Hayward and Kirkham, *William and John Linnell*.

LOCK, Matthias (c. 1710–1765) Plate 52
Lock and his sometime partner, Henry (?) Copland, were credited for many years with the published designs of Thomas Chippendale (a theory since supplanted), but from the mid 1740s to the early 1750s Lock did issue many suites of etched designs useful to wood carvers. He was a carver of great ability (e.g. Hinton House, Somerset) in the Rococo style, and his son Matthias may have continued good work in the Neo-classical style.
 See Morrison Heckscher, 'Lock and Copland: a catalogue of the engraved ornament', *Furniture History*, xv, 1979, pp. 1–23.

LOUDON, John Claudius (1783–1843)

Trained as a landscape gardener; better-known for his publications, including the invaluable *Encyclopedia of Cottage, Farm and Villa Architecture and Furniture* (1833).

See John Gloag, *Mr Loudon's England*, 1970.

MACKINTOSH, Charles Rennie (1868–1925)

Scottish architect and designer, a leading figure in the 'Glasgow School'. Although his commissions were limited in number, his work had a widespread influence. The furniture he designed for a series of tea-rooms for Miss Catherine Cranston in the late nineteenth century is particularly noteworthy. His furniture was characterized by straight lines and gentle curves, and he was somewhat influenced by the work of E. W. Godwin (q.v.).

MCLEAN, John (fl. 1774–1814)

McLean's trade card (British Museum) indicates that in addition to making cabinets and chairs, he also performed funerals. A lady's toilet table is at the head of his card, and he and his son (? William) were said to specialize in 'Elegant Parisian Furniture'. In 1806 they furnished Middleton Park for the Earl of Jersey, and several labelled tables and secretaries by the firm have been recorded, including a rosewood library table at Saltram.

See *Country Life*, 16 July, 3 September 1943 (letters); Edwards, *Shorter Dictionary*.

MACKMURDO, Arthur Heygate (1851–1942) Plate 13

Trained as an architect and influenced by John Ruskin. Founded the Century Guild in 1882. An important early influence in the Art Nouveau style.

MANWARING, Robert (fl. *c.* 1765)

Published *The Cabinet and Chairmaker's Real Friend and Companion* (1765) and *The Chairmakers' Guide* (1766), and also contributed (with Ince and Mayhew, Chippendale and Thomas Johnson) to *The 11d Edition of Genteel Household Furniture* (1764–5). Thought to have been a cabinet and chair maker.

MAROT, Daniel (1663–1752)

French Baroque architect, decorator and furniture designer, born in Paris, who sought refuge in Holland in 1684. He entered the service of the future William III, and married Catherine, the daughter of the celebrated *ébéniste*

to Louis XIV, Pierre Golle. Marot came to England to work for Queen Mary in 1694, and made at least three visits to England in the next ten years. His engraved designs (1702) had an important influence on the production of state beds, and on the work of cabinet-makers such as Gerreit Jensen (q.v.).

MARSH, William (fl. 1778–1813)
A cabinet-maker and upholsterer, who with his partners became known as Edward, Marsh and Tatham and (later) Tatham and Bailey. His partner Thomas Tatham was the brother of Charles Heathcote Tatham (q.v.), an architect who had a considerable influence on furniture design. The firm supplied furniture to the Prince of Wales for Carlton House, and to the Whitbread family at Southill (over £10,000 worth of items).

MAYHEW, John, see INCE, William

MOORE, James, senior (c. 1670–1726) Plates 38, 39 and 55
and James, junior (d. 1734)
James senior was apprenticed to John Gumley and, with his son and his apprentice, Benjamin Goodison (q.v.), worked in royal service from about 1715 to his death in 1726. He is known particularly for furniture in the royal collections, with incised gesso tops or details. James Moore junior provided two mahogany settees to a design by William Kent in 1731 for Sir John Dutton of Sherborne, Gloucestershire. One of these is now at Temple Newsam House, Leeds (see Plates 7 and 55). Several settees of similar design are known, particularly at Houghton, Chatsworth (from Devonshire House) and Raynham, all houses where Kent was involved.
 See Geoffrey Beard, *Burlington Magazine*, July 1977, pp. 479–86; Gilbert, *Catalogue*, no. 324.

MOREL AND SEDDON
Nicholas Morel (fl. 1795–1830) joined in partnership with George Seddon in 1827 after dissolving a partnership with Hughes – Morel had worked as 'Upholder' to the Prince of Wales from 1807, and from 1811 to 1820 in the same capacity with Hughes. The principal commission for Morel and Seddon was the furnishing of Windsor Castle for George IV.
 See G. de Bellaigue and P. Kirkham, *Furniture History*, VIII, 1972, pp. 1–34.

MORGAN AND SAUNDERS (fl. 1801–17)
This partnership had premises in the Strand which were illustrated in Rudolph Ackermann's *Repository* in 1809. They provided patent library

steps and various sorts of 'mechanical' furniture such as extending dining-tables and beds. They also supplied the cabin furniture to Nelson's *Victory*.
See Edwards, *Shorter Dictionary*.

MORRIS, William (1834–96)
The main inspiration of the Arts and Crafts Movement. Set up his own firm in 1861, most of the furniture sold being designed by Philip Webb (q.v.). He was a theorist and man of ideas, as well as a designer of textiles, printed books and wallpaper.
See Ray Watkinson, *William Morris as Designer*, 1979.

NELSON, Saffron or Sefferin (fl. 1775–89)
Carver/gilder. Worked on many Robert Adam commissions, and at Chatsworth Derbyshire, and Carlton House, London, in the late 1780s.

NORMAN, Samuel (c. 1732–c. 1782)
One of the most important eighteenth-century cabinet-makers, carvers and gilders, whose workshop organization and patronage have been the subject of recent research. In early partnership with James Whittle (q.v.); a nephew of William Hallett (q.v.). His premises were gutted by fire and he went bankrupt in 1767. One of his principal patrons was the 4th Duke of Bedford, and good pieces by Norman survive at Woburn Abbey. He held his post as 'Master Sculptor and Carver in Wood' for the Crown until 1782.
See P. Kirkham, 'Samuel Norman: a study of an eighteenth century craftsman', *Burlington Magazine*, August 1969, pp. 501–13.

OAKLEY, George (fl. 1786–1810)
A London cabinet-maker (at St Paul's Churchyard), who seems to have worked with Henry Kettle (q.v.) and also on his own account. He worked in the Grecian style, to a high standard. His trade card (Heal) declares that he maintained a 'Magazine of General and superb upholstery and cabinet furniture'.

OLD, William, and ODY, John (fl. 1720–38)
Cabinet-makers settled in the St Paul's Churchyard area in the 1720s, who announced on their trade card (Heal), that they made all sorts of Cane and Dutch chairs, looking-glasses and 'Cabinet Work in Japan, Walnut Tree and Wainscot'. The business was carried on by Old's widow, with the stock being sold at her death in 1738. Labelled examples of their work have survived.

PARRAN, Benjamin (fl. 1754–c. 1790)
Nephew and partner of Benjamin Goodison (q.v.), succeeding him, as by

custom, in supplying furniture to the royal palaces in 1767. He was later in partnership with William Gates (q.v.) and with John Russell (q.v.).

PERFETTI, Joseph (fl. 1771–5) Plate 63
Provided a pair of side tables and pier glasses in 1771 to an Adam design for John Parker of Saltram, and did painting, carving and gilding at Lansdowne House (1775) – one of Adam's important London town houses.

PETIT, Paul (fl. 1731–53) Plate 56
A gilder and frame-maker of consummate skill who provided picture frames to various households of Frederick, Prince of Wales, and did the double gilding and painting on the royal barge designed in 1731 for the Prince by William Kent.

PRICE, Richard (fl. 1676–83) Plate 31
A London joiner who is known to have made caned 'Elbowe chaires of the twisted turne of wallnut wood with wrought mouldings and Lyons feet' for the royal palaces between c. 1676 and 1683. An armchair attributed to him is in the Temple Newsam House (Leeds) collections.
 See R. W. Symonds, *Connoisseur*, February 1934, pp. 86–92; Gilbert, *Catalogue*, no. 53.

RANNIE, James (?–1766)
Scottish upholsterer and cabinet-maker who joined Thomas Chippendale as a partner in 1754. He provided some of the capital, and the accounting side of affairs was continued after Rannie's death by Thomas Haig (q.v.).

ROBERTS, Richard (fl. 1714–30)
The *London Journal* announced on 19 October 1728 that Roberts was 'Chairmaker to his Majesty'. It is likely that he was a son of Thomas Roberts (q.v.).

ROBERTS, Thomas (fl. 1685–1714) Plate 27
Roberts supplied seat furniture to the royal palaces during the reigns of William III and Queen Anne. He also worked at Chatsworth (1702) and furniture at Knole is assigned to him.

RUSSELL, Sir Gordon (1892–1980)
A furniture designer and artist-craftsman who worked in the Cotswold School traditions of Gimson (q.v.) and the Barnsley brothers (q.v.). Turned to industrial methods, including the design of radio cabinets for mass production. Set up at Broadway a firm which made some of the best hand- and machine-made modern furniture. A pioneer, with Sir Ambrose Heal (q.v.) of the modern movement in English furniture design.

RUSSELL, John (fl. 1773–1810)

A chair maker, upholsterer and cabinet-maker who supplied furniture to the royal palaces, 1773–1810. In 1784 he entered into partnership with Benjamin Parran (q.v.).

SAUNDERS, Paul (fl. 1758–71)

Acted as 'Yeoman Arrasworker' to the Crown, and had his Royal Tapestry Manufactory in Sutton Street. Saunders was also a notable cabinet-maker and upholsterer who had an extensive trade – thirty-two cabinet-maker's benches were in his workrooms when his premises and stock were acquired in 1760 by Samuel Norman (q.v.).

SEDDON, George (1727–1801)

One of the largest employers of cabinet-makers in the second half of the eighteenth century. He set up in London about 1750, but in 1768 his premises were burned and he had to start work again in adjacent premises. His sons George and Thomas entered into partnership in 1785 and 1788 respectively, and in 1793 his son-in-law, Thomas Shackleton, joined them.

See Edwards and Jourdain, *Georgian Cabinet-Makers*.

SHEARER, Thomas (fl. 1788)

Cabinet-maker and designer. Author of *Designs for Household Furniture* (1788). In this year, too, *The Cabinet-Makers' London Book of Prices* appeared, with seventeen designs by Shearer from his *Household Furniture*. Shearer had obviously received a training in draughtsmanship and was probably a London cabinet-maker.

See *Connoisseur*, June 1961, pp. 30–33; *Furniture History*, II, 1966, pp. 40–42; ibid., XVIII, 1982, p. 13.

SHERATON, Thomas (1751–1806) Plates 99, 101 and 103

Trained as a journeyman cabinet-maker, but better known for his informative publications, *The Cabinet Maker and Upholsterer's Drawing Book* (1791–4) and the *Cabinet Dictionary* (1803).

See Edwards, *Shorter Dictionary*; Fastnedge, *Sheraton*.

SIMPSON, Arthur William (1857–1922)

An important Arts and Crafts maker who settled in Kendal, and worked on his own account and with many architects of the calibre of C. F. A. Voysey (q.v.), who designed Simpson's Kendal house, Littlecote (1909). Made a wide range of domestic and ecclesiastical furniture, some of which (such as trays) is metal-labelled. Attempts have been made to attribute to him much which is patently below his high standard. Worked extensively in oak.

See E. Davidson, *The Simpsons of Kendal: Craftsmen In Wood, 1885–1952,* Lancaster, 1978.

SMITH, Charles (fl. 1759–67)
Sold his London premises near Carnaby Market to Ince and Mayhew (q.v.) in 1759. In 1767 he was one of the two executors named in the will of William Vile (q.v.).

SMITH, George (fl. 1808–26)
Published *A Collection of Designs for Household Furniture and Interior Decoration* in 1808. On the title-page Smith announced that he was 'Upholder Extraordinary to His Royal Highness, the Prince of Wales'. His book is an important statement on Regency furnishings but he did not aspire to the scholarly correctness of Thomas Hope (q.v.). See this book, p. 176.

STUART, James ('Athenian') (1713–88) Plate 57
A well-known architect, with somewhat dilatory ways, who was instrumental in the revival of Greek motifs in English architecture in the late 1750s. He travelled widely and, with Nicholas Revett, issued the first volume of the *Antiquities of Athens* in 1762. His designs of carved and gilt furniture for the 1st Lord Spencer at Spencer House, and for Nathaniel Curzon at Kedleston reveal him as a designer of great ability.
See David Irwin, *Athenian Stuart,* 1982.

SYMPSON, Thomas (fl. 1666) Plate 25
A London joiner who made bookcases for Samuel Pepys in 1666 (now at the Pepsyian Library, Cambridge). A similar bookcase (with a matching later copy) is at Dyrham Park, Gloucestershire.

TAITT, John (fl. 1768–99)
Partner to William Gordon (q.v.).

TATHAM, Charles Heathcote (1772–1842)
An architect who influenced furniture design in the early nineteenth century. He was a pupil of Henry Holland (q.v.) who helped him to travel in Italy. He published widely on Greek and Roman architecture and it was pronounced that 'to him, perhaps more than to any other person, may be attributed the rise of the Anglo-Greek style'. His brother Thomas was a partner in the firm of Marsh (q.v.) and Tatham.

VILE, William (c. 1700–1767) Plates 70–74
Born, probably in Somerset, about 1700. Apprenticed to William Hallett, and still calling him 'my Master' in 1749. Set up on his own account, in

partnership with John Cobb (q.v.) in 1751–2 in the Long Acre area of London. Appointed to royal service to George III and Queen Charlotte in 1761, and worked in that capacity until June 1763, when they were replaced by their former apprentice, William France (q.v.). Provided furniture of the highest quality to the royal palaces.

See this book, pp. 146–52; Geoffrey Beard, *Burlington Magazine*, July 1977, pp. 479–86.

VOYSEY, Charles Francis Annesley (1857–1941)
An architect and designer of far-reaching influence, who was initially influenced by William Morris (q.v.). His principles of design involved consideration of conditions, requirements and materials. His best furniture is post-1895 and incorporates various decorative methods as well as excellent proportions.

See John Brandon-Jones and others, *C. F. A. Voysey, Architect and Designer*, 1978; Duncan Simpson, *C. F. A. Voysey . . .*, 1979 (Brighton Art Gallery catalogue).

WEBB, Philip Speakman (1831–1915)
Born in Oxford, the son of a doctor. Worked for the architect, George Edmund Street, and there met William Morris (q.v.). Set up in practice in London (1856) and joined Morris's firm in 1861. Webb designed most of the firm's furniture, in oak and mahogany, aiming always at simplicity and clean lines.

WEDGWOOD, Josiah (1730–95)
Famous potter, whose firm provided tablets and roundels in coloured jasper-ware to insert in furniture.

See Kelly, *Wedgwood*.

WHITTLE, James (?–1759)
In partnership with his son Thomas; at Thomas's death in 1755 he entered into partnership with his son-in-law, Samuel Norman (q.v.). He provided furniture to Lord Leicester at Holkham.

See P. Kirkham, *Burlington Magazine*, August 1969, p. 501.

WILLIAMS, Henry (fl. 1729–37)
Worked for Frederick, Prince of Wales, for the Crown at Hampton Court, and for private patrons such as Sir Paul Methuen (1729). Trained as a joiner, but was a maker of both inexpensive and lavish furniture, and a repairer of damaged items.

WRIGHT, Richard, and ELWICK, Edward, and successors (fl. 1746–1824)
Of Wakefield. Upholsterers, becoming the pre-eminent firm of cabinet-makers and upholsterers in Yorkshire during the second half of the eighteenth century, enjoying a dominance almost comparable to that achieved by Gillows (q.v.) in Lancashire. Richard Wright may have moved to Yorkshire from London. The firm subscribed to Chippendale's *Director*. It dealt in exotic wares as well as providing furniture of 'neat plainness'.
See C. Gilbert, *Furniture History*, XII, 1976, pp. 34–50.

WRIGHT AND MANSFIELD (fl. 1860–86)
This short-lived firm was the first in the nineteenth century 'to gain an exhibition award for furniture in an English style'. At the Paris Exhibition of 1867 they showed a satinwood cabinet in the Adam style – it is now in the Victoria and Albert Museum.

WYATT, James (1748–1813)
Architect who, influenced by Robert Adam (q.v.) and William Chambers (q.v.), adopted a thin linear form of Neo-classical ornament for his many buildings and interiors. Some elegant pieces of furniture designed by him survive at Heveningham, Suffolk, and in the collections of the Hermitage Museum in Leningrad (cabinets to house gems sent to Catherine the Great of Russia).
See J. Martin Robinson, *The Wyatts: An Architectural Dynasty*, 1979.

ZUCCHI, Antonio Pietro (1726–95)
Painter, second husband of Angelica Kauffmann (q.v.). Worked principally to the orders of Robert Adam (q.v.) and also provided designs for furniture, carpets and so forth for other craftsmen to execute.

NOTES

(Place of publication is London unless otherwise stated.)

CHAPTER I
THE CRAFTSMEN AND THE WORKSHOPS

1. P. M. Tillot, ed., *The City of York* (Victoria County History), 1961, pp. 167, 217.

2. C. E. Whiting, ed., 'Durham civic memorials', *Surtees Society*, CLX, 1945, p. xvii.

3. ibid., p. xviii; York Minster Library MS. BB5; London, Guildhall Library, MS. 6132.

4. William F. Kahl, 'Apprenticeship and the freedom of the London livery companies, 1690–1750', *Guildhall Miscellany*, No. 7, 1957, pp. 17–20; Kahl, *The Development of London Livery Companies* (Kress Library of Business and Economics, No. 15), Boston, 1960.

5. Quoted by Hans Huth, *Roentgen Furniture*, 1974, p. 58.

6. Pat Kirkham, 'Introduction to "The Cabinet-Maker's London Book of Prices, 1793"', *Furniture History*, XVIII, 1982.

7. Edward T. Joy, 'Some aspects of the London furniture industry in the 18th century', unpublished London University MA thesis (1960); Pat Kirkham, 'The organization of the London furniture industry', unpublished London University PhD thesis (1982).

8. Michael Stürmer, '"Bois des Indes" and the economics of luxury furniture in the time of David Roentgen', *Burlington Magazine*, CXX, December 1978, pp. 799–805.

9. Christopher Gilbert and Karin M. Walton, 'Chippendale's upholstery branch', *Leeds Arts Calendar*, No. 74, 1974, pp. 26–32.

10. Pat Kirkham, 'Samuel Norman: a study of an eighteenth century craftsman', *Burlington Magazine*, CXL, August 1969, pp. 501–13.

11. Pat Kirkham, 'The careers of William and John Linnell', *Furniture History*, III, 1967, pp. 29–44; Helena Hayward and Pat Kirkham, *William and John Linnell: Eighteenth Century London Furniture-Makers*, 1980.

12. Sophie von la Roche, *Sophie in London, 1786,* edited by Clare Williams, 1933, pp. 173–5.

13. Pat Kirkham, 'Inlay, Marquetry and Buhl Workers in England, *c.* 1660–1850', *Burlington Magazine,* cxxii, June 1980, pp. 415–19.

14. Richard H. Randall, Jr, 'Templates for Boulle Singerie', *Burlington Magazine,* cxi, September 1969, pp. 549–51.

15. Ben Bacon, 'Timber and the design of furniture', *Connoisseur,* March 1980, p. 187.

16. Act of 8 George I, cap.12 (1722). The *History of Jamaica,* 1774, noted the imposition of the £8 a ton duty by the Act of 11 George I, cap.7, and stated that mahogany of foreign growth evaded the duty by going from Jamaica as 'Jamaica wood'. Cited by R. W. Symonds, *Furniture-Making in 17th & 18th Century England,* 1955, p. 118.

17. Kirkham, 'Samuel Norman', p. 506.

18. Symonds, *Furniture-Making in 17th & 18th Century England,* p. 121.

19. Charles F. Hummel, 'English tools in America: the evidence of the Dominys', *Winterthur Portfolio,* II, 1965, pp. 27–46; Hummel, *With Hammer in Hand: The Dominy Craftsmen of East Hampton, New York,* Wilmington, USA, 1968.

20. W. L. Goodman, *The History of Woodworking Tools,* 1964.

21. Collections of the New York Historical Society. Phyfe's tool-chest is described by Nancy McClelland, *Duncan Phyfe and the English Regency,* 1939, p. 134. (Reprinted 1980.)

22. G. Bernard Hughes, 'Mechanical carving machines', *Country Life,* 23 September 1954, pp. 980–81; Edward T. Joy, 'Woodworking and carving machinery', *Antique Collector,* April, September, 1978.

23. Christopher Gilbert, ed., *Victorian and Edwardian Furniture by Pratts of Bradford* (Temple Newsam House, Leeds, exhibition catalogue), 1969.

24. *Cabinet Maker,* November 1880.

25. J. L. Mayes, *The History of Chairmaking in High Wycombe,* 1960; Pauline Agius, *British Furniture, 1880–1915,* Woodbridge, 1978.

CHAPTER 2

METHODS AND TECHNIQUES

1. See section on construction in Ralph Edwards, ed., *Shorter Dictionary of English Furniture* (1963) and Robin Butler, *The Arthur Negus Guide to English Furniture* (Feltham, Middlesex, 1978) which contains many valuable observations and useful illustrations.

2. Christopher Gilbert, ed., *Back-Stairs Furniture* (Temple Newsam House, Leeds, exhibition catalogue), 1977.

3. *Furniture History*, vii, 1971.

4. Peter Thornton and Maurice Tomlin, eds., 'The Ham House inventories', *Furniture History*, xvi, 1980.

5. Peter Thornton, *Seventeenth Century Interior Decoration In England, France and Holland*, 1978, pp. 97–225.

6. Christopher Gilbert and Karin Walton, eds., *English Furniture Upholstery, 1660–1840* (Temple Newsam House, Leeds, exhibition catalogue), 1973, p. vi.

7. Edith Standen, 'Croome Court – the tapestries', *Metropolitan Museum of Art Bulletin*, November 1959, pp. 96–111; Eileen Harris, 'Robert Adam and the Gobelins', *Apollo*, lxxvi, April 1962, pp. 100–16.

8. L. O. J. Boynton, 'The Bed-Bug and the Age of Elegance', *Furniture History*, i, 1965, pp. 15–31.

9. Croome Estate Office, Worcestershire; microfilm copies of all the furniture bills are at the Victoria and Albert Museum (Department of Furniture and Woodwork), London.

10. Geoffrey Beard, *Craftsmen and Interior Decoration in England, 1660–1820*, Edinburgh, 1981, p. 136.

11. Public Record Office, LC9/276.

12. Anthony Coleridge, *Chippendale Furniture . . .*, 1968, p. 170.

13. Michael Stürmer, '"Bois des Indes" and the economics of luxury furniture in the time of David Roentgen', *Burlington Magazine*, cxx, December 1978, p. 803, pls. 3–4.

14. W. A. Lincoln, *The Art and Practice of Marquetry*, 1971.

15. Christopher Gilbert, *The Life and Work of Thomas Chippendale*, 2 vols., 1978, i, pp. 187, 209.

CHAPTER 3
THE COMMISSION

1. H. C. Marillier, *English Tapestries of the Eighteenth Century*, 1930, p. xiii.

2. Examples abound in the Lord Chamberlain's records, Public Record Office, but this one is taken from a copy record, Worcestershire County Record Office, 2252/2.

3. Christopher Gilbert, *The Life and Work of Thomas Chippendale*, 2 vols., 1978, i, p. 236.

4. ibid., i, pp. 261–3.

5. Geoffrey Beard, *The Work of Robert Adam*, Edinburgh, 1978, p. 11.

6. Listed in Geoffrey Beard, *Craftsmen and Interior Decoration in England, 1660–1820*, Edinburgh, 1981, pp. 296–8.

7. Gilbert, *Thomas Chippendale*, I, p. 71.

8. Many bibliographical facts about eighteenth-century furniture publications are assembled in *Furniture History*, XIII, 1977. See also Peter Ward Jackson, *English Furniture Designs of the Eighteenth Century*, 1958.

9. Gilbert, *Thomas Chippendale*, I, pp. 101–2.

10. Helena Hayward, *Thomas Johnson and English Rococo*, 1964.

11. Helena Hayward, ed., 'Linnell's Furniture Designs', *Furniture History*, V, 1969.

12. Nicholas Goodison, *Ormolu: The Work of Matthew Boulton*, 1974; and his 'The Victoria and Albert Museum's collection of metal-work pattern books', *Furniture History*, XI, 1975, pp. 1–30.

13. Croome Estate Office, Worcestershire; microfilm copies at the Victoria and Albert Museum (Department of Furniture and Woodwork).

14. Gilbert, *Thomas Chippendale*, I, p. 207.

CHAPTER 4
DECORATIVE STYLES

1. Peter Ward Jackson, 'Some main streams and tributaries in European ornament 1500–1750' (Parts 1–3), *Bulletin* (Victoria and Albert Museum), III, Nos. 2–4, April, July, October, 1967.

2. Gervase Jackson-Stops, 'Formal splendour: the Baroque Age', in *The History of Furniture*, 1976, p. 58.

3. Oliver F. Sigworth, *The Four Styles of a Decade, 1740–50*, New York, 1960, pp. 23–6.

4. The room was illustrated in Thomas Sheraton's *Drawing Book* (1793); see also Geoffrey de Bellaigue, 'The Furnishings of the Chinese Drawing Room, Carlton House', *Burlington Magazine*, CIX, September 1967, pp. 518–28.

5. The most convenient edition is that of 1839, reprinted in 1970, with an introduction by C. G. Gilbert.

6. H. W. and A. Arrowsmith, *House Decorator and Painter's Guide*, 1840.

7. King published many pattern books in the 1830s, but his best-known work was *The Modern Style of Cabinet Work Exemplified* (five editions, 1829–62), which emphasized cheap production.

8. Clive Wainwright, 'A. W. N. Pugin's early furniture', *The Connoisseur*, 191, January 1976, pp. 3–11.

9. The firm of Crace were active from the mid eighteenth century, and worked

notably on the decoration of the Royal Pavilion at Brighton for the Prince Regent. Frederick Crace (1779–1859) worked with Pugin at many houses in which (as at Abney Hall, Cheshire, 1847) he showed how completely he understood the architect's principles of design. They also combined their talents on the 'Medieval Court' of the Great Exhibition of 1851, and the Houses of Parliament (1840–60).

10. From a paper read to the Royal Institute of British Architects.

11. Henry Whitaker, *Treasury of Designs*, 1847. This book devoted about a third of its plates to Elizabethan-style furniture.

12. Geoffrey de Bellaigue and Pat Kirkham, 'George IV and the furnishing of Windsor Castle', *Furniture History*, VIII, 1972, pp. 1–34; *George IV and the Arts of France* (The Queen's Gallery, Buckingham Palace, exhibition catalogue), 1966.

13. John Hardy, 'Blenheim and the Louis XIV revival, the state rooms, 2', *Country Life*, 30 January 1975.

14. Clive Wainwright, 'The age before Enlightenment', *The Times*, 7 February 1976.

15. N. Pevsner, 'Art furniture of the 1870s', *Architectural Review*, LXXXIII, 1938; Elizabeth Aslin, 'E. W. Godwin and the Japanese taste', *Apollo*, December 1962, and her 'The Furniture Designs of E. W. Godwin', *Bulletin* (Victoria and Albert Museum), 11, 4, October 1967.

16. Jill Lever, *Architects' Designs for Furniture*, 1981.

17. Paul Thompson, *The Work of William Morris*, 1977; Ray Watkinson, *William Morris as Designer*, 1979.

18. Aymer Vallence, 'Mr Arthur H. Mackmurdo and the Century Guild', *Studio*, XVI, 1899, pp. 193–8; N. B. Pevsner, 'Arthur H. Mackmurdo', *Architectural Review*, LXXXIII, 1938 (reprinted in Pevsner, *Studies in Art, Architecture and Design*, 1968, II).

CHAPTER 5

FOR CROWN AND COURT

1. Discussed by Penelope Eames, 'Documentary evidence concerning the character and use of domestic furnishings in England in the fourteenth and fifteenth centuries', *Furniture History*, VII, 1971, pp. 41–60.

2. British Library, Harleian MS. 1498, fol. 59. One drawing is reproduced in Jocelyn Perkins, *Westminster Abbey: Its Worship and Ornaments* (Alcuin Club Collections, XXXIV), Oxford, 1940, II, f. p. 149.

3. Peter Thornton, *Furniture History*, VII, 1971, pp. 61–6; Pauline Agius, *Furniture History*, VII, 1971, pp. 82–3.

4. William Harrison, *Elizabethan England*, ed. L. Withington and F. J. Furnivall, 1921, pp. 94–5.

5. Sir John Harington, *Nugae Antiquae*, 1804, I, pp. 105, 202; J. G. Nichols, *Progresses of Queen Elizabeth*, 1821–3, iii, p. 250; J. E. Neale, *Queen Elizabeth*, 1934, pp. 206–212.

6. W. B. Rye, *England as seen by Foreigners in the Days of Elizabeth and James the First*, 1865.

7. Mark Girouard, *Robert Smythson and the Architecture of the Elizabethan Era*, 1966, pp. 120 ff.

8. L. O. J. Boynton, ed., 'The Hardwick Hall inventory of 1601', *Furniture History*, VII, 1971, pp. 1–40.

9. M. A. Tierney, *History and Antiquities of Arundel*, 1834, II, pp. 729–30.

10. The Lumley inventory of 1590 is printed in *Walpole Society*, VI, 1918, pp. 15–50.

11. There is a series of such chairs at Trinity Hall, Aberdeen, one dated 1574, and another 1627. They belong to the Deacons of the Incorporated Trades.

12. Margaret Jourdain, *Stuart Furniture at Knole*, 1952, gives a general account of the Knole furniture.

13. Peter Thornton, 'Canopies, couches and chairs of state', *Apollo*, October 1974, pp. 292–9; Gervase Jackson-Stops, 'Purchases and perquisites, the 6th Earl of Dorset's furniture at Knole, 2', *Country Life*, 9 June 1977, pp. 1620–22. For the first article 'A courtier's collection', *Country Life*, 2 June 1977, pp. 1495–97.

14. Christopher Gilbert and Karin Walton, eds., *English Furniture Upholstery 1660–1840* (Temple Newsam House, Leeds, exhibition catalogue), 1973, p. v.

15. Frances Parthenope, Lady Verney, and Margaret M. Verney, eds., *Memoirs of the Verney Family*, 1892–4, II, pp. 285–6.

16. Gervase Jackson-Stops, 'Formal splendour: the Baroque Age', in *The History of Furniture*, 1976, p. 82.

17. Peter Thornton and Maurice Tomlin, 'The Furnishing and Decoration of Ham House', *Furniture History*, XVI, 1980, pp. 36–177.

18. John Dunbar, 'The building activities of the Duke and Duchess of Lauderdale, 1670–82', *Archaeological Journal*, CXXXII, 1975, p. 210.

19. W. A. Thorpe, 'A great baroque bedstead', *Burlington Magazine*, XCII, 1950, pp. 3–8.

20. John Cornforth, 'Stitching in time', *Country Life*, 25 November 1982, pp. 1651–3.

21. Jackson-Stops, 'Purchases and perquisites', p. 1621; Jourdain, *Stuart Furniture at Knole*, pp. 22–3.

22. Francis Thompson, *A History of Chatsworth*, 1949, p. 156.

23. Helena Hayward, 'The Chinese influence on English furniture', *Colloquies on Art and Archaeology in Asia*, No. 3 (Percival David Foundation).

24. 'Indian' denotes all trading in the East and Far East in the seventeenth century through the East India Company's trading stations at Madras, Surat and Bengal. See R. W. Symonds, 'The craft of japanning', *Antique Collector*, September–October 1947, pp. 149–54.

25. Ralph Edwards and Margaret Jourdain, *Georgian Cabinet-Makers*, 1962, pp. 116–17; they mistakenly assume a connection with the royal cabinet-maker James Moore (d. 1726) through the phrase 'Rec'd Moore' being used in Belchier's bill to denote receipt of further, or 'more', money by instalments.

26. Francis Thompson, 'The work of Gerret Jensen at Chatsworth', *Connoisseur*, October 1935; Thompson, *A History of Chatsworth*, p. 25 ff.

27. Cited by Geoffrey Beard, 'Three eighteenth-century royal cabinet-makers: Moore, Goodison and Vile', *Burlington Magazine*, July 1977.

28. Letter from Earl Spencer, *Country Life*, 13 March 1942.

29. P. Thornton and J. Hardy, 'Spencer furniture at Althorp', *Apollo*, March 1968, pp. 182–3.

30. Anthony Coleridge, 'Some mid-Georgian cabinet-makers at Holkham', *Apollo*, February 1964, pp. 122–8.

31. Holkham Weekly Departmental Accounts, March 1756, June 1757; Coleridge, loc. cit., plates 8, 10, 12, 13.

32. Peter Thornton, *Baroque and Rococo Silks*, 1965.

33. Peter Thornton, *Seventeenth Century Interior Decoration in England, France and Holland*, 1978, pp. 115–16.

34. H. C. Marillier, *English Tapestries of the Eighteenth Century*, 1930, p. 79.

35. Gilbert and Walton, eds., *English Furniture Upholstery*, p. vi.

36. C. G. Gilbert, *Furniture at Temple Newsam House and Lotherton Hall*, 2 vols., 1978, 1, No. 45.

37. Geoffrey Beard, 'William Kent and the cabinet-makers', *Burlington Magazine*, December 1975, pp. 867–71; see also note 27 above.

38. C. G. Gilbert, 'James Moore, the Younger, and William Kent at Sherborne House', *Burlington Magazine*, March 1969, pp. 148–9.

39. Geoffrey Beard, 'William Kent and the Royal Barge', *Burlington Magazine*, August 1970.

40. C. G. Gilbert, *The Life and Work of Thomas Chippendale*, 2 vols., 1978.

41. Eileen Harris, *The Furniture of Robert Adam*, 1963.

42. Ivan Hall, 'Neo-classical elements in Chippendale's designs for the *Director* of 1762', *Leeds Arts Calendar*, No. 65, 1969, pp. 14–19.

43. Gilbert, *Thomas Chippendale*, i, p. 185.

44. ibid., i, pp. 29, 265.

45. Anthony Coleridge, 'A Reappraisal of William Hallett', *Furniture History*, i, 1964, pp. 11–14.

46. See my Hallett entry in the forthcoming *Dictionary of English Furniture Makers* (Furniture History Society).

47. Geoffrey Beard, 'William Vile again', *Furniture History*, xi, 1975, p. 114.

48. Westminster Public Library, Rate Books, New Street Ward, Castle Lane. MSS. F 519, 527, 530 (1750–55).

49. London, Guildhall Library, MS. 11936/110 (1755), f. 387.

50. Chute, Hampshire County Record Office 31M,57/630–31; Coventry, Croome Court Estate Office, Severn Stoke, Worcester – xerox and microfilm copies at Victoria and Albert Museum (Department of Furniture and Woodwork).

51. Derek Shrub, 'The Vile Problem', *Bulletin* (Victoria and Albert Museum), i, 4, October 1965, p. 32, plate 10.

52. Coleridge, 'Some mid-Georgian cabinet-makers', plates 8–10.

53. G. W. Whiteman, 'A remarkable group of English cabinets', *Antique Collector*, June 1969, pp. 116–20.

54. J. Harris, O. Millar and G. de Bellaigue, eds., *Buckingham Palace*, 1968.

55. Public Record Office, L C9/310, No. 8.

56. In particular the 'extra neat' inlaid commode at Corsham Court, Wiltshire (1772), is a documented example by Cobb allowing careful attribution of several which are similar.

57. LINNELL: Pat Kirkham, 'The Careers of William and John Linnell', *Furniture History*, iii, 1967, pp. 29–44; Helena Hayward, 'The drawings of John Linnell in the Victoria and Albert Museum', *Furniture History*, v, 1969; Helena Hayward and Pat Kirkham, *William and John Linnell: Eighteenth Century London Furniture Makers*, 2 vols., 1980. LANGLOIS: Peter Thornton and William Rieder, 'Pierre Langlois, ébéniste', *Connoisseur*, December 1971, pp. 283–8; February 1972, pp. 105–12; March 1972, pp. 176–87; April 1972, pp. 257–65; May 1972, pp. 30–35. INCE AND MAYHEW: a study is in preparation by Hugh Roberts and Charles Cater

58. Helena Hayward, 'Chinoiserie at Badminton', *Apollo*, Aug. 1969, pp. 134–9.

59. Hayward and Kirkham, *William and John Linnell*, i, chapter 5; John Hayward, articles on Fuhrlohg in *Burlington Magazine*, 1969, pp. 648–55; 1972, pp. 704–12; 1977, pp. 486–93.

60. Geoffrey Beard, *The Work of Robert Adam*, Edinburgh, 1978; Hayward and Kirkham, *William and John Linnell*; Maurice Tomlin, ed., *Catalogue of Adam Period Furniture* (Victoria and Albert Museum), 1972.

61. Pat Kirkham, 'The partnership of William Ince and John Mayhew, 1759–1804', *Furniture History*, x, 1974, pp. 56–60.

62. Morrison Heckscher, 'Ince and Mayhew: bibliographical notes from New York', *Furniture History*, x, 1974, pp. 61–4.

63. See note 49 above, and James Parker and others, *Decorative Art from the Samuel H. Kress Collection at the Metropolitan Museum of Art*, 1964, pp. 35–6.

64. L. O. J. Boynton, 'The bed-bug and the Age of Elegance', *Furniture History*, I, 1964, pp. 16–31.

65. L. O. J. Boynton, 'Italian craft in an English cabinet', *Country Life*, 29 September 1966, pp. 768–9; Nicholas Goodison, *Ormolu: The Work of Matthew Boulton*, 1974, plates 52–62.

66. Thornton and Rieder, 'Pierre Langlois, ébéniste'.

67. Gilbert, *Thomas Chippendale*, II, pp. 375–84 (Parlington); *Furniture from Broughton Hall* (Temple Newsam House, Leeds, exhibition catalogue), 1971; Nicholas Goodison and John Hardy, 'Gillows at Tatton Park', *Furniture History*, VII, 1970, pp. 1–39.

68. Dr Pat Kirkham allowed me to check her detailed notes on the Apprenticeship Registers at the Public Record Office from their commencement in 1711 to 1770. Six other Gillow apprenticeships are recorded in that period.

69. Sheraton's obituary notice, *Gentleman's Magazine*, November 1806.

70. Geoffrey Wills, 'The Carlton House writing table', *Apollo*, November 1966, p. 259.

71. *Sophie in London, being the Diary of Sophie von la Roche*, Clare Williams, ed., 1933, pp. 174–6.

72. Christopher Gilbert, *Thomas Chippendale, His Life and Work*, 2 vols., 1978, I, pp. 14 ff.

73. David Irwin, *Thomas Hope and the Neo-Classical Idea*, 1968.

74. Ralph Edwards, 'The Last Phase of "Regency" Design', *Burlington Magazine*, LXXXI, 1937, p. 272.

75. 150 volumes of their Day Books are preserved at the Victoria and Albert Museum, London (Department of Furniture and Woodwork).

76. I am indebted for this reference to the late Edward Joy, who had been engaged on a full study of Holland and Sons. His notes are in the Victoria and Albert Museum, London (Department of Furniture and Woodwork).

77. Ivan Hall, 'Patterns of Elegance, The Gillows' Furniture Designs', *Country*

Life, 8 June 1978, pp. 1612–15; 15 June 1978, pp. 1740–42. The Gillows' archives are at Westminster Public Library, Archives Department.

78. N. Cromey-Hawke, 'William Morris and Victorian Painted Furniture', *Connoisseur*, 191, January 1976, pp. 32–43.

79. Victoria and Albert Museum, London, *Liberty's, 1875–1975* (exhibition catalogue), 1975.

CHAPTER 6
FOR GENTLEMEN

1. Mark Girouard, *The Victorian Country House*, 2nd ed., 1979, p. 263.

2. Quoted by Constance Hall, *Juniper Hall*, 1904, pp. 258–9.

3. Nancy Goyne Evans, 'A history and background of English Windsor furniture', *Furniture History*, xv, 1979, pp. 24–53 (cites extensive literature in her notes).

4. ibid., pp. 38–41.

5. L. J. Mayes, *The History of Chairmaking in High Wycombe*, 1960; Ivan G. Sparkes, *The Windsor Chair*, Bourne End, 1975; Thomas Crispin, 'English Windsor chairs: a study of known makers and regional centres', *Furniture History*, xiv, 1978.

6. Album, Wycombe Chair Museum, described by Christopher Gilbert, ed., *Common Furniture* (Temple Newsam House, Leeds, exhibition catalogue), 1982, no. 29.

7. C. Gilbert, *Back-Stairs Furniture* (Temple Newsam House, Leeds, exhibition catalogue), 1977, no. 43.

8. B. Cotton, 'Country chairs', *Antique Finder*, xii, 10, Oct. 1973, pp. 18–23.

9. Edward Joy, 'Georgian patent furniture', *Connoisseur Yearbook*, 1962, pp. 8–15; Brian Austen, 'Morgan and Sanders and the patent furniture makers of Catherine Street', *Connoisseur*, November 1974, pp. 180–91.

10. *Patent Metamorphic Furniture* (Phillips of Hitchin exhibition catalogue), July 1978.

11. Geoffrey Wills, 'The Carlton House Writing-Table', *Apollo*, April 1961, pp. 256–261 (illustrates Campbell's trade card at Saltram House, Devon).

12. 1703 and 1710 housekeeper's inventories survive for Dyrham (Gloucestershire County Record Office).

13. Public Record Office, LC9/293.

14. W. D. John and J. Simcox, *English Decorated Trays*, Newport, Mon., 1964; Z. R. Lea, *The Ornamented Tray, 1720–1920*, New York, 1971.

15. See E. Gelles, *Nursery Furniture*, 1982, for a fuller explanation.

16. V. Greene, *English Dolls' Houses of the Eighteenth and Nineteenth Centuries*, 2nd ed., 1981; J. Toller, *Antique Miniature Furniture in Great Britain and America*, 1966.

<div align="center">

CHAPTER 7

FOR THE SERVANTS

</div>

1. Christopher Gilbert, *Town and Country Furniture* (Temple Newsam House, Leeds, exhibition catalogue), 1972.

2. Gilbert, *Back-Stairs Furniture* (Temple Newsam House, Leeds, exhibition catalogue), 1977.

3. Mark Girouard, *The Victorian Country House*, 2nd ed., 1979, pp. 29–30; Jill Franklin, *The Gentleman's Country House and its Plan, 1835–1914*, 1981.

4. June and Doris Langley Moore, *Our Loving Duty*, 1936, p. 212.

5. See the illustrations in Ralph Edwards, ed., *The Dictionary of English Furniture*, 2nd ed., 3 vols., 1954.

6. L. O. J. Boynton, 'Sir Richard Worsley's furniture at Appuldurcombe Park: an inventory', *Furniture History*, I, 1965, pp. 56–7.

7. Clive Aslet, *The Last Country Houses*, 1982, pp. 100–117 is informative on 'labour-saving devices'.

8. Illustrated by Gilbert, *Back-Stairs Furniture*, no. 29.

9. Aslet, *The Last Country Houses*, p. 106.

10. J. C. Loudon, *Encyclopedia of Cottage, Farm and Villa Architecture and Furniture*, 1833, fig. 728.

11. Gervase Huxley, *Victorian Duke, The Life of Hugh Lupus Grosvenor, First Duke of Westminster*, 1967, pp. 137–8.

12. Christopher Gilbert, *The Life and Work of Thomas Chippendale*, 2 vols., 1978, I, pp. 236–48.

13. Gilbert, *Back-Stairs Furniture*, no. 4, example at Newby Hall, Yorkshire.

14. Hampshire County Record Office, MS. 31M57/646.

15. Gilbert, *Thomas Chippendale*, I, pp. 183–92.

16. Gillian Walkling, *Antique Bamboo Furniture*, 1979.

17. *Studio*, I, 1896, p. 212.

CHAPTER 8
OUT OF DOORS

1. Unpublished MS., Osborn Collection, Bienecke Library, Yale University, quoted by Kim Rorschach, *The Early Georgian Landscape Garden*, New Haven, Connecticut, 1983, p. 41.

2. Morrison Heckscher, 'Eighteenth Century Rustic Furniture Designs', *Furniture History*, xi, 1975, pp. 59–65.

3. Sue Honaker Stephenson, *Rustic Furniture*, New York, 1979, p. 26.

4. Gainsborough, *Mr and Mrs Robert Andrews* (Tate Gallery); *Richard Savage Lloyd and His Sister* (British Art Center, Yale); Arthur Devis, *The James Family* (Tate Gallery).

5. William Gilpin, *Remarks on Forest Scenery*, 1791.

BIBLIOGRAPHY

Since 1964 a bibliography of books and articles on furniture has been published in *Furniture History*, the annual journal of the Furniture History Society.

Place of publication is London unless otherwise stated.

Agius, Pauline, *British Furniture 1880–1915*, Woodbridge (Antique Collectors' Club), 1978.

Aslin, Elizabeth, *Nineteenth Century Furniture*, 1962.

Beard, Geoffrey, *Craftsmen and Interior Decoration in England, 1660–1820*, Edinburgh, 1981.

Beard, Geoffrey, *Georgian Craftsmen and their Work*, 1966.

Beard, Geoffrey, *The Work of Robert Adam*, Edinburgh, 1978.

Butler, Robin, *The Arthur Negus Guide to English Furniture*, 1978.

Chinnery, Victor, *Oak Furniture, The British Tradition*, Woodbridge (Antique Collectors' Club), 1980.

Chippendale, Thomas, *The Gentleman and Cabinet-Maker's Director*, facsimile of 3rd ed. of 1762, 1962; ibid., with introduction by Ralph Edwards, 1957.

Coleridge, Anthony, *Chippendale Furniture, the Work of Thomas Chippendale and his Contemporaries in the Rococo Style*, 1968.

Comino, Mary, *Gimson and the Barnsleys*, 1980.

Cornforth, John, and Fowler, John, *English Decoration in the 18th Century*, 1974.

Duncan, A., *Art Nouveau Furniture*, 1982.

Eames, Penelope, *Medieval Furniture: Furniture in England, France and the Netherlands from the 12th to the 15th Centuries*, 1977.

Edwards, Ralph, *The Dictionary of English Furniture from the Middle Ages to the late Georgian Period*, reduced facsimile of 2nd ed., 1954, Woodbridge (Antique Collectors' Club), 1983.

Edwards, Ralph, *The Shorter Dictionary of English Furniture from the Middle Ages to the Late Georgian Period*, 1964 (shorter version of the three-volume 1954 edition of the *Dictionary*).

Edwards, Ralph, and Jourdain, Margaret, *Georgian Cabinet-Makers*, 3rd ed., 1962.

Fastnedge, Ralph, *English Furniture Styles from 1500–1830*, 1962.

Fastnedge, Ralph, *Sheraton Furniture*, 1962.

Filbee, M., *Dictionary of Country Furniture*, 1977.

Furniture History, annual journal, 1964– , of the Furniture History Society; indexed, vols. 1–10 and 11–15.

Garner, Philippe, *20th Century Furniture Design*, 1980.

Gelles, E., *Nursery Furniture*, 1982.

Gilbert, Christopher, *The Life and Work of Thomas Chippendale*, 2 vols., 1978.

Gilbert, Christopher, ed., *Furniture at Temple Newsam and Lotherton Hall: A Catalogue of the Leeds Collection*, 1968.

Gloag, John, *British Furniture Makers*, 1945.

Gloag, John, *English Furniture*, 1946.

Gloag, John, *The Englishman's Chair: Origins, Design and Social History of Seat Furniture in England*, 1964.

Gloag, John, *A Short Dictionary of Furniture*, revised edition, 1972.

Goodison, Nicholas, *Ormolu, The Work of Matthew Boulton*, 1974.

Harris, Eileen, *The Furniture of Robert Adam*, 1963.

Hayward, Helena, *Thomas Johnson and the English Rococo*, 1964.

Hayward, Helena, ed., *World Furniture*, 1969.

Hayward, Helena, and Kirkham, Patricia, *William and John Linnell, 18th Century Furniture Makers*, 2 vols., 1980.

Heal, Sir Ambrose, *The London Furniture Makers from the Restoration to the Victorian Era*, 1953.

Hepplewhite, George, *The Cabinet Maker and Upholsterer's Guide* (1788), reprinted 1970.

Hope, T., *Household Furniture and Interior Decoration* (1807), facsimile, 1971.

Ince and Mayhew, *The Universal System of Household Furniture* (1762), reprint with preface by R. Edwards, 1960.

Irwin, David, *Thomas Hope and the Neo-Classical Idea*, 1968.

Jervis, Simon, *Printed Furniture Designs Pre-1650*, 1975.

Jervis, Simon, *Victorian Furniture, A Collector's Monograph*, 1968.

Jervis, Simon, *High Victorian Design*, 1982.

Joel, David, *The Adventures of British Furniture, 1851–1951*, 1955.

Jourdain, Margaret, *Regency Furniture, 1795–1830* (1948), revised and enlarged by Ralph Fastnedge, 1965.

Jourdain, Margaret and Rose, Frank, *English Furniture, The Georgian Period, 1750–1830*, 1953.

Joy, Edward, *English Furniture 1800–1851*, 1979.

Joy, Edward, *Pictorial Dictionary of British 19th Century Furniture Design*, Woodbridge (Antique Collectors' Club), 1980.

Kelly, Alison, *Decorative Wedgwood in Architecture and Furniture*, 1965.

Lever, Jill, *Architects' Designs for Furniture*, 1981.

Liversidge, Joan, *Furniture in Roman Britain*, 1955.

Loudon, John Claudius, *Furniture Designs from the Encyclopedia of Cottage, Farm and Villa Architecture and Furniture* reprint of 1839 edition, with introduction by C. Gilbert, 1970.

Lucie-Smith, Edward, *Furniture: A Concise History*, 1981.

Mayes, J. L., *History of Chairmaking in High Wycombe*, 1960.

Mercer, Eric, *Furniture, 700–1700*, 1969.

Molesworth, H. D., and Kenworthy-Browne, J., *Three Centuries of Furniture in Colour*, 1972.

Montgomery, Florence, *Printed Textiles, English and American Cottons and Linens, 1700–1850*, 1970.

Musgrave, Clifford, *Adam and Hepplewhite Furniture and other Neo-Classical Furniture*, 1966.

Musgrave, Clifford, *Regency Furniture*, 1961.

Page, M., *Furniture Designed by Architects*, 1980.

Pinto, E. H., *Treen and Other Wooden Bygones*, 1979.

Pinto, E. H. and E. R., *Tunbridge and Scottish Souvenir Woodware with Chapters on Bois Durci and Pyrography*, 1970.

Rogers, J. C., and Jourdain, M., *English Furniture*, 2nd ed., 1961.

Sheraton, Thomas, *The Cabinet Dictionary* (1803), reprint, with introduction by W. Cole and C. F. Montgomery, 1970.

Sheraton, Thomas, *The Cabinet-Maker and Upholsterer's Drawing Book* (1793), reprinted 1970.

Sparkes, Ivan, *The English Country Chair*, 1977.

Sparkes, Ivan, *English Domestic Furniture, 1100–1837*, 1980.

Symonds, R. W., *English Furniture from Charles II to George II*, reprint of 1929 edition, Woodbridge (Antique Collectors' Club), 1981.

Symonds, R. W., *Furniture Making in 17th and 18th Century England*, 1955.

Symonds, R. W., *Veneered Walnut Furniture, 1660–1760*, 1946.

Thornton, Peter, *17th Century Interior Decoration in England, France and Holland*, 1978.

Thornton, Peter, and Tomlin, Maurice, eds., *Furnishing and Decoration of Ham House*, 1980.

Toller, J., *Antique Miniature Furniture in Great Britain and America*, 1968.

Tomlin, Maurice, *Catalogue of Adam Period Furniture* (Victoria and Albert Museum), 1972.

Tomlin, Maurice, *English Furniture*, 1972.

Walkling, Gillian, *Antique Bamboo Furniture*, 1979.

Ward-Jackson, Peter, *English Furniture Designs of the 18th Century*, 1958.

Whineray, B., and Symonds, R. W., *Victorian Furniture*, 1962.

Wills, Geoffrey, *English Furniture, 1550–1760*, 1971.

Wills, Geoffrey, *English Furniture, 1760–1900*, 1971.

Wills, Geoffrey, *English Looking Glasses: A Study of the Glass, Frames and Makers, 1670–1820*, 1965.

Wolsey, S. W., and Luff, R. W. P., *The Age of The Joiner*, 1969.

GLOSSARY OF TERMS

Italic type indicates that a word is explained elsewhere in the Glossary.

The best source for terms used in the furniture trade is Thomas Sheraton's *Cabinet Dictionary* (1803). Lists of terms used by Thomas Chippendale and William and John Linnell in the eighteenth century appear in Christopher Gilbert, *Life and Works of Thomas Chippendale* (2 vols., 1978) and Helena Hayward and Pat Kirkham, *William and John Linnell* (2 vols., 1980). An illustrated glossary is given by Robin Butler in his *Arthur Negus Guide to English Furniture* (1978), and reference can be made to Ralph Edwards, ed., *Dictionary of English Furniture*, (3 vols., 1954 – shorter edn., 1964).

ACANTHUS. Stylized leaf decoration derived from classical ornament. Found on the capitals of the composite and Corinthian orders; resembles the scalloped leaves of the acanthus plant (Plate 78).

AIR-WOOD. See *Harewood*.

ANTHEMION. A stylized honeysuckle motif derived from Greek art and used in Neo-classical decoration (Plate 80).

ANTIQUE. An eighteenth-century term, often written 'antick' in contemporary documents, to describe ancient Greek or Roman art or design.

APRON. An extension below the bottom edge of the seat of a chair or the frame of a table or cabinet (Plate 96).

AUMBRY. Medieval or Gothic cupboard, originally to house provisions given away as alms. Term soon applied to any closed cupboard or coffer (figs. 6–9).

BAIZE. A coarse open woollen material with a long nap; used for drawer linings and *case* covers.

BALUSTER. A short post or pillar, usually of circular section with a turned profile; used in series to form a balustrade supporting a rail, as on a staircase (Plates 17 and 45).

BANDING. Ornamental or veneered borders around doors, panels, drawers or table tops. In cross-banding, the grain runs at right angles to the edge (Plate 2); feather-banding and herringbone-bandings are set at an angle. Straight-banding is cut along the length of the grain.

BATTEN(S). Square deal bar(s) used in the construction of packing cases, or against walls as a framework for hanging wallpaper or fabric.

BEAD(ING). A narrow moulding of semicircular section (Plate 80).

BEVEL. Most commonly a slope cut at the edge of a flat surface, or as an applied moulding; commonly seen on the edge of plate glass and mirrors.

BOLE. A type of clay used to achieve a smooth surface under gilding and in japanning. See also *French bole*.

BOULLE (BÜHL) MARQUETRY. Brass and tortoiseshell marquetry, often set in an ebony ground. Perfected in France by André-Charles Boulle (1642–1732). Fashionable in England and France in the eighteenth and nineteenth centuries.

BRACKET FOOT. A shaped foot on carcase furniture, which projects slightly at each corner. The bracket can be ornamented with *beading*.

BUN FOOT. A flattened ball foot, used on furniture from the mid seventeenth century.

BUREAU. A desk having a lid sloping at an acute angle (usually about 45°) that folds out as a writing surface, with drawers underneath. If surmounted by a bookcase, it is known as a bureau-bookcase. The nomenclature of tables of French origin is very varied, e.g. *bureau-toilette*, a combined writing- and toilet-table.

BURNISHED GOLD. Water-gilding, highly polished or burnished.

BURR. Figure or circular pattern in the grain of wood, caused by a growth on the trunk of the tree.

BUTLER'S TRAY. A tray of wood (or silver or japanned metal) mounted on a folding stand or legs; much used in the eighteenth century. Frequently with hinged side flaps and pierced lifting handles.

CABRIOLE LEG. A leg which curves outwards at the top or knee and tapers in an elongated 'S' towards the foot. Even more popular after the publication of William Hogarth's *The Analysis of Beauty* (1753) in which it is depicted (Plate 49).

CANTED. Obliquely faced, as in a canted corner.

CANTERBURY. A stand with deep open partitions, and a drawer between the legs, for holding sheet music. According to Thomas Sheraton, so called because a 'bishop of that See first gave orders for these pieces'.

CARCASE FURNITURE. A term for furniture used for storage (as chest of drawers or *commode*) as distinct from chairs or tables. Carcase – the body or main structure of furniture, to which veneers are applied.

CARLTON HOUSE TABLE. A writing table with a low D-shaped superstructure, usually in satinwood, named after tables at the Prince Regent's Carlton House; illustrated in Thomas Sheraton's *Drawing-Book* (1791–4).

CASE. A loose cover for furniture; case cover; case curtains.

CASTER. A small swivelling wheel of wood, metal, ivory, leather, etc., attached to the leg of a piece of furniture (Plate 98).

CHAIR RAIL. Horizontal timber mould affixed to wall at height of top chair rail to prevent damage to wall decoration when chairs are against it (Plate 9). Part of the *dado*.

CHASING. Tooling or surface modelling of metal – to raise patterns in relief on mounts, etc.

CHIFFONIER. Anglicized French word for a small cupboard with a top forming a sideboard.

CLAW-AND-BALL (FOOT). A carved ornamental foot of (eagle) claws gripping a ball, in use during the eighteenth century (Plates 43 and 49).

CLOSE STOOL. A movable latrine, superseded by the pot cupboard or night table – sometimes called a necessary stool – having a hinged top which opens to reveal a pan.

CLUB FOOT. Leg terminating in the form of a club.

COLONETTE. A quarter- or half-round pilaster, fluted or reeded; frequently used in the late eighteenth century at the front corners of chests of drawers.

COMMODE (TABLE). French name for a chest of drawers, usually of elaborate appearance, serpentine in form, as in the productions of Pierre Langlois (Plate 83). From the mid nineteenth century the term was in use in England for a *close stool*.

CONSOLE TABLE. A table fixed to a wall, usually having a marble top, supported on shaped legs curving back to the wall; also applied to tables with legs or supports (e.g. stylized eagle) at the front side only.

COURT CUPBOARD. A low cupboard (*court* = short) for the display of plate.

Constructed in two stages with an open base and central cupboard with canted sides in the upper stage (figs. 6 and 8).

CRESTING. Carved wood decoration surmounting a looking-glass or cabinet.

CROSS-BANDING. See *Banding*.

DADO. Wood panelling running round the lower part of the walls of a room – with a base, panelling and a top projecting *chair rail* (Plate 69).

DAMASK. A figured fabric, the pattern being formed by differences in the surface sheen. The term is loosely applied to any silk fabric with a raised, usually floral, pattern (Plate 69).

DAVENPORT. A small writing-desk, often with a shallow-sloped top and several drawers.

DEAL. Fir or pine, often used for the carcase of furniture to be veneered.

DOVETAIL. A wood joint in which wedge-shaped projections interlock with each other.

DRAWING AT LARGE. A large-scale working drawing for use on the bench.

DRESSING GLASS. A toilet mirror which stood on a *dressing-table*.

DRESSING-TABLE. A table named after its function, usually with compartments for toilet requisites, and with a fitted, or separate *dressing glass* (Plate 98).

DRUM TABLE. A circular table with drawers, usually on a tripod base; also called a capstan table or a rent table (Plate 87).

DUMB WAITER. A wooden column with tripod foot carrying trays or shelves, one above the other in diminishing circumference; set by dining-tables to hold food, plates, etc., for self-service. Introduced in England *c.* 1740.

EASY CHAIR. A high-backed upholstered wing armchair (Plate 109).

ÉBÉNISTE. (French) A cabinet-maker.

EBONIZED. Wood stained black to simulate ebony.

ELBOW CHAIR. Armchairs, particularly those with open arms and padded rests (Plate 69).

EN SUITE. Part of a series; matching.

ESCUTCHEON. Ornamental brass or *ormolu* plate surrounding a keyhole opening (Plate 83).

FALL FRONT. The drop front of a desk or cabinet which forms a writing surface when lowered.

FESTOON. Ornament in the form of a garland of flowers or leaves suspended horizontally or vertically (Plate 45). See also *Window curtains*.

FIELD BEDSTEAD. A small folding four-post bed; also known as a 'tent bed'.

FLUTING. Rounded parallel grooves on friezes and pilasters (Plate 11).

FLY TABLE. A small table with extending flaps supported on slender gate legs or hinged brackets.

FOLDING TOP. A top enclosed by hinged flaps (Plate 98).

FRENCH BOLE. The best quality *bole*, of a blackish-red colour.

FRENCH ELBOW CHAIR. A term used during the 1750s for armchairs with upholstered seats and backs, carved frames and cabriole legs.

FRET. Cut-out geometrical ornament; for example, in a key-pattern (Plates 74 and 80).

FRET TABLE. A tea-table with a pierced trellis-work *gallery*.

'FURNITURE'. The finger-plates, handles, locks, etc., of a door.

FUSTIAN. A rough cloth with a linen warp and cotton weft. Usually brown in colour and made with many finishes and textures.

GALLERY. A small decorative railing at the edge of a table or tray, usually of turned spindles set between a top and bottom rail.

GARDEN MAT(T). A matting of a chequered weave, used as a packing material.

GATE-LEG TABLE. A circular or oval table, whose flaps are supported by jointed gates which swing out from the central section (Plate 96).

GENOA DAMASK/GENOA CUT VELVET. Silk damask and velvet made at Genoa, *c*. 1670–*c*. 1750, but imitated in France and England, particularly at Spitalfields (Plate 6).

GERMAN STOVE. Used for drying and heating in workshops.

GESSO. A plaster-like composition, of gypsum size and glue, usually gilded or painted (Plates 1 and 39).

GIRANDOLE. A candelabrum. In the eighteenth century, the word also described large Rococo sconces and mirror-backed wall brackets.

GIRTH WEB. Woven hemp strips which support the stuffing of upholstered chairs.

GROS POINT. Canvas embroidered in cross-stitch.

HAIR CLOTH. A durable dark fabric made from horse hair, used in upholstery for covering, in particular, dining and library chairs.

HAREWOOD. A veneer of sycamore wood dyed brownish-grey; used extensively in the late eighteenth century (Plate 78).

HARLEQUIN TABLE. An elaborate form of small *Pembroke table* in which a central nest of drawers in a square or oval frame is raised by weight or spring mechanisms, and pushed back flat with the table surface after use.

HESSIAN. A strong, coarse brown cloth.

HIPPED KNEE. A cabriole chair leg with carved ornament on the knee (Plate 50).

HOLLAND. A linen fabric, usually dyed brown or green, and used for window blinds.

INDIA PAPER. Hand-painted oriental wallpaper.

INLAY. Decorative technique, replaced by *marquetry*. A pattern of different woods inset into the carcase wood (Plate 20).

JAPANNING. Various methods of imitating oriental lacquer by using resins mixed with other materials, coloured, polished and gilded (Plate 82).

KETTLE STAND. A small table to support a hot-water kettle or urn.

KNEE. The top of a cabriole leg, sometimes carved (Plate 50).

KNIFE BOX. A case fitted with slots in which knives would be stored blade-downwards. Frequently of urn shape, or square with a sloping top (Plate 64).

KNOLE SETTEE. A settee with high back and hinged arms which are held upright when not in use by rope loops. Popular in the 1920s. Named after a seventeenth-century example at Knole Park, Kent.

LACQUER. A water-resistant clear varnish of oriental origin, having many variants (shellac) and imitations.

LIBRARY CHAIR. Armchair with padded, leather-covered, saddle-shape seat. The back has an adjustable hinged flap to hold a book, and compartments are located in the two padded arms for pens and ink, or for supporting candlesticks. The sitter usually straddles the seat facing the back. Incorrectly called a cock-fighting chair.

LINENFOLD. Carved ornamentation on panelling or settee-backs imitated folded cloth – a popular decoration in the early sixteenth century.

LIVERY CUPBOARD. Frequently mentioned in sixteenth- and seventeenth-century inventories; a cupboard which housed the *livre*, or food, for consumption at night – bread, beer, spiced wine – drinking vessels and candles (Plate 16).

LOO TABLE. A large oval or circular card table with a central support and tip-up top.

LOOSE SEAT. A slip seat that fits into the frame of a chair or stool (Plate 67).

LUTESTRING. A silk fabric, the surface dressed to give a sheen: often used for curtain linings.

MARQUETRY. A pattern made by fitting together pieces of different coloured woods and other materials (ivory, thin metal, etc.) into one sheet, and applying this to the surface to be decorated (Plate 77).

MOROCCO LEATHER. A goat-skin leather, coloured and used for surfacing library writing-tables (Plate 66) and for chair covers.

MORTISE AND TENON. A joint in which the projecting tongue (tenon) is inserted into a rectangular cavity (mortise) in the adjacent piece of wood.

MOTHER-OF-PEARL. A shiny substance from the lining of certain shells. Used as an inlay for furniture, particularly in the nineteenth century (Plate 113).

MOULDING. A shaped strip of wood, sometimes carved, applied to conceal joints, or as a decorative feature to panels and doors (Plate 21).

MUNTIN. A vertical wooden member between two panels (fig. 2 and Plate 93).

NECESSARY STOOL. A *close stool* with a hinged top which opens to reveal a pan.

NIGHT TABLE. A bedside pot cupboard, often with a tray top, and a *necessary stool* that pulls forward in the lower part.

NONSUCH CHESTS. Chests richly decorated with marquetry patterns of arches and fantastic architecture reminiscent of Henry VIII's (vanished) palace of Nonsuch, but having no connection with the palace. (The name means unequalled – 'non-such'.) Probably made in north Germany, or by sixteenth-century German craftsmen settled in London at Southwark and elsewhere (Plate 20).

O's/OES/OWS. Round brass rings for hanging curtains.

OIL GOLD. A type of gilding in which linseed oil is used in preparing the ground. It cannot be burnished. See *water gilding*.

ORMOLU. Gilt bronze, used for furniture mounts and door 'furniture'. The term is also applied, less precisely, to gilt brass (Plate 80).

PANEL. A shaped or rectangular member framed by *stiles, rails* and (often) *muntins* (fig. 2 and Plate 93).

PAPIER MÂCHÉ. Mashed paper combined with binding substances, which

hardens on drying, may be lacquered and decorated (Plate 113).

PARCEL-GILT. Partly gilded.

PATERA. A Neo-classical motif, oval or round, resembling a flower or rosette (Plate 68).

PATTERN CHAIRS. Models from which to work, frequently with arms or legs showing alternative forms and styles of decoration.

PEDESTAL TABLE. One supported on a single column or pillar. A pedestal desk stands on two side sections with a kneehole between.

PEDIMENT. Originally the gable above the portico of a classical temple. Adapted in various forms for the tops of furniture – e.g. 'broken', with a central break in base or apex, to incorporate a bust (Plates 60 and 73). If the sides are segmentally curved and end in scrolls they are titled 'swan-necked'.

PEMBROKE TABLE. A drop-leaf table on four legs. The leaves are supported on hinged wooden brackets when in use. Sometimes called a sofa table.

PENDANT. Ornament that hangs or is suspended – frequently a representation of flowers and fruit as a decorative feature.

PETIT-POINT. Canvas embroidered in tent stitch, a series of parallel stitches worked diagonally across the intersections of the threads.

PIE-CRUST. A raised edge to tables resembling a pie-crust (Plate 97).

PIER TABLE. One designed to stand against a pier, as between windows; often surmounted by a pier mirror (Plate 63).

PILASTER. Applied decoration in the form of a flat-sided column (Plate 77).

POLE SCREEN. A firescreen mounted on a pole, with a tripod or platform base. The screen may be moved vertically and locked at various heights.

PRESS BEDSTEAD. A folding bedstead built into a cabinet which outwardly resembles a press or chest.

RAIL. Any horizontal timber member in cabinet-making.

REEDING. Consecutive parallel convex curves formed for vertical or horizontal decoration on chair and table legs, borders and edgings (Plate 68). The opposite of *fluting*.

REFECTORY TABLE. A large hall table.

SECRETARY (SECRETAIRE). A writing-desk or cabinet with a fall-front desk drawer (Plate 72).

SHIELD-BACK. Chair design made fashionable in the 1780s by George Hepplewhite. The rail and stile form the shape of a shield (Plate 86).

SIDEBOARD. A serving table, often in the Neo-classical period *en suite* with pedestals and urns, wine cooler, and knife boxes (Plate 64).

SIDE TABLE. Designed to stand by a wall, frequently acting as a secondary serving table (Plate 52).

SIENA MARBLE. An Italian marble, yellow streaked with grey, frequently used for table tops in the eighteenth century (Plate 52).

SOFA TABLE. See *Pembroke table.*

SPLAT. A vertical member between the seat and top rail of a chair (Plate 58).

SQUAB. A removable stuffed cushion for a chair or stool (Plate 23).

STATE BED. A grand, lavishly upholstered bed intended for princes and noblemen (Plates 29, 32 and 45).

STILE. A vertical timber member of the side of a frame. The frame is formed from stiles, *rails* and *muntins* to contain panels (fig. 2 and Plate 93).

STRAP-WORK. Stylized representation of geometrically arranged leather straps: copied from Renaissance decorations.

STRETCHER. Horizontal timber member connecting and supporting the legs of furniture (fig. 5).

STRINGING. Narrow band of wood inlay; in the Regency period brass was sometimes used.

STUCCO NAILS. Nails with round brass heads and of varying lengths, used in fixing large looking-glasses or pictures.

STUMPWORK. A form of embroidery, padded so as to be in relief. Popular in the seventeenth century.

SURBASE. The moulding above the base of a column.

SUTHERLAND TABLE. A small swing-leg drop-leaf table; the central portion is very narrow.

SWAN NECK. An ogee (S-shaped) curve applied to handles and 'broken' pediments.

TAMMY. A fine woollen or wool and cotton fabric. Popular for linings, bed furniture and curtains, and for backing chairs.

TEA BOX. A tea-caddy, often compartmented (Plate 111).

TEA POY. A small stand on a column frequently set on a foot of four splayed legs. The top houses a hinged compartment for tea-caddies, etc.

TENT BEDSTEAD. See *Field bedstead.*

TERM (THERM). A free-standing tapering column of architectural form, or a

pedestal merging at the top into a sculptured animal or human figure (Plate 41).

TESTER. A canopy over a bedstead supported on the bed-posts. An angel canopy is suspended from the ceiling on chains; a half-tester is a short canopy projecting from the headboard and otherwise unsupported (Plates 32 and 33).

TILL. A small box, casket or closed compartment contained within a larger chest or cabinet (Plate 98).

TORCHÈRE. A torch-holder, tall candelabrum or hall lamp; sometimes incorrectly used to describe a stand designed to support a *torchère* or a lamp.

TRUSS. A scrolled bracket, often supporting a door head, cornice or pelmet.

TUNBRIDGE WARE. A type of marquetry decoration developed at Tunbridge Wells in the late seventeenth century. Pieces of different coloured woods were glued together so that the ends formed a pattern; the block was then sliced transversely, making up to thirty identical repeats of the pattern (Plate 105).

TURKEY WORK. Imitation of Persian and oriental pile carpets. The wool was drawn through a canvas and knotted to form a pile. Usually found on chair seats as upholstery.

TURNING. Decoration applied to wood as it rotates in a lathe by gouges and chisels (Plate 22).

VALANCE. A border of drapery hangings around the canopy of a bed (Plate 5).

VARNISH. A clear, often waterproof, coating of shellac applied to protect wood and enhance its colour.

VENEER. A thin sheet of wood applied to a timber base (Plate 2).

VENETIAN CURTAINS. See *Window curtains*.

VERRE ÉGLOMISÉ. A process of decorating glass by drawing and painting on the underside and backing the decoration with gold or silver leaf or foil.

WAINSCOT. Wood panelling generally. Also, panelling which goes up to dado or chair-rail height only.

WHATNOT. A stand of square or rectangular shelves, sometimes incorporating a drawer.

WINDOW CURTAINS. Drapery or reefed curtains are pulled up diagonally; festoon curtains are made to draw up perpendicularly by means of pulleys, often with a tassel at each gathering – they are sometimes called Venetian curtains (Plate 63).

INDEX

*Page numbers of illustrations are given in **bold** type.*